PAINTING BOATS AND COASTAL SCENERY

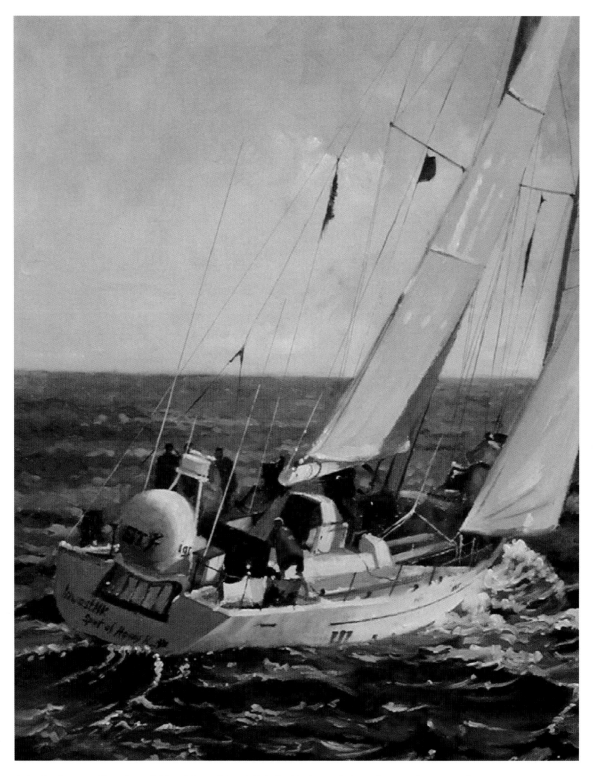

B.T. Challenge *Oil on board 25 × 30cm (10 × 12in). By kind permission of Mr and Mrs M. Thorpe.*

PAINTING BOATS AND COASTAL SCENERY

ROBERT BRINDLEY RSMA

THE CROWOOD PRESS

First published in 2009 by
The Crowood Press Ltd
Ramsbury, Marlborough
Wiltshire SN8 2HR

www.crowood.com

British Library Cataloguing-in-Publication Data
A catalogue record for this book is available from the British Library.

ISBN 978 1 84797 119 7

Typeset by Jean Cussons Typesetting, Diss, Norfolk

Printed and bound in India by Replika Press Pvt Ltd

CONTENTS

ACKNOWLEDGEMENTS

I would like to thank all my students, past and present, especially those I have known for many years now and who have become valued friends; all my painting colleagues, with whom I have spent many happy hours discussing our mutual passion for painting; in particular David Curtis for writing the foreword, and for his help and guidance at vital times in my development; and all my family, especially my wife Liz, my counsel and constant companion.

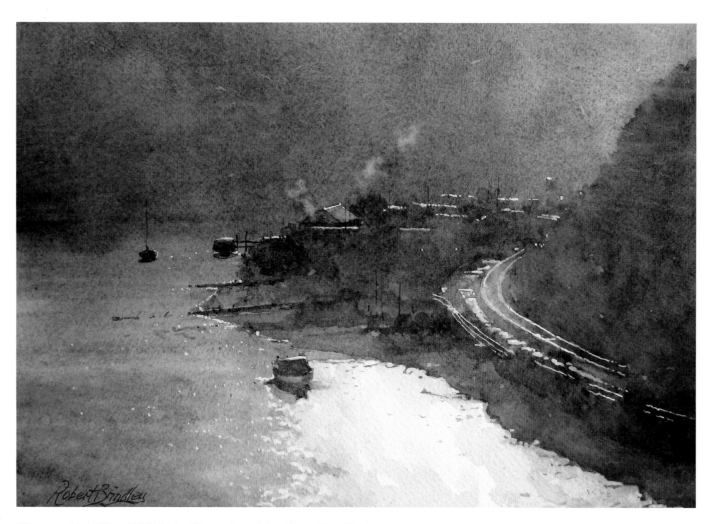

Afternoon Light/River Esk/Whitby *Watercolour, 25 × 20cm (10 × 8in).*

FOREWORD

With the well observed accolade of membership of The Royal Society of Marine Artists fully achieved, Robert has developed his admirable skills to an impressive new level. The joy to the eye of his recent *plein air* studies is manifest to his tenacious ambition to excel at all levels in his three chosen media. His beautifully considered watercolours are avidly collected – the variety and acute observation of the subject matter in all media gives his work its particular and very individual identity.

Always on the lookout for visual stimulus, Robert travels widely and is aware of the necessity for a degree of experimentation in technique and in challenging subjects, so keeping his imagery edgy and exciting.

Robert is recognized as one of the select band of formidable figurative painters of our time, and we look forward to more fine work in the future.

Of course he has been generous in sharing his considerable skills with a dedicated following of students over many years, and this book enhances that generosity of spirit within its pages. There is a feast of sublime works in the finished illustrations, and a vast quantity of information for all his readers.

It has been a delight to pen this foreword to what will be, I'm sure, a very successful volume.

David Curtis ROI, RSMA

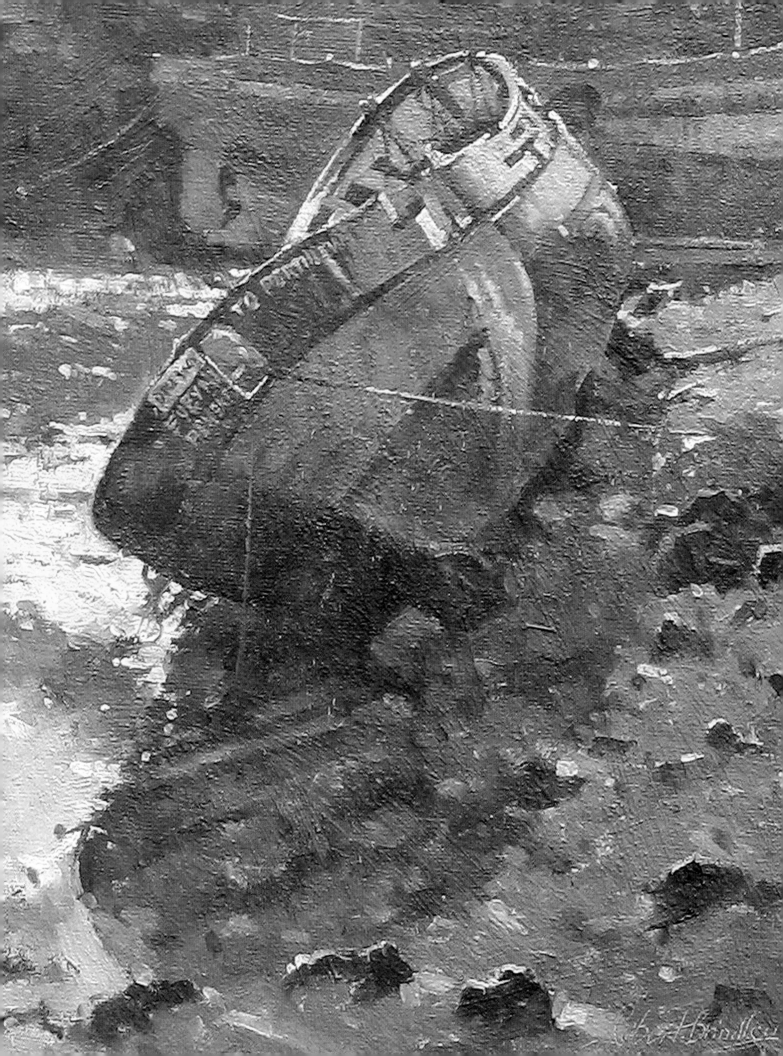

INTRODUCTION

From an early age I can remember looking at the landscape and wanting to reproduce what I saw. Dad had always drawn and painted, and this was an obvious inspiration. I could always draw reasonably well, however I always struggled with colour, invariably ending up with garish or 'muddy' results. Strangely, all these years later it's colour that really excites me, and although I have never neglected the drawing process I can't wait to introduce colour. This apparent lack of enthusiasm for drawing has always been a concern for me; however, I have never underestimated the importance of sound drawing skills, and I believe them to be the foundation from which all good works of art are created.

Very few of us are gifted and have a genuine ability to paint and draw; indeed for most of us, the love of painting compels us to strive constantly to improve our work. Learning to paint is no different from learning to play a musical instrument or training for a profession. It sometimes puzzles me why the skills of established painters are underestimated by a few impatient beginners, who expect to be able to paint well in a very short period of time. Many accomplished artists, past and present, have toiled constantly throughout their lives looking for progress in their work and hoping that the next painting will be something special. It never is, of course; although occasionally a high point is achieved, the special one is always out of reach. All we can do is strive for improvement.

I realize now that enthusiasm, hard work and an ability constantly to analyse your own and other artists' work, pays great dividends. By keeping an open mind to new ideas, and with a willingness to learn, I am confident that anyone with a basic ability and the desire to draw and paint can learn to do so and eventually achieve rewarding results.

I firmly believe, however, that the most important factor, no matter how skilful you become, is the enjoyment you experience every time you pick up a brush. Without this feeling you will never be able to transmit heart and soul to your work.

OPPOSITE: One Way to Porthleven *Oil on board, 25 × 30cm (10 × 12in).*
This painting is held in The Royal Society of Marine Artists Diploma Collection in Falmouth.

Dedicating time and effort to the process of painting has brought me many rewards, and I have become far more sensitive to detail, mood and atmosphere in nature. Time spent painting has relieved many of the stresses and worries of everyday life for me. There are many recommendations that I could make for students as they begin the learning process, and I would like to stress the importance of the following:

- Try to paint only what inspires you. It's extremely difficult to paint convincingly unless you are personally 'tuned in' to the subject.
- Don't be led too much by the detail in any subject matter, especially if it's based on photographic reference. Try to be creative with all aspects of colour, tone and composition; the result will be a more personal rendition of the subject.
- The language of painting is infinite, so always take the opportunity to look, listen and learn from all sources. There is nothing more likely to speed up development than learning from experienced artists, visits to quality exhibitions, books and so on. Assess everything, and filter out what you feel may be beneficial to you, as painting is a very personal experience. Never put any new advice into practice without fully understanding the process and the likely benefits to your own work.
- Never ignore or forget knowledge already gained. You may need this information sometime in the future should you ever need to re-evaluate your work.
- Be prepared to be disappointed, because even with all the skills in the world, painting is always going to be difficult. By recognizing this fact you will be able to allow improvements to take place naturally, the results you obtain will be more rewarding, and your skill levels will increase accordingly.
- Never let self-doubt take hold of you, but work through these periods with confidence in your ability. Self-doubt is a major handicap to all painters and is directly responsible for many failed paintings. Having confidence in your abilities will help to dispel negativity and allow you to develop with less stress.

Barges/Stavoren/ Holland *Oil on board, 20 × 25cm (8 × 10in).*
This small plein air *oil was painted on a Royal Society of Marine Artists expedition to Holland.*

- Should you ever begin to feel that your work has become laboured or stale, try one of the following suggestions:
 - Treat yourself to a painting-related book or DVD; there are hundreds on the market, and sometimes this is all you need to get a 'shot' of inspiration. On similar lines, a visit to an exhibition may do the trick.
 - Seek advice and constructive criticism from one of your peers, or an experienced painter (make sure that you get an honest opinion, as kind remarks will not help in the long term).

 - Try using different colourways or textures in your paintings.
 - I find the best remedy of all is to paint in several mediums. When I feel that my work is becoming laboured in one medium, I switch to another. This advice was given to me by a painting colleague some years ago, and it has never failed to banish those 'painting blues' that we all feel from time to time.

All painters occasionally feel that the quality of their work is suffering. It's almost impossible to paint consistently well, and in

any case, if painting becomes too easy and every work is a relative success, wouldn't it all become mundane? Very little is learned from a rapidly executed, successful work that seemed to paint itself, and often more is learned from failures or paintings that you have 'done battle with' and still achieved a painting of some merit.

Painting is a self-disciplined activity that you have to learn by yourself.

Romare Bearden

My advice is to work through these times of self-doubt, using the above measures to regain your confidence and stimulate your creativity.

In this book I will share my knowledge and experience in the many aspects of painting the coast, from creeks and tidal rivers to bustling beach scenes, boats and harbours, with a strong emphasis on capturing light, mood and atmosphere. I have been fortunate to be able to paint the coast in many locations throughout the world, and hope to give a flavour of my travels over the following pages through variety, colour and subject matter.

Using the Book

In this book I deal with painting coastal subjects using three primary mediums: watercolour, oil and pastel. Acrylic paint has been referred to on one or two occasions, however I have covered only the basic materials required for using this medium when used in conjunction with watercolour.

I have included 'step by step' demonstrations throughout, which I hope will be informative. To keep these demonstrations varied and at the same time informative, they each have an underlying theme together with an explanation as to how I develop a painting from initial inspiration to completion. I must stress that all artists have their own individuality, interpretation and working methods, which in the main they should adhere to.

New ideas should only be incorporated into your method of working if you are sure that these additions will extend your repertoire and enhance your paintings. My interpretation of subject matter, and how I develop each painting, may give a starting point or framework around which you can further explore the joy of coastal painting, especially those with little experience. Do by all means follow the stages outlined in the following pages; however, I encourage you to make any changes that reflect your own interpretation of the scene.

The Boatyard/Whitby
Oil on board, 25 × 35cm (10 × 14in).
My first painting to be accepted for a Royal Society of Marine Artists' exhibition. It was painted in the company of friends on a balmy summer's day.

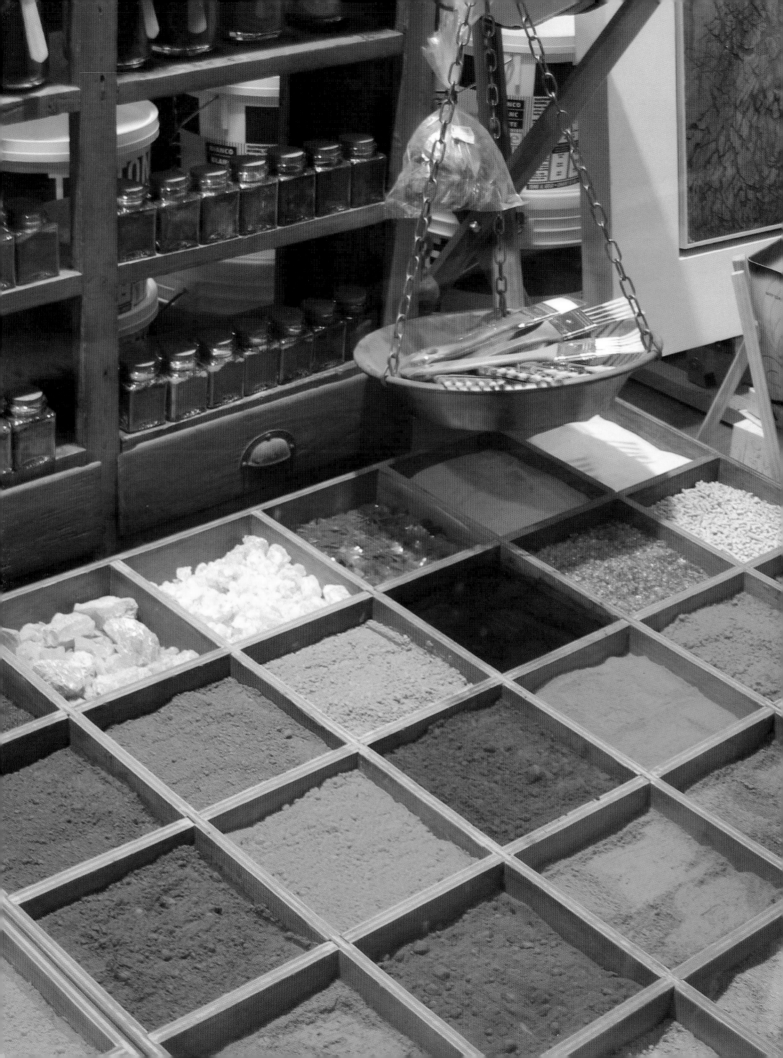

MATERIALS AND EQUIPMENT

The photograph opposite shows the window of an art shop in Venice. It is almost impossible to walk past a window such as this and not get excited by the rich selection of tempting colours on display.

The selection of suitable materials is vital to the execution of any painting, and the choice available to the artist these days is extensive. It is important, however, that you always buy the best quality that you can afford. This daunting task can be simplified by considering the recommendations outlined in the following sections.

Painting in Watercolour

The good watercolours take a lifetime – plus half an hour.

Toni Onley

Papers

The first consideration should be the paper that you use, as the choice you make can have a strong bearing on the success of your painting. Broadly speaking, each manufacturer produces paper in three quite different finishes, therefore it is important that you select the right one for the job in hand.

Rough

Many different effects can be reproduced using this textured surface, ranging from even, wet overall washes to textural dry-brush work.

OPPOSITE: Art shop window/Venice.

Cold Pressed (Not)

This is a smoother paper, although still textured. It is ideally suited to broad 'wet-into-wet' washes, even graded washes, and a more detailed approach. Should you want to achieve a 'soft', diffused atmosphere, this paper is the one for you.

Hot Pressed

This specially produced, extremely smooth paper is ideally suited to the more advanced artist who will be able to handle the sensitive nature of the surface. A build-up of washes or 'glazes' is difficult to achieve due to the likelihood of the underpainting lifting or being disturbed. It would therefore be ideally suited to 'one hit' painting, or detailed illustrative work.

Watercolour paper is generally produced in two different weights: a lightweight paper of 300gsm (140lb), and a heavier weight of 620gsm (300lb). To avoid having to pre-stretch your paper when working in a very wet manner, you should consider using the heavier weight.

Tinted paper is also available, and can be extremely useful for rapid, tonal outdoor sketches. Try out this paper using white gouache to produce highlights.

By selecting a colour that suits your subject, harmony can be achieved in your finished painting. For example, a warm grey paper would suit a misty Venetian morning where low colour is required and shapes loom out of the mist, and a subtle pink always works well for sunny beach scenes, where the warm-toned paper harmonizes beautifully with blue skies and sun-struck sand.

Brushes

Brushes once again are available in a vast array of types, sizes and shapes; it is therefore advisable to browse through a catalogue, or even better, to visit your local art shop and handle the brushes before selection. Watercolour brushes are generally

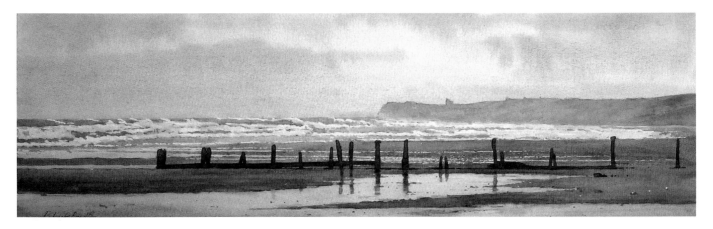

Breakwaters/Sandsend Beach *Watercolour, 48 × 15cm (19 × 6in).*

round or square in shape, and are made from a variety of hairs and synthetic fibres. Generally speaking, pure sable brushes remain the highest quality, and their ability to hold a good reservoir of pigment is unbeatable.

Choosing a brush is purely personal, and at the end of the day, any brush will fulfil its purpose once you have become familiar with its characteristics.

Pigments

Price is a major consideration when considering the purchase of pigments. The most expensive range of colours are usually referred to as 'artist's' quality, and their intensity and permanence is far superior to the 'student's' quality colours, where substitute pigments, fillers and binders may have been used – although I think it is fair to say that these days, all the well known manufacturers' colours are of extremely high quality, and you could safely buy any. Be aware however, that the colours may vary slightly from one manufacturer to another – for example, Raw Sienna by one manufacturer may be slightly different to the same colour by another manufacturer. It may be prudent therefore to stick to one manufacturer's colours, providing they are giving you the desired results.

Pigments are available in tubes (14ml or 5ml) or pans (full or half). Tubes obviously give a readily available, liquid colour and are preferred by many painters. Pans, however, offer a compact, more transportable alternative. Do bear in mind that when using pans, more patience is required when mixing colour, and valuable time will also be taken up when mixing large colour pools. Consider this when working outdoors, where the speed of execution has to be taken into account.

The selection of colours ideally suited for coastal subjects will be discussed later.

Pencils

A good quality 2B pencil is all that is needed for your initial drawing. It is soft enough to leave a strong line, which can be easily erased if necessary.

Equipment

The equipment used by the watercolour artist can happily be kept to a minimum, and the following items should be quite sufficient:

- an enamelled, brass watercolour box containing tube colour
- two or three ceramic mixing palettes
- sable brushes
- 14ml tubes of 'artist's' quality watercolour
- watercolour paper
- water vessels
- copious amounts of kitchen towel

Easels

A lightweight wooden or aluminium easel would be an advantage for use when painting outdoors, and could also be used in the studio.

Watercolour Painting Box

There are many varieties of painting palettes/watercolour boxes available; however, select a well made, compact metal box with deep mixing wells in preference to a plastic one.

This is a typical layout for the execution of watercolours in the studio.

Mixing Palettes

Aluminium, ceramic, enamelled tin or plastic palettes are widely available in many different shapes and sizes. All are acceptable, but it is worth noting that plastic palettes stain easily, and colour pools separate into unusable droplets until the new surface wears off.

Masking Fluid

Never has there been so much debate and general disagreement over an art product. Should masking fluid be used? Does it constitute 'cheating'? It produces hard, mechanical edges, so how can its use be valid? The debate still rages on. You may consider using masking fluid: after all, what have you got to lose by trying? It could prove beneficial to your work. The use of masking fluid, including the 'pros and cons', will be covered more fully in later demonstration paintings.

There are other, smaller items of equipment that you may find advantageous, but these will be covered in the watercolour demonstrations.

Painting in Acrylic

In this book acrylic paints are only used as a means to make alterations to watercolour paintings that fall short of expectations in some way. For example, they can be used to add or to re-emphasize a 'highlight', or to repaint whole passages of a failing watercolour. Only a bare minimum of materials are therefore recommended in this section.

Brushes

Inexpensive, synthetic brushes can be used for acrylic painting, and all that are needed would be three or four 'rounds' between numbers two to eight. One particular manufacturer makes a synthetic brush called 'Acrylix' especially for acrylic painting; these are reasonably priced and are to be recommended.

Pigments

All the main manufacturers make acrylic paints, all are excellent quality, and no particular recommendations can be given to aid your selection. The 75ml tubes are a convenient size, and all you will need are three primary colours and a white.

Painting in Oils

> When I was thirteen or fourteen I bought a paintbox with oil paints from money slowly saved up. The feeling I had at the time – or better, the experience of colour coming slowly from the tube – is with me to this day.
>
> Wassily Kandinsky

Canvases, Boards and Supports

The painting support is important for several reasons. Each surface responds differently to the brush (for example, there is a completely different 'feel' when using the brush on a flexible canvas compared to that of a rigid support). It is worth experimenting with different types of canvas or textured board, as 'rough' or 'smooth' surfaces provide a variety of results.

Canvases and prepared boards are available in many sizes. Try as many as possible before making your choice.

'Home-made' textured boards are used widely, and the following procedure outlines how to make and prepare your own:

- Cut a piece of hardboard or MDF to the required size, and lightly sand with fine-grade sandpaper to a matt finish.
- Treat the board with one coat of acrylic primer (the drying time will only be a few minutes).
- Apply a coat of 'texture paste' or 'moulding paste' to the board using a 25mm stiff brush, leaving random brush marks if desired (the drying time will be approximately 30 to 40 minutes).
- Treat the board with another coat of acrylic primer.
- Finally paint the finished board with a coloured 'ground' of oil paint, heavily diluted with turpentine or a similar solvent. Some artists prefer to work on a white ground; however, coloured grounds will enable you to work quickly over the entire surface of the board without having to worry about small areas being missed. Providing an appropriate coloured ground has been chosen, any small gaps

you may have left should add to the overall harmony of the painting.

- A board tinted with Raw Sienna and a touch of Cadmium Red works really well for any painting with large areas of green, and also under blue skies; a neutral tint of Raw Sienna and Ultramarine Blue is ideal for many 'low key' beach and harbour scenes. Once again, there is no better way than experimentation to find out which colour combination works best for your style of painting.

Brushes

An extensive range of shapes and sizes is available, made from various bristles, hairs and synthetic fibres. When selecting brushes, many of the considerations and comments in the watercolour section are applicable. It is important that you purchase good quality brushes, because although many cheap varieties are available, they tend to be of inferior quality. The old adage is probably true, that 'You get what you pay for'!

Pigments

Oil pigments are also available in 'artist's' and 'student's' quali-

ty and in several different sizes. Although the 'artist's' pigments are superior in that the strength of colour and quality of pigment is far greater than that of the equivalent 'student' variety, the painter should achieve satisfying results with either.

As with watercolour paints, there will be colour variations from one manufacturer to another, so once again it may be beneficial to find a manufacturer's colour you are happy with and stick with it. This should enable you to achieve a certain amount of consistency in your work.

Considerations for selecting a 'limited palette' will be discussed later in the chapter on light, tone and colour (*see* pages 68 and 72).

Equipment

The basic equipment generally needed for painting in the studio is as follows:

- a traditional wooden palette with 'dipper' attached for holding turpentine and such like
- various tubes of 'artist's' quality oil paints
- a palette knife
- a selection of 'hog' and synthetic brushes

Shown here is a typical layout for the execution of oils in the studio.

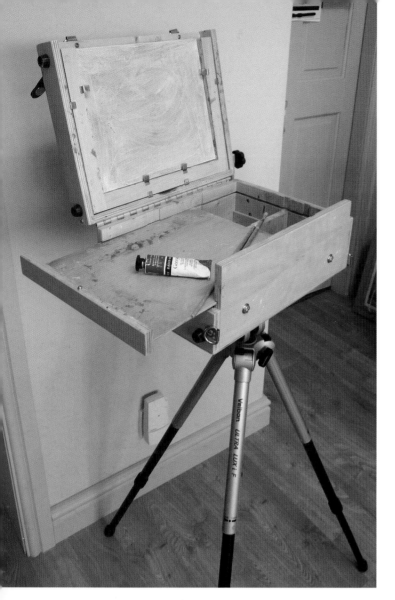

This is a compact, medium-sized pochade, ideal for small-scale plein air paintings.

Easels

A traditional 'French' or 'box' easel is ideal for both studio and outdoor work, whereas a 'pochade' would be ideal for small scale, *plein air* painting, as it is extremely compact and light. Many of them come with a built-in racking system in the lid to enable you to carry several wet boards. A medium-sized pochade will cater for a variety of board sizes, wet or dry, together with an integral palette and ample storage space. The one illustrated is mounted on a sturdy, collapsible camera tripod. The overall dimensions of this pochade are 25 × 34 × 13cm (10 × 13 × 5in).

Palettes

Traditionally oil palettes were made out of a hardwood, but nowadays for studio work more and more artists use palettes made from a variety of materials such as clear acrylic, plastic and glass. Size is an important consideration, as there is nothing more inhibiting than working on a palette that is not large enough to accommodate all the colours and mixing areas you need.

Palette Knives

Two or three palette/painting knives are extremely useful, not only for mixing paint and cleaning the palette, but also for applying the paint to the canvas or board you are working on.

Painting in Pastel

San Lazzaro Island/Venice *Pastel, 25 × 23cm (10 × 9in).*

Pastel is possibly the purest form of painting – we work with pure pigment and nothing else!

Amanda McLean

Papers and Boards

Over recent years the range of papers and boards for pastel painting has expanded greatly.

Traditional papers such as 'Ingres' are not so widely used, as many of today's pastel painters prefer more 'tooth' to their paper, which in turn allows more pigment to be applied. These rougher papers include a very fine 'wet-and-dry' sandpaper, available in black or grey, unmounted, or mounted on stiff card. This beautifully sensitive and expressive surface can be tinted using inks or acrylic. It is a joy to work on, but be aware that it does use a great deal of pigment.

The pastel painting *San Lazzaro Island/Venice* was painted on fine, grey sandpaper, tinted with a thin wash of Yellow Ochre and Alizarin Crimson acrylic to create a 'warm' orange ground. This surface and ground colour perfectly suited the softness of the early evening light just before sunset. To achieve this soft, hazy effect the pastel was blended quite extensively using a finger. The details and highlights were added after the blending was completed.

For personal expression and interpretation, it may be advisable to try as many surfaces and colours as possible, to find the one that works best for you and your style of painting.

Pastel Paints

Pastel paints come in three basic varieties: soft, hard and oil. In this book we will deal only with the use of soft pastels; however, as usual it is good for personal development to try all the other types.

Soft pastels come in various sizes and an amazing choice of colour. Try not to be seduced by the tempting array, as it could prove very expensive! A good tip for starting out with pastel would be to purchase a 'warm' and a 'cool' version of all the basic colours, and select a light, medium and dark version of each.

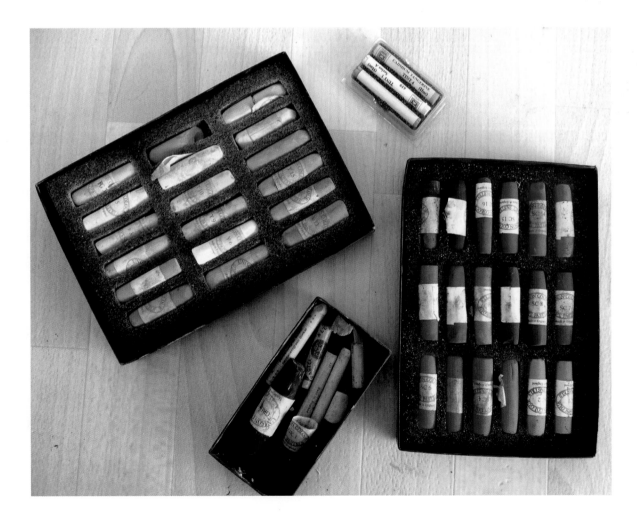

A selection of pastels.

Equipment

Aerosol Fixative

Although traditionally fixative was widely used to stabilize the pastel on a finished work, its use can darken the paint quite dramatically and you could be left with a painting that has a completely different 'feel' from the one that was intended. Nevertheless, fixative is occasionally very useful for stabilizing a partly completed work where you may be running short of 'tooth'. Instead of erasing pastel, which often results in 'dirty', tired-looking patches, try using a lightly applied spray of fixative to reintroduce the lost 'tooth'.

Erasers and Blenders

Plastic and putty erasers are ideal for removing pastel efficiently and cleanly. Do, however, make sure that you keep the eraser really clean at all times, as a dirty eraser will transfer unwanted marks to the paper.

For blending, a paper 'stump' is a very useful tool, especially when you are working on fine sandpaper where extensive blending using your finger can result in your skin becoming extremely sore. The paper of the 'stump' is also easily uncoiled, ensuring that it is constantly clean.

Demonstration *Morning Light/Morston Quay*

This pastel painting was inspired by an early morning painting session along the North Norfolk coast. Surrounded by salt marshes, Morston is a beautiful and peaceful painting location. The low 'silvery' early morning light reduced colour, creating a wonderfully atmospheric subject.

Materials

Paper:
Grey 'Hermes' glass paper, mounted on stiff card

Pastels:
All pastels were 'Unison' in the following colours and tones:
Blue Violet nos 2, 3, 5, 6, 10, 11, 14, 15, 16, 17
Brown Earth nos 22, 23
Green Earth nos 5, 15, 18
Blue Green nos 14, 15, 18
Grey nos 9, 10, 11, 23, 24, 26, 27, 28, 32, 33
Dark nos 4, 5, 7, 8, 18
Yellow no. 6
A (additional colours) nos 10, 11, 12, 21, 22, 23, 24
Red Earth nos 1, 4, 8
A neutral grey pastel pencil

Step 1: Drawing out
Use any neutral grey pastel pencil to draw a simple outline of the subject. A simple outline is all that is needed.

Step 2: Develop the sky and mid distance
• Begin to paint the sky using the lighter tones of grey

and blue-violet. The Yellow no.6 was used for the warm glow around the 'holes' in the clouds.
• Establish the far blue-grey distance using Blue Violet no. 11 and the nearer distant hills using Blue Green nos 14, 15 and 18.

Step 1.

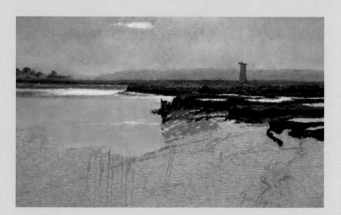

Step 2.

- At this stage a little blending of the applied colours can be carried out using your finger, taking care not to over-blend.
- The mid distance can now be tackled using the slightly darker-toned pastels such as Dark nos 5, 7, 8, 15; Blue Violet nos 12, 15, 16; 'A' assorted colours nos 21, 22, 23, 24; Brown Earth nos 22, 23; Green Earth nos 5, 15, 18.
- The water can be rendered by returning to the lighter tones in the blue-violet and grey range used for painting the sky.

Step 3: Develop the strong 'tonal' darks in the foreground

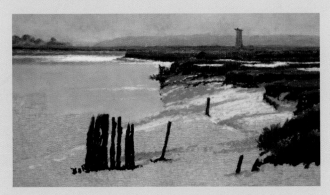

Step 3.

- You will now need to turn your attention to the extreme 'darks' present in the foreground. These need to be firmly established to set the extremes of tone.
- Use the following colours for this stage: Dark nos 1, 3, 4, 5, 7, 8, 18; Blue Violet no. 17.
- Try to avoid any artificial blending at this stage; let the pastel marks work against and into each other in a natural way to create texture and interest.

Step 4: Complete the foreground and add the finishing touches

- Paint the foreground light-struck banks, once again using the lighter tones in the blue-violet and grey range, with the addition of Red Earth nos 1, 4, 8.

Step 4.

- This area contains all the lightest lights, where you will be able to evaluate the darks selected in Step 3. The nature of the medium allows you to make small tonal adjustments where necessary.
- Once again rely on the pastel marks to create natural blending. The Red Earth colours can be used with caution to introduce a little warmth to the water surface, the top edges of the foreground timbers, the 'light-struck' river banks, and also to the middle ground marshes.
- Now is the time for evaluation and reflection. Ask yourself questions such as:
 - Does the composition work? (Give special consideration to the visual path through the painting, and the focal point.)
 - Do the tonal sequence and colour harmony work?
 - Do any of the 'edges' require strengthening or softening?
- Make any necessary adjustments.

A large number of pastels have been used for this painting, however the close colour range and the subtlety of the subject matter demand this attention to colour and tonal changes. Experiment with your own selection of colours and tones should you try this demonstration painting. As always, your choice when working with infinite combinations of tone and colour could produce a quite different and rewarding result.

Drawing and Sketching

Pencils

For drawing and sketching a selection of pencils or graphite sticks would be an advantage. Ignoring 'H' grades of pencil, which are usually too hard, a good selection from 'B' to '6B' would enable you to achieve the full range of tonal variations required.

Charcoal is also a very expressive drawing tool, giving a richer, darker mark than pencil, and able to produce an enormous variety of marks and tones with the added benefit of being easy to blend and erase.

Pens

Pens of varying types offer you a real opportunity to interpret your chosen subject in many different ways. Calligraphy and fountain pens can be especially useful if lines of different width are required. They can be used with either standard or waterproof inks.

Artists have always been wonderful innovators, and over the years have experimented with many different tools for sketching; for example, Edward Wesson sometimes used a sharpened twig or lollipop stick for his pen and wash drawings, as they gave him variety in line width and tonality. Sharpened black bamboo also gives a wonderfully expressive range of marks. Brush pens, a relatively new concept, in conjunction with felt tips can give a variety of softer marks of varying width and tone. All are wonderful tools for drawing and sketching.

Paper

Paper comes in a variety of different sizes and qualities, ranging from typing/printing paper for practice, up to high quality and relatively expensive paper that is sometimes sold in individual sheets. Papers can vary in texture, hue, acidity and strength. Smooth paper is good for rendering fine detail, but a 'toothier' paper will be more useful for depicting texture and tone more convincingly.

For pen and ink drawing, a heavier paper works better. 'Bristol Board' provides a hard surface that is also especially good for ink or fine detailed graphite drawing. 'Cold pressed' watercolour paper is sometimes favoured for ink drawing, as its slight texture produces a more natural, irregular line than a smooth drawing paper.

Sketchbooks

Sketchbooks come in a wide variety of shapes, sizes and types of paper. They are a useful way of providing a readily available supply of drawing paper in a convenient format. Sketchbooks made out of high quality paper, differentiated by weight and tooth, allow for a wide variety of techniques to be used, ranging from pencil drawings, to watercolour, to coloured pencil, to pen and ink, and so on. The paper in the sketchbook shown in *Watercolour Sketch of Plockton* is a relatively rough, cream paper and is a joy to work on. Sometimes the paper used in sketchbooks is cartridge paper or similar, which may only be suitable for drawing purposes; such a book would not be suitable for very 'wet' watercolour sketches. It is therefore important that you select a sketchbook that contains the correct paper for your intended purpose.

The illustration overleaf depicts the equipment necessary for simple pen-and-wash drawings. The sketch pad shown can only withstand light washes of colour, but is a smooth, very white

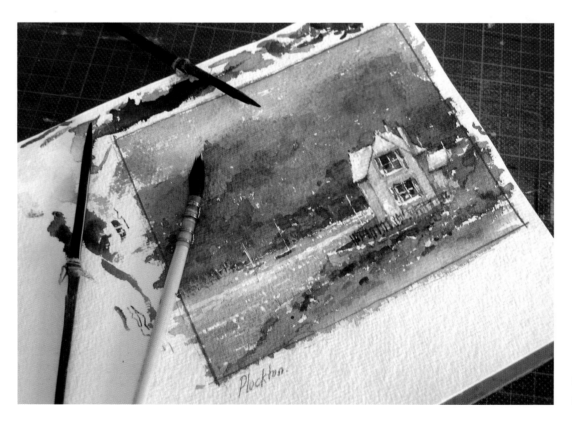

Watercolour sketch of Plockton.

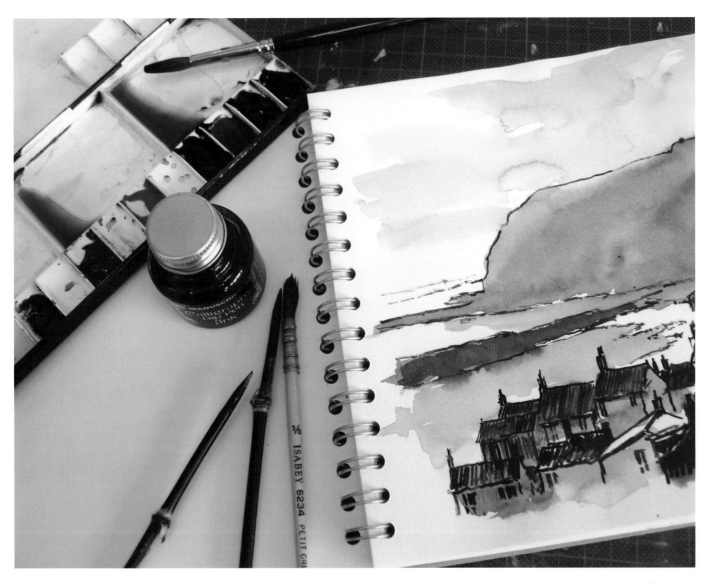

Pen-and-wash sketching equipment.

paper ideally suitable for pen and wash. The additional equipment illustrated comprises two sharpened sticks of bamboo, a wash brush, a bottle of waterproof ink, and a box of watercolour paints with a limited range of colours. The use of this equipment will be covered in greater detail later in the book.

Sketchbooks are used for many different reasons by artists. Some use them as a 'support' and a means to record something seen briefly, such as the setting sun on the horizon, or the attitude of constantly moving figures on the beach. Others like to take a little more time, to produce a painting complete with all the details necessary for studio reference. Sketches such as these often have sufficient merit to be framed, and occasionally they will outshine the future studio piece.

Characteristics of the Mediums

The mediums covered in this book are watercolour, oil and pastel. By experimenting with more than one medium, you will soon realize how each has its own characteristics. These characteristics can be used and exploited to interpret your subject in many different ways. It may be worthwhile considering not only the differences in the mediums, but also the similarities. Some subjects only lend themselves to one specific medium – for instance, a brightly lit, colourful cameo of boats and their reflections may suit a pastel painting – but on other occasions there may be an overlap where any one of the mediums could be adopted.

The scope and variety offered by using several mediums will enable you to develop flexibility and variety in your work.

A good working knowledge of the characteristics of each medium will help in the making of creative decisions; for example:

The Moorings/River Esk/Whitby *Watercolour, 25 × 18cm (10 × 7in).*

- For creating texture in your work, try working with oils on boards treated with texture paste.
- Should you want to create an atmospheric, hazy, transparent painting, watercolour would be the ideal choice.
- For creating a painting with strong colour and real impact, oil or pastel should be considered.

The Characteristics of Watercolour

Watercolour is a lifetime pursuit – mainly uphill.
Robert Wade

Watercolour by its very nature allows the artist to utilize its fluidity and transparency to interpret subjects where diffusion, delicacy and a light and airy touch are required. Early morning and evening beach and harbour scenes, where the light may be hazy, are ideal watercolour subjects. The nature of watercolour enables the artist to achieve diffused edges and simplify distant features in a sympathetic manner. The fluidity of the medium when used wet-into-wet will allow you to eliminate unnecessary detail and create the required mood and atmosphere in your subject.

The painting *The Moorings/River Esk/Whitby* was painted as a demonstration with the aid of sketches and reference photographs. It illustrates perfectly how watercolour suits this type of subject, allowing transparent 'wet-into-wet' washes to mingle and merge, creating mood and atmosphere.

By experimenting with different paper and colour combinations, the granular effects that watercolour produces can be extremely interesting, and prove very useful for painting skies, water and beaches.

The Characteristics of Acrylic

Acrylic paints are the perfect medium for painters who require a fast-drying medium that can be used in both a watercolour style, by building up transparent washes, and as with oils, by layering the paint as thickly as desired. However, this book

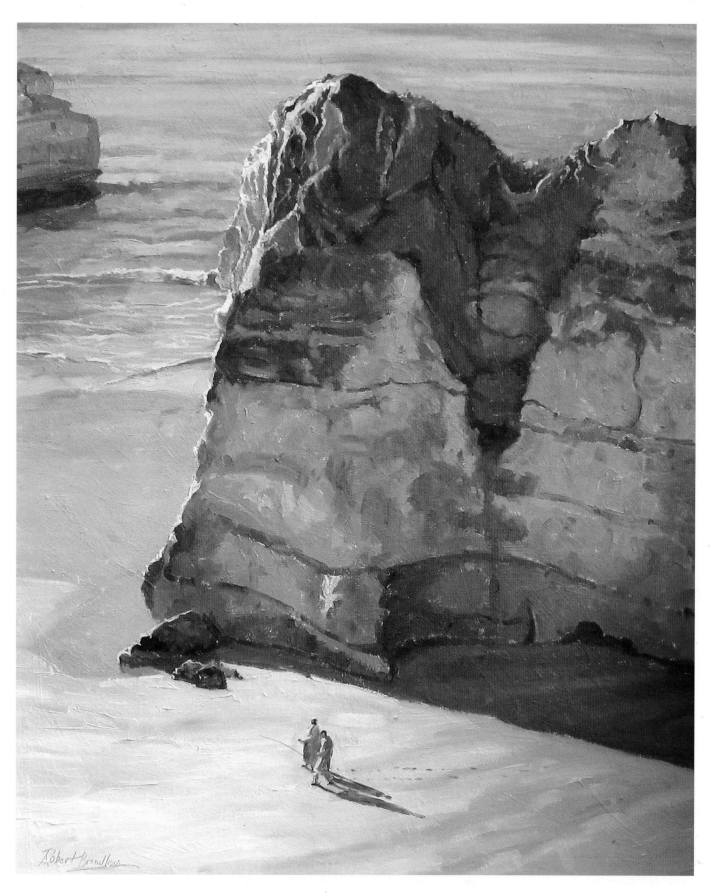

Praia de Rocha/The Algarve *Oil, 50 × 61cm (20 × 24in)*.

only covers the use of acrylic paints as a supplement to watercolours.

The Characteristics of Oil

Oils are a wonderfully versatile and expressive medium, potentially carrying much more weight and drama than watercolour. They lend themselves to the often vibrant, dense colour and texture in many coastal subjects. However, depending on its application much 'thinner', almost transparent effects can be achieved which, if you haven't tried already, you may find to be an interesting way of using oil paint. This method can be utilized to capture some of the more transient and gentle lighting conditions, where watercolour may normally have been used. It could be very useful for your development to experiment and subsequently discover the similarities in these two mediums.

The high aspect of the studio painting *Praia de Rocha/The Algarve* gives added drama to the subject. Notice how brush strokes can be used to accentuate the texture and planes in the rock surface, and also capture the movement in the water.

Oil paint is a perfect medium to use for *plein air* painting. Unless the completion of a painting is prevented by the extremes of weather, work can usually be continued in conditions unsuitable for painting in other mediums.

The Characteristics of Pastel

Pastel is a surprisingly diverse medium, ideally suited to strong, colourful, graphic subjects, many of which can be found when painting coastal scenes (as in the demonstration in Chapter 4, *see* page 70).

Pastels are essentially a 'drawing' medium, and are at their best when used boldly and with confidence. Their characteristics can be more readily exploited by artists who possess good drawing skills, and if drama and a sense of design are important in the work. Furthermore the strength of colour and contrast can be enhanced by using a black or dark-coloured 'ground'.

The pastel painting *Tractor and Huts/Skinningrove* was the result of a day's painting with a colleague. The tractor almost fills the painting plane, and the intention was to concentrate purely on texture and colour. Strong colour dragged over fine-grade black sandpaper was used to create the texture in this powerful subject.

Tractor and Huts/Skinningrove *Pastel, 38 × 28cm (15 × 11in).*

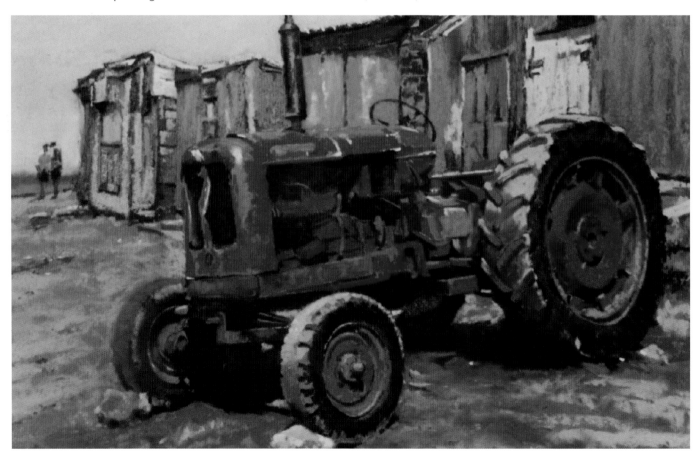

Setting Up a Studio Space

A suitable studio or working space is essential for any serious painter. It should be a place where you can work and concentrate without the intrusions of everyday hustle and bustle. Many artists will not be able to dedicate an entire room to their painting; others may have the luxury of unlimited space. It's extremely difficult to make recommendations that will suit everyone; however, the following considerations may help with the creation of your own special working environment.

Easels

A large studio easel is essential for the painter who works with oils and pastels on a large scale. To preserve valuable studio space, consideration should be given to purchasing a dual-purpose easel that can be used for both oil and pastel.

Workbenches and Layout Areas

A good sized workbench/layout area is essential, with maybe a hinged, adjustable slope incorporated for watercolour work.

Lighting

Lighting is one of the most important aspects of working indoors and is often overlooked. Not many artists can boast a studio flooded with natural northern light. It is therefore essential that a good balance of 'warm' and 'cool' artificial light is used. 'Daylight' fluorescent tubes and bulbs will produce a 'cooler' light, whilst normal household tubes and bulbs will provide a 'warmer' light. By using a combination of the two, the correct balance can be achieved. For close-up work an anglepoise lamp is useful, and for lighting paintings spotlights are ideal.

This typical workbench incorporates an adjustable slope for watercolour work, a layout area, together with plenty of storage space.

The adjustable slope shown here is especially useful for watercolour painting.

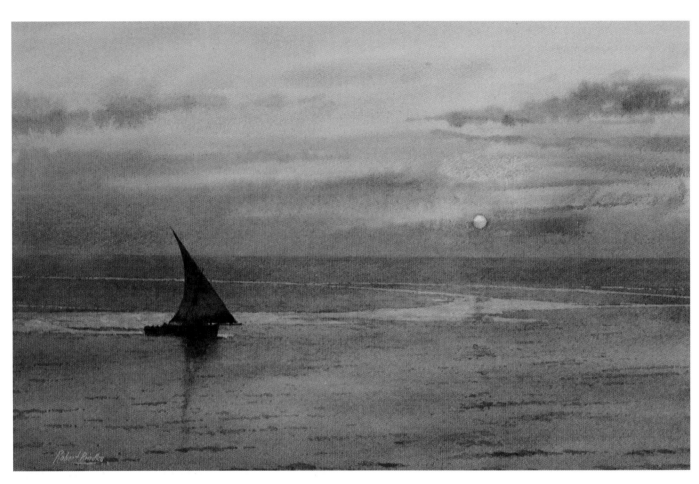

Zanzibar Sunset *Watercolour, 45 × 30cm (18 × 12in).*

SUBJECTS AND IDEAS

Diversity of Subject Matter

The subject matter for painting coastal scenery is wonderfully diverse, so you should never find selecting a subject too difficult.

Water has a magical effect on many people, and its inclusion in so many paintings is testament to this fact. The ability to portray water convincingly is no easy matter, but when achieved successfully, it is a rewarding experience. Coastal waters reveal themselves in many forms; for example, sparkling light in an early morning or evening scene, reflections, calm tranquil seas and rising mist. All these elements provide the painter with constant challenges and variety of subject matter.

A willingness to seek out new subjects and to interpret them with imagination will be sufficient to keep any painter busy for more than one lifetime!

An Artist must insinuate certain elements by painting information, not detail.

Scott Christensen

The watercolour painting *Zanzibar Sunset* illustrates many of the qualities to look out for in your search for the 'magical subject'. This tranquil evening in an exotic location provided an almost perfect subject: the atmosphere, light, colour, tonal arrangement and composition were there already, leaving few decisions to be made. The only problem encountered was the time available, as sunsets invariably last only ten minutes or so from start to finish. In situations such as this, a few mental notes and reference photographs should prove extremely useful. Make the most of these opportunities, as they don't come along too often.

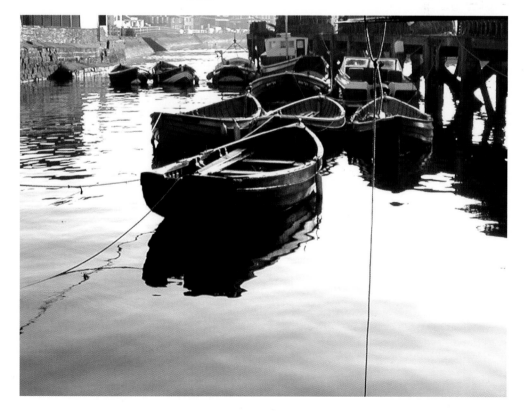

Whitby Cobles.

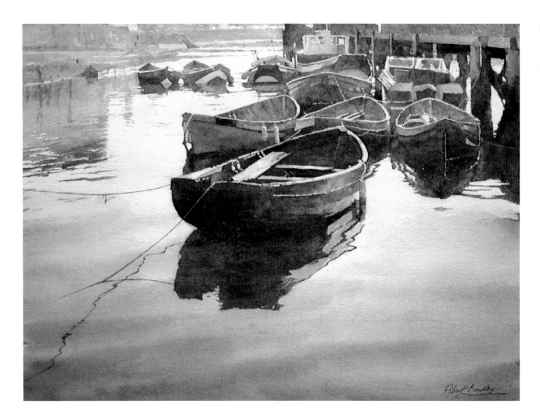

Cobles/Whitby Harbour
*Watercolour, 46 × 35.5cm
(18 × 14in).*

Plein Air versus Photography

Painting *plein air* on a regular basis is vital for development, and doing so will enable you to make far more accurate observations than working from photographs alone. Photographic images are a useful source of information but should be treated generally as 'memory joggers', as they can be extremely misleading in terms of tone, colour and recession. Many artists paint from photographs in conjunction with sketches, small 'on site' paintings, and their experience of painting in the field. When painting outdoors, or just information gathering, train yourself to analyse the subject, look carefully into shadows, and be aware of the subtlety of colour, an aspect that is often overlooked by inexperienced painters. By understanding the many problems encountered when painting from photographs, their use becomes more valid.

The photograph of Whitby Cobles illustrates some of the problems encountered when painting away from the subject, using photographic reference alone. Notice how the shadows are extremely dark and lack colour change and detail.

Compare this photograph with the painting *Cobles/Whitby Harbour*: this painting illustrates how it is possible to produce a studio painting using photographic reference in conjunction with the observational skills and experience gained from many years of painting *plein air*. Watercolour is the ideal medium for creating the illusion of the tranquil water in this subject. Observe how the shadows have been painted, creating trans-

parency, together with 'warm' and 'cool' colour changes. Superfluous detail has also been eliminated for simplicity.

When planning a *plein air* trip there are certain factors regarding subject matter and its execution that should be considered, such as subject theme, first impressions, the best viewpoint, tide times and the weather.

Subject Theme

The subject may be chosen from numerous themes, for example:

- Vistas, taking in several miles of coastline
- Beach scenes (busy or deserted)
- Cliffs and rocks
- Harbours
- Salt marshes
- Tidal creeks and rivers
- Boats
- Rough water and waves
- Cameo scenes of figures on the beach
- Textures and patterns in features such as rocks, rock pools, breakwaters

Many of these subjects will be dealt with in detail in later chapters.

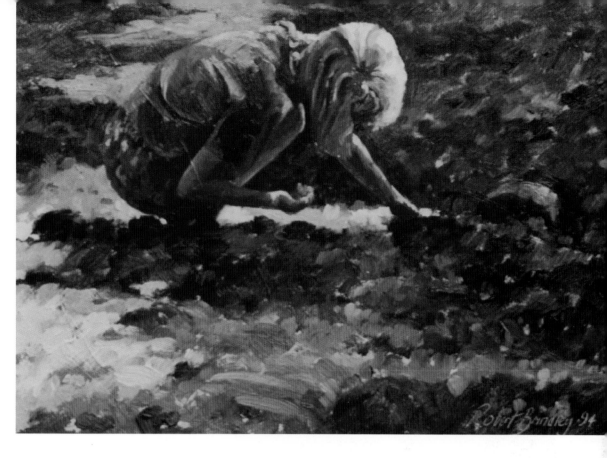

The Shell Seeker *Oil,*
30 × 25cm
(12 × 10in).

Incorporating Figures

The Shell Seeker shows a young girl searching rock pools, and demonstrates how figures can be incorporated successfully into a coastal scene. Paintings such as this often transport the viewer back to similar days from their own childhood, providing the artist with an immediate empathy with the viewer. Remember the following in your composition:

- When painting figures in your seascapes, they should be composed from natural groups and arrangements.
- Never paint a posed figure, as they seldom work convincingly.
- Always paint odd numbers of figures – one, three, five – and not even numbers, as they can appear 'staged'.

Including figures in your paintings will be covered in Chapter 6, where the above-mentioned points will be discussed in more detail.

First Impressions

Try to determine which elements initially attracted you to the subject under consideration. Was it a light effect, mood or atmosphere, design, colour tone or texture? This is extremely important and should be remembered when undertaking the painting, as often first impressions are lost during the execution. It is unwise to attempt to incorporate too many elements, as any future viewer of your painting may be overwhelmed. As with many other aspects in painting, 'less' is sometimes 'more', and simplicity is usually more desirable than complexity.

The Best Viewpoint

When visiting a promising painting location, never settle for the first subject that appeals, even if it looks perfect, but take a little time to absorb all the possibilities as there is often a more rewarding viewpoint to be considered. (Having said that, a word of caution is called for here, as too much deliberation, and subsequent indecision, can lead to a wasted painting trip! Time is always a factor, so never spend too much time looking for the 'gem', because it's not very often found.) You may find that sitting, standing, or moving several feet to the left or right makes a tremendous difference to the composition. Also be aware that high viewpoints invariably offer greater drama and better design than the same subject viewed from a lower plane.

A valuable tool for aiding composition is a viewfinder. Make your own by cutting a window in a piece of stiff card, or purchase a ready-made one. The viewfinder illustrated is fully adjustable to any proportion, and has strips down each side for making tonal and colour comparisons.

Once you have settled on a subject to paint and are confident that you know which of the features you should be concerned with and which are less important, blot out the rest of what you see. Be single-minded, stay in control, and don't work too quickly. Quality and good observation are paramount, and an incomplete, well executed painting is far more rewarding than a poorly executed completed piece of work, especially when

Viewfinder.

TIP

A successful painting is a combination of accurate observations and statements that work as a whole.

considering the learning process. Therefore start the painting process in a controlled manner, and think carefully about every mark you make: they all count. Haphazard, unconsidered statements never result in a successful painting.

Tide Times

When painting coastal subjects, remember that tide times are always important. There is nothing more frustrating than settling down to paint boats in a creek or harbour where the tide is out, and then half an hour later the same boats are beginning to float. Always do your research beforehand. If you are aware of the tide times in advance, you will make better use of the limited time available for the execution of the painting. This knowledge also reduces the risk of becoming trapped by incoming water.

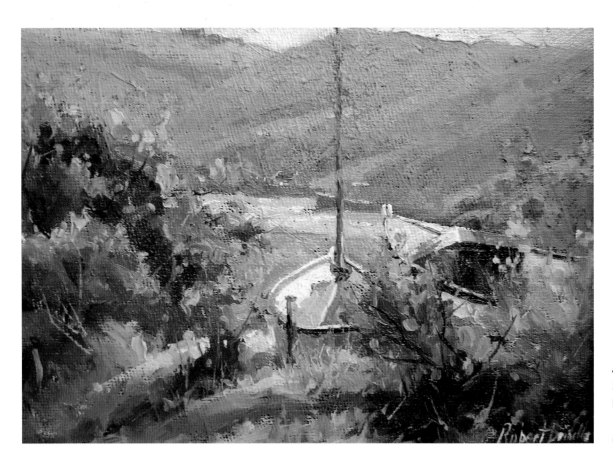

A Secluded Spot/Runswick Bay *Oil on board, 18 × 13cm (7 × 5in).*

Venetian sketch.

The Weather

The weather is also a factor in any *plein air* trip, so if the forecast is very bad, plan to paint from some form of shelter. Most traditional seaside resorts still have shelters on the promenade; these offer protection from the elements, and in some cases a view, which gives you the opportunity to paint a scene with Nature in a less favourable mood. If there are any boat-building yards or sheds in the locality then it's a good idea to ask if you could tuck yourself away in a quiet corner. Most of the time owners will be only too pleased to let you do this, and what an opportunity to practise your boat drawing and painting skills!

Work Quickly

When dealing with rapidly changing lighting conditions, consider working small or taking advantage of the free-flowing qualities of watercolour. Speed comes naturally with experience, so always work within your capabilities, spending more time on the difficult passages. Try to develop a simple shorthand to convey the less important elements; as experience grows you will find that confident, swiftly executed brush strokes work best.

Should the weather or changing light threaten to intervene, always resist the temptation to rush your work because more often than not you will make mistakes, more time will be lost, and worst of all panic will often take over. Stay calm; maybe

take a few photographs, as often the painting can be completed back in the studio. Better still, you could return to complete the painting when similar light conditions prevail.

The small *plein air* study *A Secluded Spot/Runswick Bay* was completed in around an hour while the early morning light was at its best. By selecting a simple subject such as this, you will ensure that the painting can be completed within the timescale created by changing light conditions. Notice how economical, expressive brush strokes have been used in the foreground. Small studies such as this can be used in conjunction with photographs and sketches to execute a large studio painting.

Whether you opt to work from your studio or to paint *plein air*, remember that you should always have sufficient control over the chosen medium to deal with the complexity of the subject matter.

Developing Paintings from Sketches

Although photography is a very useful tool, a far better way to be more creative in your studio work is to make use of colour notes, sketches and any small paintings that you have made on site. The Venetian sketch illustrated was made very quickly using waterproof ink and three colours: Paynes Grey, Raw Sienna and

Burnt Sienna. Simple sketches offer a way into a subject, and will enable you to explore different possibilities. You would also be advised to make a sequence of sketches in pencil, watercolour and oils, as each one is likely to give a different rendering of the subject. From these ideas a larger, more rewarding or complete painting may evolve.

Sketches, however simple, are a quick and effective way of recording many different aspects of the scene. Sketching and drawing will be discussed in more detail in Chapter 3.

Creativity is allowing yourself to make mistakes. Art is knowing which ones to keep.

Andrew Wyeth

The small *plein air* watercolour sketch *Towards San Giorgio/ Venice* was painted on a warm-tinted, oatmeal-textured watercolour paper in approximately 30 minutes. White gouache tinted with colour was used to paint the 'lights', as this simplifies and speeds up the painting process. Try painting two of these

sketches at the same time; while one is drying you can work on the other.

Cropping

Cropping either a photograph, sketch or even a completed painting should always be a consideration as sometimes we don't look critically enough at our subject matter. By selecting a handful of reference photographs and looking carefully at each one, you will probably discover that within many of them lies more than one subject. An easy way to isolate smaller areas of a photograph is to use two pieces of L-shaped card; these can be used together to form an adjustable mount. You will be amazed at the variety of shapes and compositions available to you for consideration.

Towards San Giorgio/Venice *Watercolour sketch,*
14 × 10cm (5.5 × 4in).

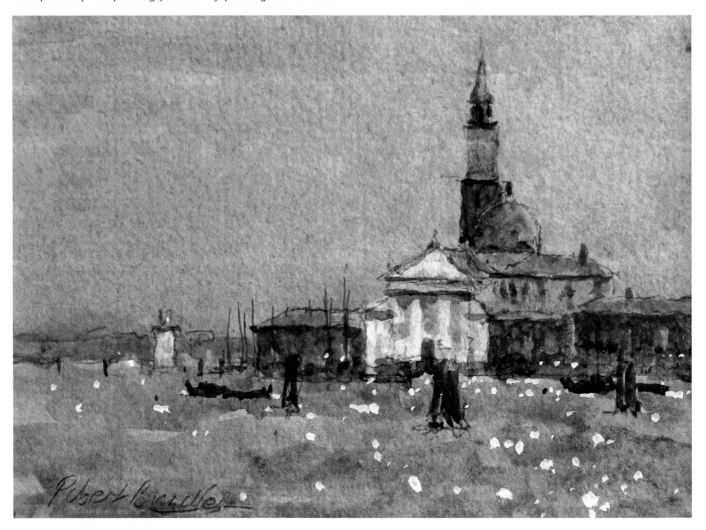

These two pieces of L-shaped card can be cut to any size and used to isolate many different areas of your photographs when composing your painting.

The photograph has been cropped to one of many pleasing compositions.

For various reasons, a painting sometimes just doesn't 'work'. It may have been that the composition was poor, or that one area of the painting was weakly executed. It is often extremely difficult to assess just what is wrong with your painting. By using the cropping tool you will be able to isolate different areas of the painting and hopefully locate any problems.

The painting *Evening Reflections/Venice* demonstrates how an unsuccessful, completed work may be rescued by cropping. In some cases, cropping can produce more than one usable image; however this is not the 'norm'. The bottom left section of the painting could be discarded, or the board reused with its texture and colour employed in the production of another painting.

Evening Reflections/
Venice *Oil on board,
68 × 61cm
(27 × 24in).
Cropping has been
used on this
unsuccessful painting.*

Special Light Effects, Colour and Texture

You will occasionally observe 'special' light effects. These are commonly found when looking straight into the light source (*contre jour*), and produce stunning imagery of dazzling light, accompanied by a simplicity of shape and form. When looking directly into a light source, the human eye and camera lens shut down, reducing detail and simplifying the image. Subsequently the light effect appears to be more dramatic and the shapes appear almost in silhouette. These subjects offer a real challenge for any *plein air* painter, and should be observed and painted rapidly. The light will never remain constant for more than 30 minutes, therefore time is of the essence.

If you don't work very quickly, it's always worth bearing in mind that a drawing can be made in a fairly short time, and the painting can then be completed later. If the conditions are favourable, you could return at the same time the next day to complete the painting.

Should this not be possible, a studio painting could be undertaken from the drawings made in conjunction with your memories of the lighting conditions, mood and atmosphere.

The atmospheric, *contre-jour* photograph of the Grand Canal from the Accademia Bridge was taken in rapidly changing light, so there was not enough time to paint this subject on site and photographic reference was used to execute a studio painting. Whilst in front of subjects like this, always remember to commit the scene firmly to mind, assessing the true tonal values, especially in the shadow areas. Make small colour notes at the same time if possible.

The photograph illustrates perfectly one of the pitfalls of working from photographs. Notice how the intensity of the dazzling light has reduced the building shapes into virtual silhouette. Care must be taken, when rendering these shapes, to ensure that they remain transparent and also contain 'warm' and 'cool' colour variations.

There is a far greater feeling of light, colour and atmosphere in the watercolour painting *Morning Light/Grand Canal/Venice*, which was based on the photograph we have discussed. Care was taken to focus attention on the light effect, whilst simplifying the details in the buildings. Note how the colours in the shadows vary from 'warm' to 'cool', and the tones are lighter and more transparent than in the photograph. A Raw Sienna and Cobalt Violet wash has been used for the early morning sky, producing a warm, atmospheric glow.

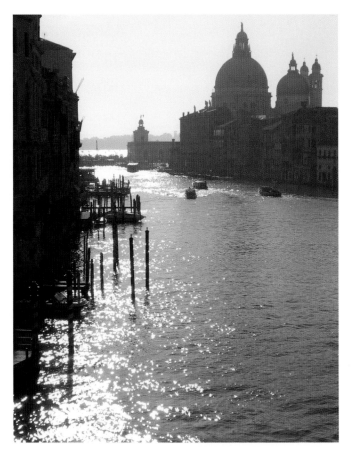

The Grand Canal from the Accademia Bridge.

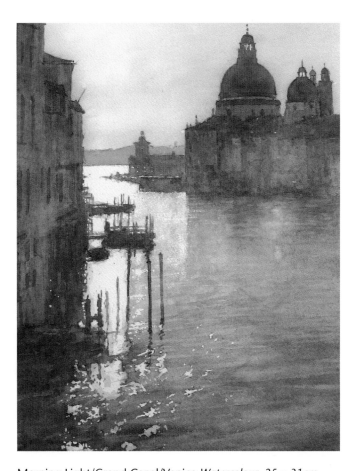

Morning Light/Grand Canal/Venice *Watercolour, 25 × 31cm (10 × 12.5in).*

Other effects created by light are caused by sea frets (fog and mist), which produce wonderful, subtle images; and stormy days often produce dramatic skies and light effects, especially after rain or through gaps in the cloud. All these are useful when painting coastal scenery.

The special light effects and atmosphere created by stormy skies are illustrated in the watercolour *Storm Clouds Over Whitby*. Quite often subjects such as this reflect a 'cool' moodiness, and this has been emphasized by using a limited palette with an accent on Cobalt Blue. The painting hopefully depicts the type of light experienced just after a passing storm.

Storm Clouds Over Whitby *Watercolour, 40 × 20cm (16 × 8in). This painting depicts the special light conditions after a passing storm.*

Towards San Giorgio/Venice *Oil on board, 25 × 20cm (10 × 8in).*

Nocturnes also make wonderful subjects, especially those depicting reflections of harbour lights, and moonlight over the sea. They give the painter the opportunity to paint simple, moody silhouettes.

You will find it extremely rewarding should you achieve a subtle and convincing rendering of any coastal subject. However, you may find a subject that is overwhelmingly about colour, texture, or a combination of both, and even if your preferred style is to paint in a subtle, conservative way, why not this time step out of your 'comfort zone' and tackle the subject in a completely different way – consider the use of strong colour, a heavily laid texture, or both, to add variety and drama to your work.

This could be beneficial to your development and thereby prove to be an inspirational move.

I advise students on the subject of colour as follows: if it looks good enough to eat, use it.

Abe Ajay

A colourful, textural subject is particularly suited to oil and pastel where colour and texture can be fully exploited. Oil paint will allow you to create all the texture necessary, especially if

Close-up showing texture.

used in conjunction with 'texture paste'. Building up texture purely by the application of thickly applied or layered paint can require patience while drying. Should you wish to speed up the drying time, 'Alkyd' paints can be used in conjunction with, or instead of traditional oils. The same, shorter drying time, can be achieved by using all your usual oil colours with the exception of titanium white, which can be substituted by an 'Alkyd' titanium white.

The oil-on-board *Towards San Giorgio/Venice* demonstrates how texture can be used effectively even at a very small scale. The combination of fresh colour together with the use of irregular texture creates an additional dimension to this painting. 'Texture paste' and a little clean sand were applied to the board before being treated with a warm, Burnt Sienna 'ground' (see the close-up).

Pastel can also be applied over some textured surfaces, but its real strength comes from the vibrant colours available.

The pastel painting *Evening River Thames* employs broad

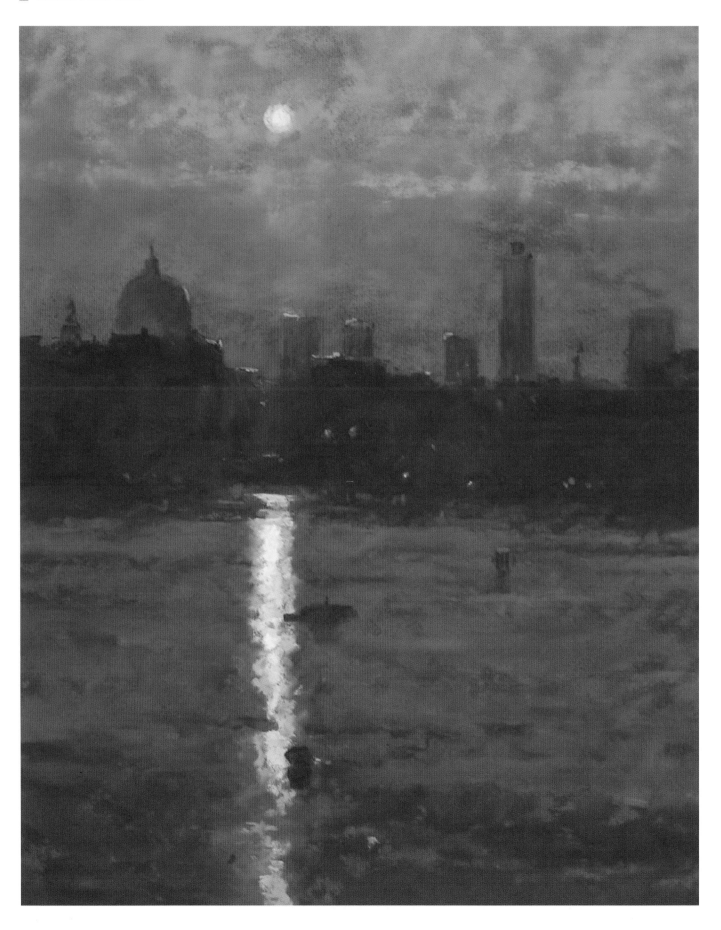

OPPOSITE: Evening River Thames *Pastel, 20 × 25cm (8 × 10in).*
A limited palette of colours and a black ground were used in this
painting.

BELOW: The Reaper/Whitby Harbour *Watercolour, 24 × 28cm*
(9.5 × 11in).
The inverted 'L' composition, demonstrated here, always ensures a
sound, interesting aspect to any painting.

strokes of pastel to create colour and texture. The black coloured ground works well for this subject, where a limited palette of colours was used, and a sense of drama intended. Try to use your own reference material and create a similar painting using a dark ground, limited palette and broad pastel marks.

Size and Proportion

The size and proportion of any painting is worthy of discussion. For many years, paintings were generally created in standard sizes and proportions determined by fundamental mathematical theories, one of these being the 'golden section' (this will be covered further in Chapter 3).

The watercolour painting of *The Reaper/Whitby Harbour* uses a high horizon line that works particularly well, especially as it meets the traditional requirement that the major focal point in any composition should lie on the golden section. The strong vertical elements of the boat and figures on the left-hand side also conform to this theory. The inverted 'L' composition has been used for this painting; this will also be discussed further in Chapter 3.

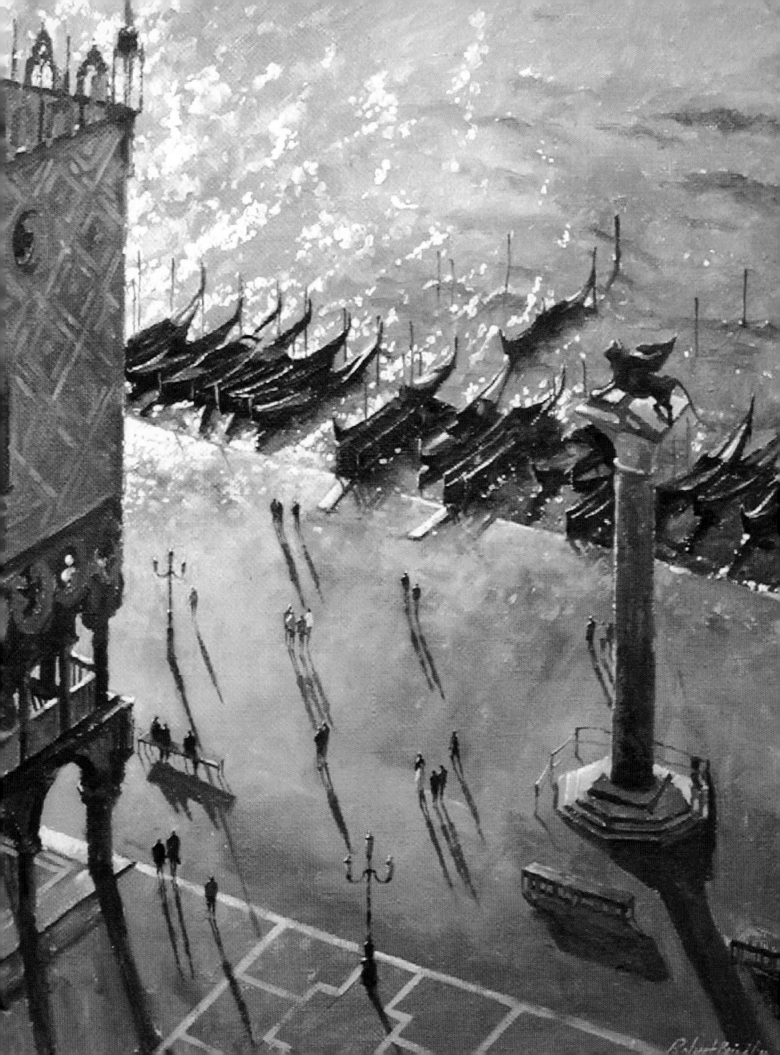

DRAWING AND COMPOSITION

The high viewpoint in *View from the Campanile/Venice* illustrates the importance of good drawing skills and having an 'eye' for an unusual composition. In a dramatic subject such as this, the perspective has to be accurately drawn because the vanishing point is well out of the painting and any slight inaccuracy would be immediately apparent. The positioning of the column and the water's edge is also critical to achieving the correct compositional balance.

The Importance of Sound Drawing Skills

It is through drawing that masters are first revealed; through drawing that they live and prove their value, whatever variations they may impose on their talent.

Gerard Bauer

Sound drawing skills are extremely important for the depiction of coastal subjects. Boats in particular must be drawn accurately with an understanding of how they are made. They vary enormously in character, shape and size, and a poorly drawn representation of a boat is not sufficient to satisfy many of today's art buyers or critics.

The watercolour *Cobles/Whitby Harbour* shows two fishing boats at low tide with the light reflecting off wet mud. This small watercolour with its low viewpoint is typical of the type of subject you should look for in order to practise boat-drawing skills. Harbour scenes make wonderful subjects and provide artists with a variety of challenging and demanding elements. A good working knowledge of perspective is vital for the successful rendering of such a complex subject.

All subjects depicted from an elevated viewpoint demand accurate drawing, together with a sound knowledge of perspective: see the watercolour painting *Moorings/Whitby Harbour*. Never be intimidated by the apparent difficulty of subject matter such as this. By opting for easier subjects you will never be challenged as an artist, and your confidence and development will subsequently be restricted. Remember, 'No pain, no gain'.

OPPOSITE: View from the Campanile/Venice *Oil, 40 × 50cm (16 × 20in).*

RIGHT: Cobles/Whitby Harbour *Watercolour, 23 × 18cm (9 × 7in).*

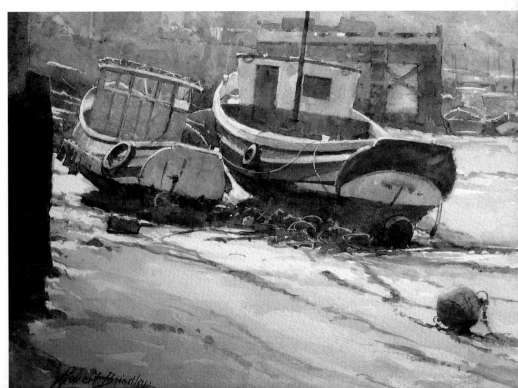

Moorings/Whitby Harbour *Watercolour, 28 × 30cm (11 × 12in).*

Perspective

Linear perspective is a method of portraying objects on a flat surface so that the dimensions shrink with distance. The parallel straight edges of any object, whether a boat or a harbour wall, will follow lines that eventually converge at infinity. Typically this point of convergence will be along the horizon, and is called a 'vanishing point'. The photograph *Perspective 1* shows a view along a Venetian canal and illustrates the simplest form of perspective. The horizon line and two vanishing points have been shown. However, in reality the number of vanishing points could be many more, especially with buildings on a curving canal, where each one would have its own vanishing point.

Frequent practice and observation will enable you to master perspective. Small sketches or drawings can be carried out at any time and in any place, so carry a small sketchpad around with you at all times. When drawing or sketching outdoors, always remember to establish the horizon line first. This can be achieved by holding your pencil horizontally, immediately in front of your eyes; where the pencil cuts through the view will be the horizon line.

The next step is to establish all the radiating lines of perspective. Tackle them one at a time by using your pencil (this time at arm's length) to align with the tops and bottoms of buildings, harbour walls and so on. Keep your pencil fixed at each aligned angle, and transfer this line to your drawing. This can be very tedious in a complicated scene, but with practice it becomes instinctive and rapid progress will be made.

Achieving Depth in Drawings

Depth can be portrayed by several techniques in addition to the perspective approach above. Objects of similar size should appear ever smaller the further they are from the viewer. Thus distant figures on a beach will appear slightly smaller than nearer figures. The photograph *Perspective 2* has a number of artists painting alongside a canal in Venice. Notice how, generally speaking, the heads of all standing, adult figures align themselves on a horizontal line. This line roughly establishes the 'horizon line'. You will also observe from this illustration that the feet of all the figures are positioned at differing heights within the picture, depending how near or far they are within the picture plane. This diminishing perspective enables the artist to create a feeling of depth and space within a painting.

As only the very basics of perspective have been discussed, you should be aware that situations such as rising and falling ground, and drawing from elevated locations, will prove to be more demanding.

Depth can be portrayed through the use of texture. As the texture of an object gets further away it becomes more com-

Perspective 1: The simplest form of perspective.

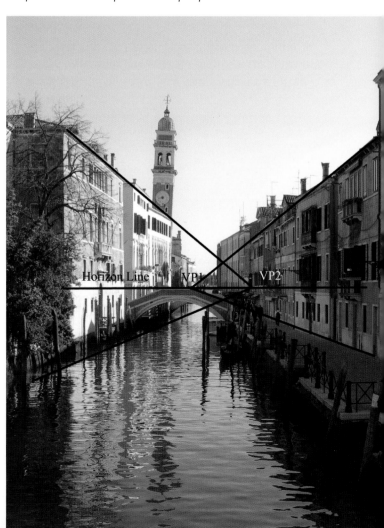

pressed and less noticeable, taking on an entirely different character than if it were close. Depth can also be portrayed by reducing the amount of contrast of more distant objects by making the colours paler and the edges softer. Foreground objects remain darker, slightly 'warmer', and the edges sharper. This is often referred to as 'aerial perspective', and gives the viewer the feeling of being able to walk right into the painting.

Drawing Implements and their Use

Always lines, never forms! But where do they find these lines in Nature? For my part I see only forms that are lit up and forms that are not. There is only light and shadow.

Francisco de Goya

Prior to working on an image, it would be beneficial to gain an understanding of how the various implements can be used in your work. You could use practice sheets to discover how each implement can be used to produce value, texture and other effects.

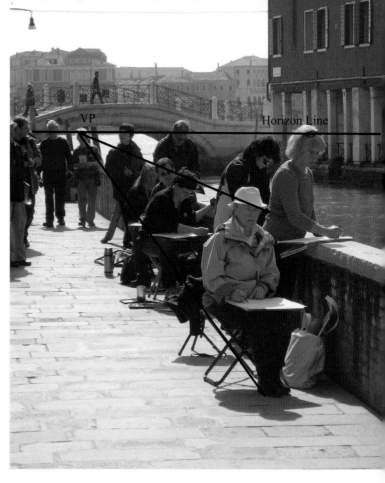

Perspective 2: This perspective sketch illustrates how depth and space can be created in your work by introducing figures.

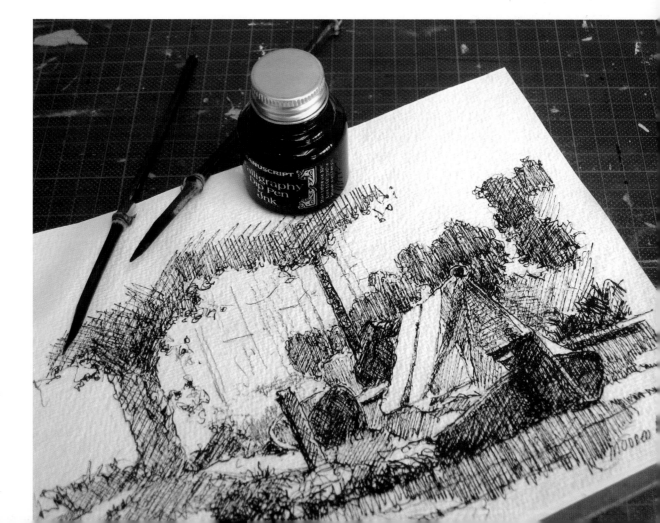

The use of waterproof ink and bamboo pens.

The stroke of the drawing implement can be used to control the appearance of the image. Line drawings in sepia or ink typically use 'hatching', which consists of groups of parallel lines. 'Cross-hatching' uses groups of parallel lines, overlaid in two or more different directions to create a darker tone. 'Broken hatching', or lines with intermittent breaks, is used to form lighter tones, and by controlling the density of the breaks a graduation of tone can be achieved. These techniques have been used in the sketchbook illustration shown (*see* page 45) ('The use of waterproof ink and bamboo pens'). Sticks of bamboo can easily be sharpened to give a variety of points, and are an expressive tool with which to draw. Experiment with them to achieve different line widths and tone.

'Stippling', which uses dots to produce tone, texture or shade, can also be incorporated into this form of drawing.

Pencils and drawing sticks can be used in a similar way, achieving continuous variations in tone. For best results the lines in a sketch are typically drawn to follow the contour curves of the surface, thus producing a depth effect.

Shading and Blending

Shading is the technique of varying the tonal values on the paper to represent the shade of the material as well as the placement of the shadows. Careful attention to reflected light, shadows and highlights can result in a very realistic rendition of the image.

Blending can be achieved by using your finger or a 'blending stump' (an implement to soften or spread the original drawing strokes); it is most easily done with a medium that does not immediately 'fix' itself, such as graphite, chalk or charcoal.

For both shading and blending, the artist can use a blending stump, tissue, a kneaded eraser, a fingertip, or any combination of them.

Continuous tone can be achieved with graphite on a smooth surface without blending, but the technique is laborious, involving small circular or oval strokes with a somewhat blunt point.

Texture in Drawing

Shading techniques that also introduce texture to the drawing include hatching and stippling, as discussed earlier. A number of other methods can produce texture in drawings: for instance, a suitably textured paper can be used to create many textural effects. Also, texture can be made to appear more realistic when it is drawn next to a contrasting texture – thus a coarse texture will be more obvious when placed next to a smoothly blended area. A similar effect can be achieved by drawing different tones in close proximity – a light edge next to a dark background will stand out to the eye, and almost appear to float above the surface.

Demonstration *Boats/Staithes Beck*

A wonderful subject such as this is ideal for practising your drawing skills. By drawing these two boats from an elevated viewpoint, drama was increased, providing a greater challenge for drawing purposes. Texture and interest is present not only in the boats themselves but also in the foreground beach. Soft diagonal shading was used for this demonstration; however, you may decide to use firmer, more defined strokes in another direction. There are no rules, and the decision is yours!

Materials
Paper:
Arches 140lb, hot pressed watercolour paper
Miscellaneous:
2B and 4B pencils
Staedtler plastic eraser

Step 1: Drawing out

Step 1.

- Use the 2B pencil to lightly draw out the lower boat, making sure that its scale and position are accurate; should the positioning and scale of this major feature be incorrect, the rest of the drawing may not fit the paper.
- A drawing such as this may take a considerable time to complete, so allow yourself the pleasure of adding some degree of detail and shading even at this early stage.
- Both pencils can be used at this stage; however, you will need to be confident that any of the more deliberate, darker marks are correct, as any later adjustments or erasure could be very difficult.

Step 2: Develop the second boat

Continue using the same methods to develop the second boat.

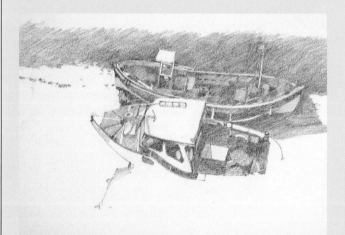

Step 2.

Step 3: Develop the tonal sequence

- Consideration should be given to the tonal sequence. For example, the lightest areas such as the cabin roofs should be left as pure white paper.
- The tonal sequence can be developed by 'layering' the shading. For instance, the lighter tones should be carefully rendered first, and the mid tones developed by shading over these first lighter ones. The final darks are developed progressively by carefully darkening previously applied tones.
- Never begin to darken any area until due consideration has been given to its relationship, not only to the adjacent area, but to the drawing as a whole. Any incorrectly judged tone at this stage can create problems later on.

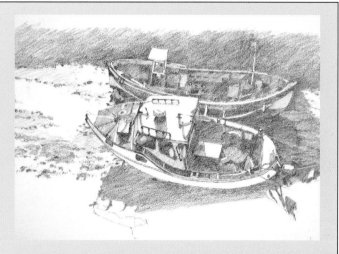

Step 3.

Step 4: Draw the shadows across the beach and add final details of texture

- The cast shadows across the beach can be drawn at this stage, taking care with the tonal sequence as outlined in Step 3. The shadows can be made slightly lighter than needed at this stage, leaving scope for darkening them when the beach details and textures are applied later.
- Further detail can also be introduced at this stage.
- Complete the beach and add the final details to the boats.

No specific blending was used in this drawing, only the natural blending that occurs by overlaying shading with soft pencils.

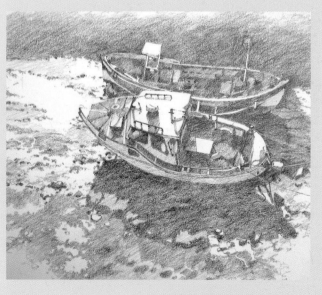

Step 4.

Compositional Theory

In relation to painting, the term 'composition' means putting together a work of art. The various elements in the overall design usually relate to each other and to the whole work of art. A successful compositional arrangement determines the focus of the painting, and results in a harmonious design that is aesthetically appealing and stimulating. By composing the elements carefully before you begin to paint, you will be better able to communicate your ideas and feelings to the viewer. A strong focal point is essential to achieve a successful composition.

In the painting *Feeding the Ducks/Staithes*, the position of all the elements is structured to ensure that the viewer's eye is directed to the 'focus' or centre of interest. The figures, almost in silhouette, lead the viewer to the ducks, which have been positioned carefully within the dazzling light in the top left-hand third of the picture. The three other corners have been dealt with very simply, ensuring that there are no distractions to the harmony and balance of the painting.

The 'golden section', mentioned in Chapter 2, is a mathematical proportion accepted by Renaissance artists as having significant aesthetic and artistic significance. Applied practically to painting, it can be summed up that any significant feature within a painting, such as a boat or a figure, is best positioned approximately two-fifths of the way across the picture. Renaissance artists used the theory of the golden section to create visually satisfying and harmonious paintings. This can be seen in Leonardo da Vinci's *Mona Lisa*.

In contrast there seems to be no use of these theories in many of the works by artists such as Van Gogh, Gauguin and Matisse. Their composition was obviously based more on intuition. Thanks to these individuals, today's artists are more liberated, and are free, should they choose to be, of the many restraints obeyed by the old masters.

Some paintings obey virtually none of the theories of composition, and yet work well; a good example of this is the oil painting *The Beach/Aldeburgh*. The main boat is positioned almost exactly in the centre of the picture, but the second boat on the left-hand side creates balance in the painting. The strength of colour in the boat and the simple handling of the foreground ensure that the viewer is drawn into the painting.

LEFT: The Beach, Aldeburgh *Oil, 25 × 20cm (10 × 8in).*
This painting obeys few of the theories of composition.

BELOW: Feeding the Ducks/Staithes *Oil, 20 × 20cm (8 × 8in).*

Should you ever have a problem with composition, return to geometry and theory to help you work things out. The water-colour painting *The Endeavour/Whitby* illustrates, in a simple manner, how the golden section can be used successfully. The ship has been positioned approximately two-fifths of the way across the painting. Notice also how the horizon line has been positioned well below the centre of the painting to give balance to the composition.

Viewpoint in Composition

The viewpoint you paint from can strongly influence the aesthetics of an image: not only does it influence the elements within the picture, it also influences the viewer's interpretation of the subject. For example, the photograph *Boats/Staithes Beck* was taken from quite a low viewpoint, and is a sound subject. However, compare it with the painting *Cobles/Staithes Beck*, showing the same boats from a more unusual and interesting elevated position. This painting illustrates perfectly how the artist can interpret the same subject matter quite differently by changing the viewpoint. By spending a little time exploring any promising subject, you will probably discover many different compositions, all with their own particular strengths.

In some instances a subject can carry more drama when it fills the frame. There exists a tendency to perceive things as larger than they actually are, and filling the frame fulfils this perception. This can be used to eliminate distractions from the background. The two fishing boats in *Cobles/Staithes Beck* were isolated from the background by the surrounding dazzling light, which adds drama and focus to the subject.

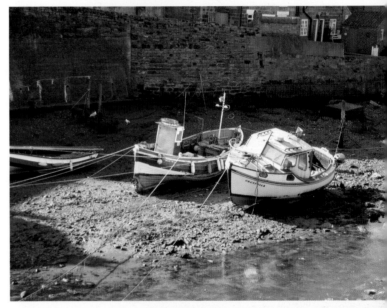

The Importance of Lines in Composition

Literally lines do not exist in nature, but are the optical phenomenon created when surfaces curve away from the viewer. Nonetheless, line-like shapes are considered important, as they create a visual path that enables the eye to move through the

TOP: The Endeavour/Whitby *Watercolour, 20 × 30cm (8 × 12in).*

MIDDLE: Boats/Staithes Beck.

BOTTOM: Cobles/Staithes Beck *Watercolour, 35.5 × 30cm (14 × 12in).*
This painting shows the same boats from a more unusual, elevated position.

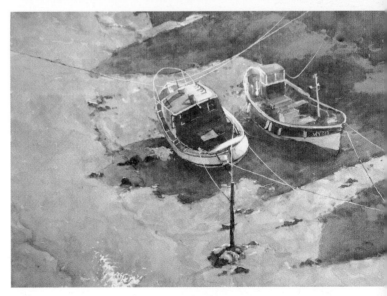

ABOVE: Low Tide/Robin Hood's Bay *Oil, 25 × 30cm (10 × 12in).*

LEFT: Cobles/Staithes Beck '2' *Oil, 25 × 30cm (10 × 12in).*

BELOW: Low Tide/Sandsend Ness *Oil, 40 × 30cm (16 × 12in).*

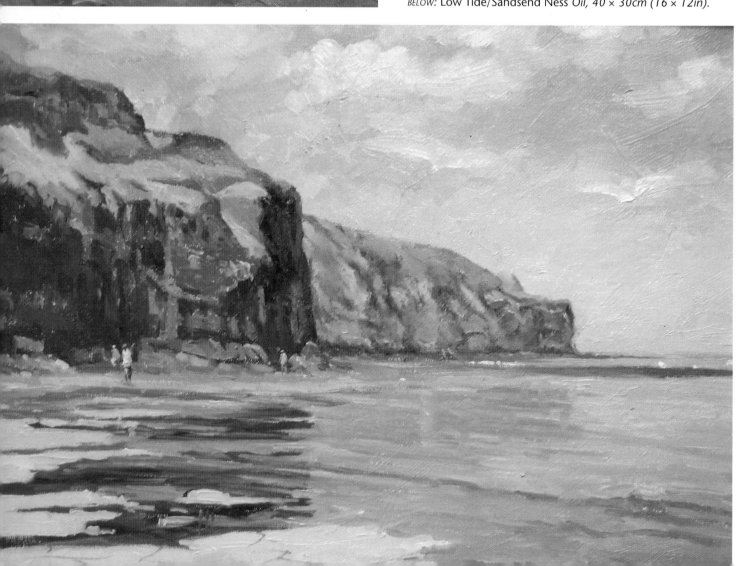

painting. For example, mooring posts, masts and rigging can be used to dramatic effect as a compositional device. Also, in the painting *Low Tide/Robin Hood's Bay*, consider the formation of the rocks – together with the zig-zag lines created by the lying water and rock pools, they provide the viewer with a visual path and the means to travel into the picture.

Less obvious lines can be created, intentionally or not, which influence the direction of the viewer's gaze. These could be the adjacent areas of differing colour or contrast, such as where the beach meets a harbour wall, rocks, seaweed and so on. Lines may be exaggerated or created for this purpose. The use of too many lines, however, will suggest chaos, and may conflict with the mood the artist is trying to evoke.

Lines in a painting contribute to both mood and linear perspective, giving the illusion of depth. Oblique lines convey a sense of movement, and angular lines generally convey a sense of dynamism and possibly tension. Lines can also direct attention towards the main subject of the picture, or contribute to organization by dividing it into compartments.

To help illustrate these points further, study the painting *Low Tide/Sandsend Ness*, where the lines and features in the beach help direct the viewer into the painting. The shapes and patterns created by these lines provide interest and tension to the painting.

Horizontal, vertical and angled lines all contribute to the creation of different moods in a painting. For example, an image filled with strong vertical lines tends to create an impression of height and grandeur. Consider the painting *View to the Beck/Staithes*, where the use of strong vertical lines in conjunction with an unusual format works extremely well: height and grandeur have been accentuated in this tall, slender composition, and the viewer is tempted to travel down towards the light and into the beck. While you are out and about, keep your eyes open for this type of subject matter.

Similarly, tightly angled, convergent lines help to create a dynamic, lively image. Curved lines, on the other hand, are used to create a sense of flow within an image, and they are also generally more aesthetically pleasing. Compared to straight lines, curves ensure a greater dynamic influence in a painting. *Morning Light/Whitby* uses the curve of the water's edge to lead the eye into the picture, creating a more pleasing path than a straight line would have done.

Illumination as a Compositional Element

The illumination of the subject is also a key element when creating a painting, and the interplay of light and shadow is of particular value to the artist. The type of light, and the position of the light source, can make a considerable difference to the message that is being presented; for example:

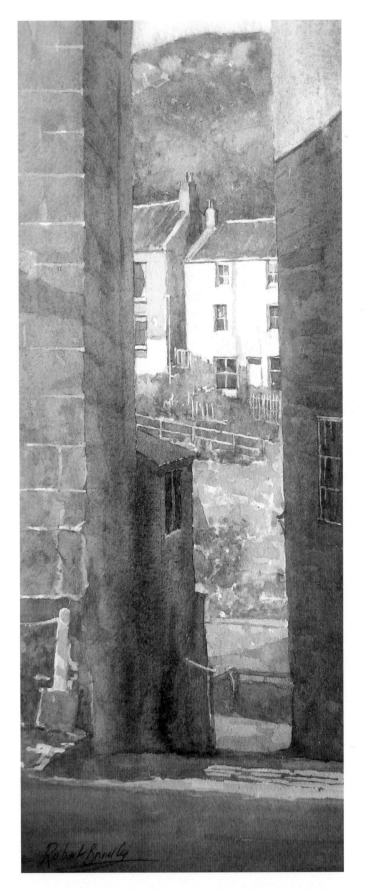

View to the Beck/Staithes *Watercolour, 15 × 35cm (6 × 14in).*

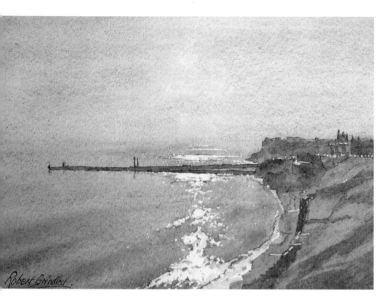

Morning Light/Whitby *Watercolour, 23 × 18cm (9 × 7in).*

- A light source such as full sunlight can serve to highlight texture or interesting features.
- Strong, low light creates long shadows, offering wonderful opportunities for design and composition.
- Strong, direct illumination, as in the painting *Boats in the Beck/Staithes*, helps to highlight texture, details and colour, so important to the successful rendering of this subject.
- *Harbour Light/Whitby* illustrates how a diffused light source has the opposite effect, reducing texture and simplifying features and detail.

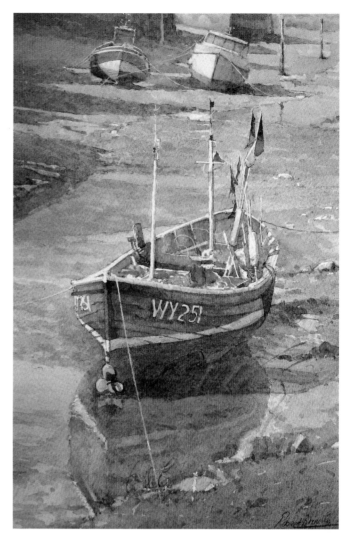

ABOVE: Boats in the Beck/Staithes *Watercolour, 23 × 34cm (9 × 13.5in).*

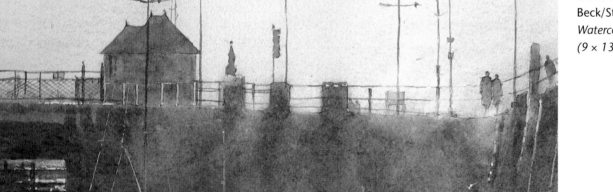

LEFT: Harbour Light/Whitby *Watercolour, 25 × 20cm (10 × 8in).*

Low Water/Alnmouth
*Watercolour, 33 × 25cm
(13 × 10in).*

- Side lighting can be dramatic, and you can use the direction of the light, and the resulting shadows, to direct the viewer's eye around the painting.
- Low light, found when painting early in the morning or in the evening, produces wonderful long shadows, full of reflected light and colour.
- Winter light also produces similar long shadows, although they will invariably be more subtle in terms of tone and intensity of colour than summer shadows.
- The low side lighting in *Low Water/Alnmouth* casts a long shadow from the boat across the beach. (Note the 'warm' and 'cool' colour changes in this shadow, and also how the shadow is darker close to the boat, getting progressively lighter as it moves further away.) The light has also created areas of wonderful 'warm' light on the side of the cabin and in the lit faces of the cottages. These patches of light act almost like stepping stones for the viewer to move into the painting.

Try to paint your own interpretation of the following lighting conditions:

- Dramatic midday light with the sun directly overhead.
- Hazy winter light that has reduced detail, colour and contrast, resulting in soft, distant edges and shapes.
- A strong, low light source from the side resulting in long shadows and brilliantly lit vertical surfaces.

Major Shapes and Tonal Masses

A good composition, and ultimately a successful painting, relies strongly on the sound use of major shapes and tonal masses. These forms can more easily be assessed by squinting your eyes to eliminate some detail, colour and texture, thus reducing the subject to a series of abstract shapes and tonal masses. The correct use of these shapes and masses will go some way towards achieving a balanced, successful painting.

Study the photograph of boats moored at Pin Mill (*see* page 54) in order to analyse tonal or value masses. This photograph is reproduced in colour, before any consideration is given to composition.

To simplify the selection of tonal masses and shapes, the same image has been digitally changed into 'grey scale' (*see* page 54). Without the influence of colour and some unnecessary detail, the major masses and most important shapes become more apparent. Try squinting your eyes when looking at a subject: you will obtain similar results. In time, this process will become almost second nature.

Try to reduce any image that you may be working on to three tones, as in the study shown on page 54 ('Tonal/value study of boats at Pin Mill') where black ink, a 2B pencil and the white of the paper have been adopted. For a more detailed value study, try working with five or six tones. Remember to work with only simple blocks of tone, with no detail whatsoever.

Photograph of boats at Pin Mill.

The photograph has been changed digitally into 'grey scale'.

A tonal/value mass study of boats at Pin Mill.

The small watercolour *Wrecks/Pin Mill* is the painting that has been produced from the above studies of major value masses and shapes. When working on site, use your sketchbook to create small studies that are concerned only with the major shapes and value masses of the scene. Try to make them as simple as possible, and then use them in the development of a painting *in situ*, or back in the studio, where more consideration can be given to them.

Six Common Compositional Layouts

There are numerous compositional layouts, however the following six examples are amongst the most widely used. They may seem obvious, but notice that there is often a combination of layouts used in any one of the examples.

The Diagonal Layout

The painting *Canal Reflections/Venice* is a classic example of the 'diagonal' layout. Whenever you decide to use this layout be

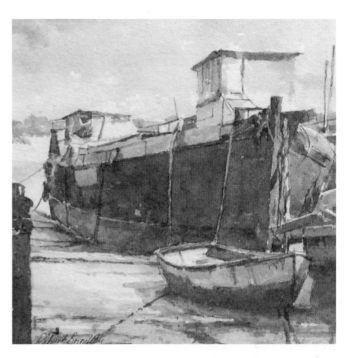

Wrecks/Pin Mill *Watercolour, 15 × 15cm (6 × 6in).*

Canal Reflections/
Venice *Watercolour,*
25 × 23cm
(10 × 9in).
This is a classic
example of the
'diagonal' layout.

Cobles, River Esk/Whitby *Oil, 25 × 20cm (10 × 8in). This oil painting shows the 'L' layout.*

BELOW: Staithes Beck *Oil, 30 × 40cm (12 × 16in). This painting demonstrates the use of the 'S' compositional layout.*

careful not to let the diagonal line run out near the top of the painting, but use a shape, a strong vertical or some other element to stop the eye travelling out of the picture. The bridge and smaller moored boat work well for that purpose in this painting.

The 'L' Layout

The painting *Cobles, River Esk/Whitby* was painted as a demonstration at the Royal Society of Marine Artists' annual exhibition, and was used partly to illustrates the 'L' layout. This shape is a very common compositional format and can be used in four different ways by rotating the 'L'. (*See* the inverted 'L' composition on page 57.)

The 'S' Layout

Never make the 'S' layout too obvious. The shape should flow smoothly through the picture plane, taking the viewer on a leisurely stroll, and not a roller-coaster ride. This layout always works better if the 'S' shape is 'lost and found' as it weaves its way through the picture.

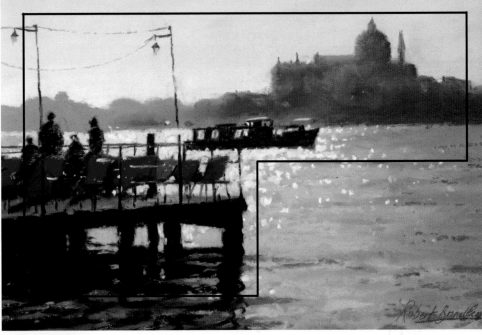

From the Riva/Venice *Pastel, 30 × 25cm (12 × 10in).*
This example of the inverted 'L' shows the centre of interest very near the intersection of the two arms. A perfect position!

BELOW: Harbour Light/Mousehole *Oil, 25 × 30cm (10 × 12in).*
This painting is an example of the 'O' compositional layout.

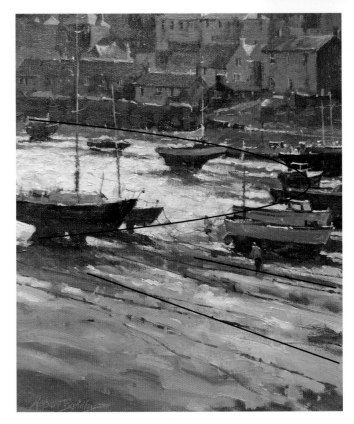

The Inverted 'L' Layout

See the pastel painting *From the Riva/Venice.*

The 'O' Layout Combining Radial Lines

The 'O' compositional layout used in *Harbour Light/Mousehole* frames the centre of interest. This particular example also uses radial lines to assist movement through the picture. Be careful never to be too obvious with the use of this layout; it is better to lose and find the edges, and never over-emphasize the centre of interest.

Try using these layouts in as many variations as you can for your paintings. Never be afraid to experiment with design and composition in your work.

Radial Lines with 'Lead-In'

Radial lines are an extremely useful compositional device. Any combination of lines at various angles can be used, though remember to keep everything simple. The painting *Towards Ravenscar* incorporates an obvious 'lead-in' in the track that enters at the bottom of the painting. The combination of radiating lines and a good 'lead-in' moves the viewer's eye straight into the painting.

Towards Ravenscar *Watercolour, 30 × 20cm (12 × 8in).*
This painting demonstrates radial lines with a 'lead-in'.

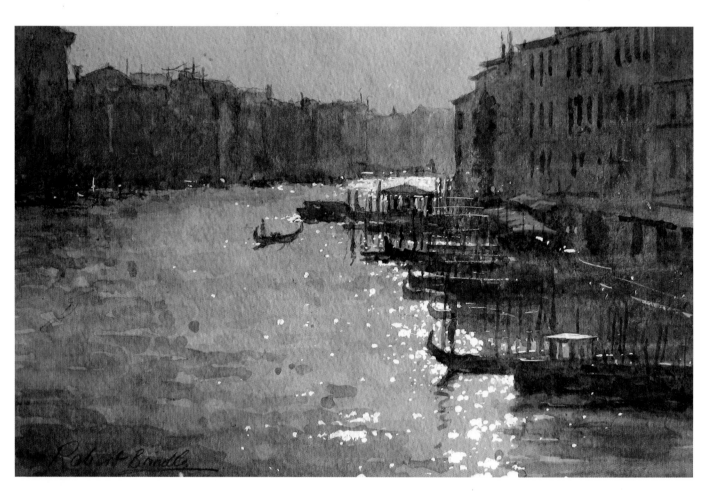

Evening from the Rialto Bridge *Watercolour sketch, 23 × 15cm (9 × 6in).*

LIGHT, TONE AND COLOUR

Light, tone and colour together with composition are the essential ingredients that hold a painting together. It is therefore imperative to understand the differences between these three elements, and how they combine to create a successful painting. The 'on site' watercolour sketch *Evening from the Rialto Bridge* has light, tone and colour, which combine to produce atmosphere and a sense of place.

Light

> The substance of a painting is light.
>
> André Derain

The above quotation says almost everything about the importance of light to any painting. Light influences everything by illuminating the everyday scene. Actual light can't be created in a painting: in terms of light, even the most successful painting competes very poorly with true daylight. Therefore you should aim to interpret these light effects as convincingly as possible by creating paintings that reflect harmony, tone and colour.

Light is transient and presents itself in many forms, providing a constant challenge for the artist. Different qualities of light create excitement, mood, atmosphere and emotion, all very difficult elements for you to transmit via your painting. When painting *plein air*, the dazzling light that you may love to paint often rapidly disappears as clouds form and the light effect changes. You must learn to accept this as normal, especially when painting in this country. Your development as an artist depends on observation, and your ability to make quick decisions and to record valuable information when confronted by changing light effects.

The quality of the light will not only assist you to create the mood and atmosphere in your paintings, but also, in many cases to create recession. The 'path', or direction of light, in your paintings is also an important factor for you to consider. The direction of side lighting, low lighting or back lighting can be used creatively to ensure good design and composition.

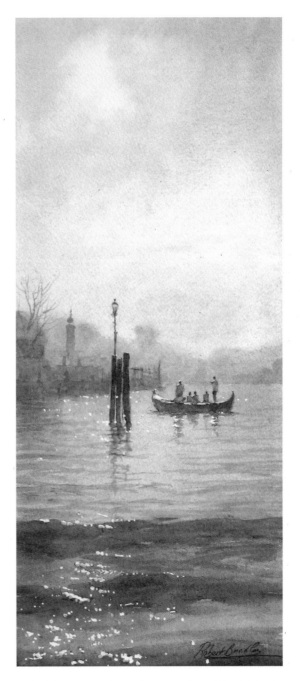

Hazy Light/The Lagoon/Venice *Watercolour, 15 × 35.5cm (6 × 14in).*

The watercolour *Hazy Light/The Lagoon/Venice* illustrates how light creates mood and atmosphere. To achieve this light effect most of the painting has to be captured in the first 'wet-into-wet' application of colour. The more clearly defined foreground waves, the distant boat and the mooring posts were added after the initial wash had dried.

When considering light, tone must also be taken into account as the two go almost 'hand in glove'; for instance, the tone of any object will be dependent upon the light at that time. You should also be aware of the contrasts of light and dark by asking yourself, how light is that shape against that dark? and vice versa. By answering these questions you will be gain-ing an understanding of the importance of tone, and at the same time developing a true understanding of light and its effect on tone.

You may be inspired by many, varied light conditions. Occasionally an observed light effect will be so special that cap-turing its beauty will be your sole concern. On these occasions the subject matter will sometimes be quite ordinary, something that you would normally pass by without even noticing. Should you be really fortunate, you will encounter the perfect combi-nation of stunning light and stunning subject matter. Relish these rare opportunities: they are very few and far between. The following observations regarding more commonly observed

Demonstration *Evening Light/Blackwater River*

The watercolorist's vocabulary consists of the ability to handle edges in a variety of ways, from 'soft' to 'hard'.

Tony Van Hasselt

The low light in this subject creates mood and atmosphere, and demonstrates the importance of the direction and path of light in paintings. The photograph for this work was taken directly into the light just before sunset, which has produced a magical effect. All the main shapes in this paint-ing have been reduced to simple silhouette, thereby shifting all the emphasis on to the light on the water in the centre of the painting.

This demonstration illustrates how to reproduce a special light effect by careful planning, and the use of masking fluid to trap and retain the lightest elements, using free-flowing, wet-into-wet washes.

Materials

Paper:
Whatman 200lb 'Not' watercolour paper

Brushes:
* Nos 4, 6 and 8 round sables
* No. 2 rigger
* A worn 'hog' oil-painting brush, to soften the edges of masking fluid
* A used, partly worn no. 2 round brush, for applying the masking fluid

Colours:
14ml tubes of Winsor and Newton, artist's quality watercolour in the following colours:
Raw Sienna, Raw Umber, Burnt Sienna, Cobalt Violet, Cobalt Blue, Cerulean, Ultramarine Blue, Permanent Magenta and Viridian.

Miscellaneous Items:
* Traditional yellow masking fluid in a 75ml bottle, by Winsor and Newton
* 2B pencil, eraser and kitchen towel
* Two or three ceramic mixing palettes

Step 1: Drawing out

Step 1.

To ensure that the path of light in this painting is as effective as possible, 'Whatman' paper was selected for its whiteness as compared to other varieties of paper. However, if you decide to attempt this, or a similar subject, feel free to experiment with other papers.

Use a good quality 2B pencil to draw out the subject. As usual, a good drawing will be required to ensure that there is no hesitation when placing the colour.

Apply the masking fluid (using an old, worn no. 2 brush) to the entire area of the light on the water, and also to the decks of the main boats. By washing the brush regularly during the application you will ensure that it remains usable for future work.

Step 2: Mix colour pools

Mix the following pools of colour before introducing any paint to the paper:

Pure colours
Raw Sienna
Cobalt Violet (one weak and one slightly stronger)
Cerulean Blue
Cobalt Blue

Colour mixes
Raw Sienna plus Cobalt Blue
Raw Sienna plus Viridian
Raw Umber plus Cobalt Blue
Cobalt Blue plus Permanent Magenta (two mixes, one weak and one stronger)
Burnt Sienna plus Ultramarine Blue

Step 3: Paint a soft, diffused overall wash

Step 3.

- Wet the paper all over and carefully introduce the mixes in the strict order light to dark, to produce a soft, diffused image.
- Work as quickly as possible, and never spend unnecessary time trying to make minor adjustments.
- Never introduce a weaker wash into the damp/drying paper, otherwise you may create unsightly 'runbacks'.
- Now leave the paper to dry completely, however keep your eye on the drying process, and should any 'runbacks' begin to appear, dry the paper immediately with a hair drier.

Step 4: Paint the backdrop of distant trees

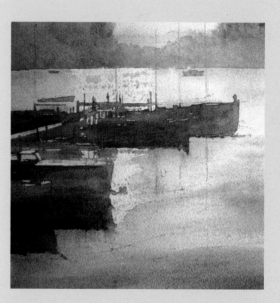

Step 4.

Demonstration *Evening Light/Blackwater River (continued)*

- You can now turn your attention to the backdrop of trees by introducing the following mixes, 'wet-into-wet' but on dry paper:
 - Cobalt Blue plus Raw Sienna
 - Ultramarine Blue plus Raw Umber
 - Ultramarine Blue plus Permanent Magenta

Step 5: Paint the boats and landing stages

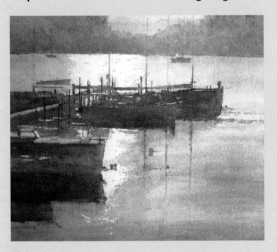

Step 5.

- You can now begin to introduce the main areas of interest around the focal point by painting the middle-ground boats and landing stages. Keep the shapes simple at this time, and concentrate purely on shape and tone. The recommended mixes are:
 - Cobalt Violet
 - Cobalt Blue
 - Ultramarine Blue plus Burnt Sienna
 - Burnt Sienna plus Ultramarine Blue
 - Raw Umber plus Cobalt Violet
- With a very clean finger and light touch, the masking fluid can now be removed. Never attempt to remove any masking fluid until the paint is completely dry.
- Once all the masking has been removed, some of the edges revealed will need softening. There are several ways of doing this, depending on the robustness of the paper used. In this case, as Whatman paper is more delicate than some other papers such as Arches, the edges selected for softening were gently worked upon using a damp sable brush and the colour blotted out using kitchen towel. Be extremely careful not to leave evidence of staining when you do this, and most impor-

tant of all, don't be too heavy handed with the brush and cause damage to the paper surface.

Step 6: Develop the reflections and add details

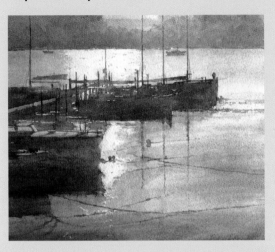

Evening/Blackwater River *Watercolour, 20 × 20cm (8 × 8in).*

- Carefully add the reflections of the masts, and begin to introduce some details such as the buoys and masts. Any of the colour mixes can be used for these additions.
- At this stage consider how far you want to develop the painting. You may decide to take the painting a little further with respect to detail, colour, tone and so on.

Step 7: Add all the final details

You can now add all the detail on the deck of the foreground boat, together with the mooring ropes and their reflections.

This is the time for evaluation, where you should be asking yourself the following questions:

- Does the composition work? Especially with regard to the visual path through the painting, and the focal point.
- Do the tonal sequence and colour harmony work?
- Do any of the 'edges' require strengthening or softening?

If you are unsure about any of the above points, seek advice from someone you trust to be honest with their opinions. Never take the attitude that 'it will do', because all you will end up with is mediocrity.

lighting conditions are included for your consideration. All will offer you a challenge, albeit without the same level of excitement and fulfilment.

Morning and Evening Light

Morning and evening lighting conditions often present the most rewarding opportunities for producing dynamic, exciting pieces of work. The low lighting conditions encountered early and late in the day create powerful shadows that are helpful in ensuring good design in your paintings. For example, long shadows can be used creatively to lead a viewer's eye into the painting. Similarly a little artistic licence can sometimes be creatively introduced by moving or adjusting the shadows to enhance the design in your work. You can also invent shadows for this purpose by imagining that there is a building or tree just outside the picture area.

A word of caution: whenever you decide to be imaginative with the use of shadows, make sure that all the angles work convincingly with respect to the direction of the light. You will also need to ensure that the pattern of lights and darks used in the painting creates a good compositional balance. A simple arrangement of well placed shadows will always look convincing.

Low Light and Dull Conditions

Many painters never paint in dull conditions, preferring to work with good light and believing that perfect conditions produce the best paintings. Although there is some truth in this belief, should you be concerned with capturing the subtleties of tone and colour created by low light and dull conditions, you will reap the benefit of light that is constant and unchanging in character, which gives you additional time to complete your work.

Rapidly Changing Light

Coastal sunsets and sunrises can produce wonderful paintings, but the light in these circumstances is generally rapidly changing, and the painter is often unable to work quickly enough to capture the light effect. Other than adopting a rapid method of working, which can take many years to develop, you may have to rely on anticipating a promising situation by setting up early, knowing that you may only achieve the bare essentials necessary to complete the painting back in the studio. Photographs of sunsets are extremely unreliable, and are often disappointing when referred to at a later date.

When considering a sunrise or sunset as a possible subject, try to avoid the temptation of being spectacular and overdramatic in your painting; such images tend to belong to chocolate boxes and colourful greetings cards!

Contre Jour Light

Spectacular, *contre jour* light has always seduced artists. Any subject matter exposed to these lighting conditions appears as a simplified silhouette and in dazzling light. Conditions such as this can produce stunning, atmospheric images if successfully executed. However, capturing what appears to be a simple image is fraught with problems: the fact that you are looking straight into the light may cause you to have difficulty in identifying the correct tonal range simply because the light is blinding and your eyes will often not be able to adjust to it. Similar problems can occur when taking photographs in these lighting conditions, as the camera cannot compensate adequately. The resultant images are therefore more often than not desperately disappointing: the dark tones tend to be completely lifeless and 'black', and the dazzling light effect is reduced to a flat, 'burnt-out' white.

In addition, these lighting conditions tend to be short-lived, and when painting 'on site' you will need to work very quickly. The following tips could help you cope with these conditions:

- Wear a cap or hat with a broad brim to protect your eyes from the bright light.
- If possible, arrive early before the light reaches its optimum level, and prepare your drawing in advance; this will allow you maximum time to execute the painting.
- Try to isolate the mid tones and darks from the lights by using a viewfinder or by using your hand as a viewfinder to eliminate the light; this will enable you to assess tonal relationships more accurately.
- When working from photographs it is essential that you memorize the true tones that were present at the time. Small sketches and colour notes are invaluable in such situations.
- When painting these subjects try to avoid making the edges where the darks meet the lightest light too sharp. These edges can be diffused in places and overlapped with a warm tone. For watercolour paintings, Cobalt Violet and Raw Sienna work quite well. The watercolour painting *Sparkling Light/Venice* (*see* page 66) shows where this has been used.
- If you intend painting a *contre jour* subject in the studio, always work from tonal/colour notes and sketches made on site.

Tone

An artist is either good at colour or good at value, but rarely good at both. I focus on the tonal range, the dark–light effects, rather than the full colour range of bright colours. I just don't know what to do with all those cadmiums.

Thomas S. Buechner

What is tone, and why is it important to painting, perhaps even more than colour? Before considering the answer to this question, study the simple diagram shown (*right*) ('The relationship between tone and colour'), which goes some way to explain the differences between the two.

Should you decide to make a chart of your own, experiment with just the primary colours as illustrated, and then move on to the secondary colours. A simple chart can be created very quickly and easily using watercolour paints. Just use more water in the mix to create a lighter tone.

It will be a little more difficult to create your chart using oil paint. Adding progressively more white to a colour will lighten the colour, but other changes will occur, beyond lightening. By experimenting with your colour charts you will observe the following points:

- The addition of white creates a new, cooler colour.
- A few intensely dark colours will be hard to identify until white is mixed with them. The addition of the smallest amount of white often reveals the characteristic of the dark colour.

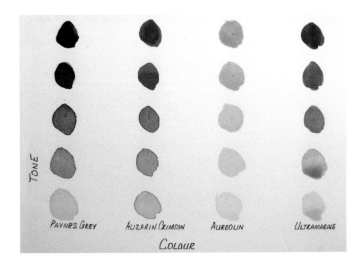

The relationship between tone and colour.

- Some colours in their mid-value range appear more intense.

Quite simply, 'tone' in painting terms means how dark or light a colour is. Once we have decided this, we can then ask ourselves, 'What is the colour or hue?' The reason for dealing with tone and colour separately is that the strength and visual attraction of some colours overwhelms us, and therefore we misinterpret their tone.

Every colour produces a variety of tones; how light or dark these are depends on the colour. You must always be aware that 'tone' is relative, and how dark or light a tone is often depends on what surrounds it; for example, a tone that appears very light when surrounded by a substantially darker one, may appear quite dark when placed against a much lighter one.

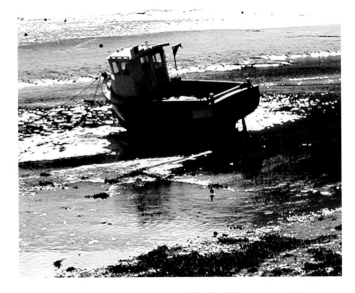

Photograph of a moored boat in Solva harbour.

Bright Light/Solva Harbour *Watercolour, 20 × 18cm (8 × 7in).*

Simplify using three tones.
Boats at Alnmouth
Watercolour sketch,
15 × 20cm (6 × 8in).

The range of tones from the darkest black to the lightest white (irrespective of colour) is infinite, and therefore can never be represented by the painter. Take a look at the photograph of the moored boat in Solva harbour: this simple subject, which has been reduced to black and white, is a good example of the full range of tones. The range of tones that can be reproduced by the painter, however, is limited by the characteristics and properties of each individual colour; for instance, lighter hues such as yellow will produce a smaller range of tones than a darker colour such as red.

To deal with these facts, the artist has to adapt and reduce the tonal range accordingly. Look at the painting *Bright Light/ Solva Harbour* (*see* page 64), where both tonal range and colour have been simplified.

A simple painting can be made using three tones, a dark, medium and light, plus the white of the paper, as illustrated in the watercolour sketch *Boats at Alnmouth*, which was made on hot pressed watercolour paper using Paynes Grey. To experiment with this method, all you have to do is mix three simple washes graded from 'light' to 'dark', and apply them to your sketch starting with the lightest tone and finishing with the darkest. Should you decide that you want to introduce further tones, just 'glaze' (overlay) further washes of the same three tones carefully over the top.

Practically speaking, a more realistic number of tones for the development of a successful painting would be eight or thereabouts. However, the tones used in any particular painting very rarely incorporate the full range from the lightest light through to the darkest dark. Take, for instance, a misty morning, where if you adopt a tonal range of 'one' to 'eight', the range of tones will be extremely limited – it is likely that only tones 'two' to 'four' would be used. On the other hand, a bright, sunny summer day may have the complete range of tones. When painting regularly on the coast you will observe greater extremes of tone, due to the reflection of the light off the sea and also to the clearer atmosphere. It is therefore important that you master the basics of tone.

Counterchange

When evaluating tonal relationships you will regularly come across instances where you will have to use counterchange. This phenomenon occurs everywhere, and if correctly observed, will enable you to solve many problems concerning not only tone, but also how convincingly three-dimensional objects are painted.

Counterchange and its interpretation can be seen in the watercolour painting *The Slipway/Newlyn Harbour* (*see* page 73), where it appears in several places. For instance, observe where the light-toned mooring ropes pass across the dark hull of the boat and then across an area of light-toned water. The rope has purposely been 'lightened' against the boat and slightly 'darkened' against the water. There are uses of counter-

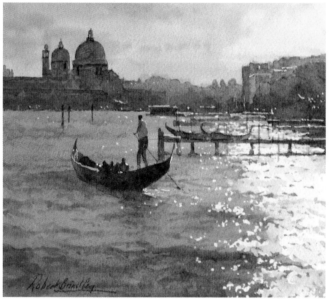

TOP: Sparkling Light/Venice, *tonal.*

BOTTOM: Sparkling Light/Venice *Watercolour, 40 × 38cm (16 × 15in).*

enters your eyes, and the simpler the image becomes in every aspect. Practise this constantly, as it will prove to be your most valuable aid.

Experiment by making several tonal studies in tones of grey; without the distraction of colour you will begin to handle tone confidently. Try taking these experiments a little further by making a series of simple tonal paintings using colour. You may start with subtle, colourful greys and finish with strong vibrant colours.

It can be a very useful test to evaluate your tonal sequences by taking a digital photograph of one of your paintings, and then convert the image to 'greyscale' (shades of grey). Any mistakes that you may have made with respect to tone will be noticed immediately, and you then have the opportunity to make any necessary changes.

The illustration *Sparkling Light/Venice*, tonal, shows a photograph of a watercolour painting digitally converted into shades of grey. Notice how all the tonal sequences still work, and compare it with the full colour version of the painting.

If a painting isn't working for one reason or another, check the tonal range and the tonal sequence. Focus on tone/value, rather than the colour; it could be that the tonal range or tonal sequence in the painting is not working. A successful tonal composition should have a convincing balance of tones. The following ideas concerning the distribution of tone may prove to be useful:

- The first and most obvious use of tonal distribution employs the full range of tones from light to dark. This layout can be very effective, however make sure that the spread of extreme lights and darks is well designed. Too many distracting shapes spread around the painting will destroy the focus, and a viewer's eye will jump from one shape to another without moving smoothly to the focal point.
- Try using a relatively narrow range of tones, for instance light and middle value lights, a range of mid tones, and finally middle value darks and darks.
- Try using combinations of tone in the proportions two to one; for instance, group the light and middle values together against a dark value, and the dark and light values together against the middle value (using these two opposites together can be difficult to orchestrate, but produces dramatic results). Finally try middle and dark values against a light value.

change in other ropes against the harbour wall, and also in the treatment of the handrail.

Once you have decided on your composition and have commenced painting, you may find it useful to constantly ask yourself 'is this tone light enough or dark enough, against the surrounding tones'? and more importantly, 'Does this tone fit the overall tonal sequence of the painting?' If the answer is no, then make any adjustments necessary. The accurate assessment of closely related 'mid-tones' is the most difficult, so always give these tones more consideration. The assessment of tone and the differentiation between tone and colour is often made easier by squinting the eyes. Try almost closing your eyes when looking at your subject; notice how the colour intensity reduces and shapes seem to merge. The more you squint, the less light

- Experiment by using isolated accent tones, such as the lightest light or the darkest dark in or around the focal point. By keeping the rest of the painting relatively easy on the eye, a powerful focus can be created within your work.

Some painters start a painting with the highlights, some with the extreme darks, or even a combination of the two. By establishing these extreme benchmarks early on, it becomes much easier to fit all the remaining tones somewhere in between. When painting with watercolour, however, try starting with the lightest tones and gradually develop the darks.

Whenever you think that your painting is finished, check whether the tonal sequence, from the darkest darks to the lightest lights, reads correctly. If it doesn't, the painting isn't finished and you will need to make adjustments.

Remember that after composition, *tone is all-important*. You can be slightly incorrect with the use of colour, but never with tone.

There is always a myriad of colour choices that will work in any situation, as long as the tonal value is appropriate.

Gaye Adams

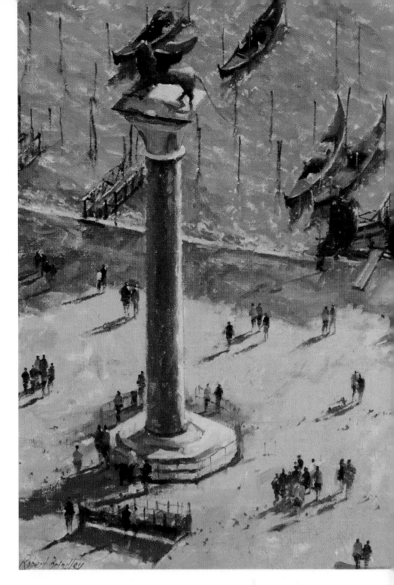

High Aspect/Venice *Oil, 40 × 50cm (16 × 20in).*

Colour

If one says 'Red' – the name of a colour – and there are fifty people listening, it can be expected that there will be fifty reds in their minds. And one can be sure that all these reds will be very different.

Josef Albers

The oil painting *High Aspect/Venice* uses strong colour for the water and gondolas to ensure that the eye is drawn beyond the foreground and into the painting. Compare this image with the oil painting *View from the Campanile/Venice* in Chapter 3 (*see* page 42). They are both essentially the same subject, however the use of colour is very different.

Although composition, tone, drawing and the handling of edges remains paramount, colour itself is a very personal choice, and the artist has a free rein when consideration is given to its use. This freedom of choice regarding colour is largely responsible for the emotion and excitement translated to the viewer.

The small oil sketch *Evening/Grand Canal/Venice* uses exaggerated colour to enhance mood, atmosphere and an emotional response. Colour for some artists is the most important element, and its use has an immediate and striking effect. However, for others it is much less important.

Colour has an emotional element, which if used correctly will enhance many aspects of the completed painting. The successful creation of mood and atmosphere is highly dependent upon colour selection. Colour and the colour harmonies chosen for any particular painting will trigger many different emotional responses from the viewer.

Colour creates, enhances, changes, reveals and establishes the mood of the painting.

Kiff Holland

Evening/Grand Canal/Venice *Oil sketch, 20 × 10cm (8 × 4in).*

Bearing these considerations in mind, the remainder of this section will cover some of the basic essentials needed to develop an understanding of colour.

What is Hue?

Basically hue is the actual colour of a pigment or object. However, the use of the word 'hue' becomes more complicated when used by manufacturers for their paint colours. This is because the term 'hue' is used to indicate that a colour is not made from the pigment(s) that were originally used for that paint, but modern equivalents that are either cheaper or more lightfast. Judging a hue is the first step in colour mixing as it identifies what tube of paint to reach for.

What is Chroma?

The chroma, or saturation of a colour, is a measure of how intense it is. Think of it as pure, bright colour as compared to a colour diluted with white, darkened by black or grey, or thinned by being a 'glaze'. Variations in chroma can be achieved by adding different amounts of a neutral grey of the same value as the colour you want to alter.

Primary Colours

In colour mixing for painting, the fundamental rule is that there are three colours that cannot be made by mixing other colours together. These three are red, blue and yellow, and they are known as the primary colours.

There are various different blues, reds and yellows. For example, blues include Cobalt Blue, Cerulean Blue and Ultramarine. Reds include Alizarin Crimson or Cadmium Red, and yellows Cadmium Yellow, Cadmium Yellow Light, or Lemon Yellow. These are all primary colours, just different versions of them.

One question that is often asked is 'What primary colours should I use'? There is not, however, a definitive answer, as each blue, red and yellow is different and therefore produces quite different results when mixed. Probably the best advice would be to select a 'warm' and a 'cool' version of each primary colour, for example Ultramarine and Cerulean Blue, Cadmium Red and Alizarin Crimson, and Cadmium Yellow and Lemon Yellow.

Many oil painters use a further reduced palette of just three primaries plus white (Permanent Bright Red, Ultramarine Blue and Cadmium Yellow Lemon work well together).

The oil painting *By the Bridge/Staithes Beck* was painted using the above three primaries and white, and illustrates the

subtlety and also the wide range of colours that can be mixed using a limited palette.

Secondary Colours

By mixing two primary colours together, you will create a secondary colour. Mixing blue and red makes purple; red and yellow makes orange; yellow and blue makes green. The exact hue of the secondary colour you have mixed depends on which red, blue or yellow you use, and the proportions in which you mix them. If you mix three primary colours together, a tertiary colour is obtained.

Complementary Colours

The complementary colour of a primary colour (red, blue or yellow) is the colour you get by mixing the other two primary colours (secondary colour). So the complementary colour of red is green, of blue is orange, and of yellow is purple.

The complementary colour of a secondary colour is the primary colour that wasn't used to make it. For example the complementary colour of green is red, of orange is blue and purple is yellow.

To create contrast, or to enhance one element against another in your paintings, experiment by placing complementary colours side by side. A complementary 'ground,' or 'under painting' can be used in a similar way; for example, red works well under green, yellow under purple and orange under blue.

Complementary colours can also be used when painting shadows; for example, the shadow cast by a red object could contain some green. It is important to train your eye to observe these subtleties.

Tertiary Colours

By mixing any three primary colours, or a primary and secondary colour, an infinite number of browns and greys will be produced. By varying the proportions of the colours you are mixing, you create the different tertiary colours.

To mix brown, use a primary colour with its complementary colour; for example, add blue to orange, yellow to purple, or red to green. Experiment by trial and error to determine how many subtle browns you can create.

A grey can be created in a similar way, but include more blue into your mixes, and experiment with the quantity of white used in the mixes. For watercolour greys, lighter tones are created by adding more water.

By the Bridge/Staithes Beck *Oil, 18 × 12.5cm (7 × 5in).*

If your tertiary colours keep turning 'muddy', you are probably mixing too many colours together. If the brown or grey isn't looking as you want it, start again rather than adding more colour and hoping that it will turn out all right.

Black and White

If you have used colour throughout most of your artistic life, try just black and white… it will take your painting to another dimension where tone and form in all their permutations reign supreme.

David Louis

Black and white cannot be created by mixing together other colours, although a good strong dark that is very close to black can be created by mixing three suitable primaries. Black is used by a few artists, but its use is frowned on by many others. If you add white to a colour you lighten it and if you add black you darken it, and mixed together various shades of grey are produced. However, the diverse range of greys classed as tertiary colours are preferred to the rather lifeless, mechanical greys produced by mixing black and white. Nature contains a perfect harmony of colourful 'greys'.

No shadow is black. It always has a colour. Nature knows only colours ... white and black are not colours.

Renoir

Warm and Cool Colour

Every colour has a certain bias, either 'warm' or 'cool'. This bias is not often overwhelming; it is often subtle. However, it is an important element to be aware of when mixing colours, as it has a real influence on any painting.

Generally speaking, reds and yellows are considered to be warm colours, and blue a cool colour. However, if you compare different reds, yellows or blues, you'll see that there are warm and cool versions of each, relative to each other. For example Cadmium Red is much warmer than Alizarin Crimson, although Alizarin Crimson is infinitely warmer than a blue.

It is vital to the success of your painting that you recognize these differences, no matter how subtle. Should you mix two warm colours together, a warm secondary colour results, and conversely, if you mix two cool colours together a cool

Demonstration *Harbour Reflections/Whitby*

This pastel painting was inspired by a visit to Whitby on an expedition to gather subject matter. This colourful subject was 'cropped' down from a larger photograph in order to concentrate on the colours and patterns created in the reflections.

Materials

Paper:
Black Hermes glass paper, mounted on stiff card

Pastels:
The pastels are 'Unison' from which a selection of reds, oranges, yellows, blues and greys were selected. Choose at least three tones of each colour to paint this sort of subject matter.
A red pastel pencil by 'Conte' was used for drawing out.

Step 1: Drawing out
Draw out the composition using the red pastel pencil. Only a simple outline is required for this stage.

Step 2: Begin blocking in
* Begin to paint the boats and their reflections, taking care not to place too much pastel on the board in the early stages. Using too much pastel at this early stage would probably result in filling the tooth of the paper, giving no scope for 'layering up' in the later stages.

Step 1.

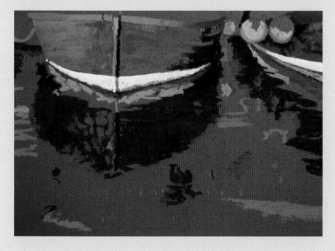

Step 2.

- A little blending using a finger can be done at this time, however don't over-blend as the texture will be lost.
- Work generally from 'dark' to 'light', as cleaner, crisper highlights are achieved by placing them in the final stages.

Step 3: Develop the reflections

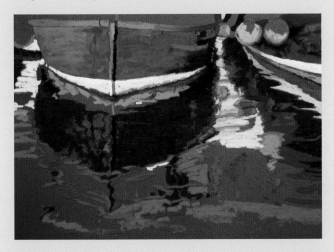

Step 3.

You will now need to turn your attention to the reflections, working in the same manner as Step 2.

Step 4: Complete the blocking in

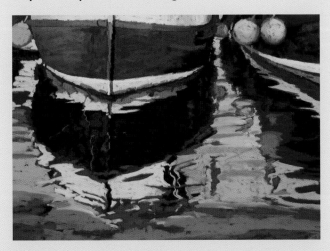

Step 4.

- Continue blocking in until the entire board is covered.
- Further subtle blending can be carried out.
- Consider all the 'edges': the majority need to be left crisp, which increases the impact of the image. However, the 'softer' edges observed in the foreground

water act as a foil to the 'sharper' edges in the reflections of the boats.

Step 5: Add the final details

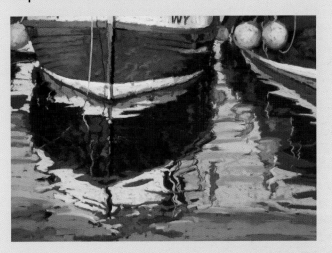

Step 5.

- All the final touches and details can be added now, however never add too much detail, otherwise you risk losing the impact of the painting. A few buoys and mooring ropes were omitted from this painting to reduce clutter and add focus.
- Pay attention to subtle blending on the sides of the boats, where mid tones blend into dark tones. These gradual tonal shifts are vital to give a convincing three-dimensional 'feel' to the boats.
- A final tip is to paint the reflections of the boats in a slightly darker tone, with plenty of broken edges to create movement in the gently undulating water.

Now is the time for evaluation and reflection. As always, ask yourself questions, such as:

- Does the composition work? (Give special consideration to the visual path into the painting, and the 'focal point', which in this case is the cluster of buoys in the top right-hand corner.)
- Does the 'tonal sequence' and 'colour harmony' work?
- Do any of the 'edges' require further strengthening or softening?
- Make any necessary adjustments.

A fairly limited, bright range of pastels was used for this painting to enhance its impact. Try to find a similar subject for which you can use a similar range of colours of your own choice.

secondary colour will be achieved. For example, by mixing Cadmium Yellow with Cadmium Red Light, a warm orange will be created. However, by mixing Lemon Yellow with Alizarin Crimson, a cooler, greyer orange will be created. Therefore when mixing secondary colours, you need to be aware not only of the proportions in which the two primaries are mixed, but also what colour the different reds, yellows and blues produce.

Colour Mixing for Coastal Subjects

When painting coastal subject matter, you will probably encounter a more limited range of colours than you would have to deal with for landscape painting. In addition, the chances are that more blues and yellows will be used than greens and reds. Greens and reds will still, of course, play their part but in a reduced way.

For pastels, a carefully chosen range of colours including 'warm' and 'cool' primaries, plus a selection of greys, should be sufficient for painting the majority of subjects without the need for mixing on the paper.

For the oil painter working with three primaries and white, the difficulties of colour mixing are not usually too overwhelming. Additional time can be taken, when working in the studio, for experimentation using a wider selection of colours.

The following suggestions deal with watercolour mixes. Watercolours generally present the most problems to inexperienced painters when trying to capture subtle, transparent combinations of colour, often with little time for analysis.

Clear Skies

Cobalt Blue, Cobalt Violet and Raw Sienna work reasonably well in simple, clear skies.

- Keep the Cobalt Blue in the top of the sky.
- Weaken the mix as you bring it down the paper, and introduce Cobalt Violet and Raw Sienna as required towards the horizon.
- The sky can be made a little 'warmer' towards the light source by using more Raw Sienna and Cobalt Violet.

Cloudy Skies

Cloudy skies present the painter with a vast combination of shapes, tones and colours, but a convincing variety of skies can be painted with the following colours: Cobalt Blue, Cerulean, Ultramarine Blue, Raw Sienna and Light Red.

- Cobalt Blue, Cerulean and occasionally Raw Sienna can be introduced to the paper for the sky between the clouds.
- Combinations of Cobalt Blue plus Light Red and Ultramarine Blue plus Light Red can be mixed for the clouds.
- Burnt Sienna can also be used as a substitute for Light Red.

Water

Relatively few colours are recommended for painting water, as a limited palette keeps mixing simple. Of course the range of colours would need to be expanded for painting complicated reflections, such as those found in harbours and in relatively calm water below cliffs. However, the following colours and mixes, together with experimentation and reference to some of the demonstrations in this book, should enable you to tackle most eventualities:

Cobalt Blue, Cerulean, Ultramarine Blue, Viridian, Cobalt Violet, Raw Sienna, Permanent Magenta and Light Red.

Probably the most difficult waters to paint are found abroad where the light is more intense; however, this type of water is also found in Britain, especially around the west coast, in particular in Cornwall and parts of Wales and in Scotland. This water is generally 'high key', transparent, and full of 'subtle' colour changes where the use of Cerulean and Viridian come into their own (see the demonstration painting *Kalami/Corfu* on page 138, and the painting *Agious Gordis Beach/Corfu* on page 152, both in Chapter 8).

Most of the waters around the British coast, especially where overcast lighting conditions prevail, can be painted using Cobalt Blue and Ultramarine Blue, with the inclusion of small amounts of Raw Sienna, and Permanent Magenta or Light Red to 'grey down' the blue. The watercolour demonstration *Cobles/Whitby Harbour* (see Chapter 5, page 74) uses some of the above mixes.

Sand

The colour of sand varies enormously depending not only on the prevalent light conditions but also on the natural colour of the sand itself and whether it is wet or dry. In some locations the sand is extremely light, in fact almost white – for instance Morar, on the west coast of Scotland, is renowned for its pure white sands. In other places, such as parts of the Devon coast, the sand is quite red.

- To paint light-coloured or white sand a combination of Raw Sienna, Cobalt Violet and either Cobalt Blue or Cerulean will be sufficient. Remember, when the sand is very light,

the mixes should be quite watery, and contain very little colour. The consistency of this mix will ensure lightness and transparency. Adding too much colour to the mixes will not achieve the desired results.

- If the sand is wet but not reflecting the sky, a little more colour can be used. For shadows, once again, darken the mix slightly and use a little more blue.
- Darker-coloured sands can be painted using the same three colours with the addition of Burnt Sienna and Permanent Magenta.
- The colour of darker, sunlit sand can be achieved by mixing Raw Sienna, Cobalt Violet, Cobalt Blue, Burnt Sienna and on some occasions a touch of Permanent Magenta.
- For wet sand, or sand in shadow, a mix of Cobalt Blue and Permanent Magenta can be introduced wet-into-wet into the natural colour of the sand, or glazed when the natural sand colour has dried.

Other Features

For harbour walls, groynes and timber jetties, try the following mixes:

- Cobalt Blue plus Raw Sienna (a little Viridian can be added for moss-covered timber or stone).
- Cobalt Blue plus Raw Umber (a little Viridian can be added for moss-covered timber or stone).
- Cobalt Blue plus Burnt Sienna.
- Ultramarine Blue plus Burnt Sienna.
- Cobalt Blue plus Permanent Magenta (used as either a 'wet-into-wet' glaze, or a 'wet-on-dry' glaze).
- Raw Sienna plus Permanent Magenta.

Thoughts on Technique

All the above colour mixes will enable you to paint most of the features covered, however some experimentation will be necessary with regard to tone, how the paint is applied (for example wet-into-wet or otherwise), and the exact proportion of one colour to another when mixing. To achieve more vibrant and variegated washes, try introducing pure colour to the paper wet-into-wet, allowing the applied colours to fuse naturally. When using 'glazes' to previously applied passages of dry colour (for instance when painting shadows), be absolutely sure that the paper is completely dry. These glazes should be mixed with clean water and paint to ensure transparency. Never be tempted to use 'dirty' colour already mixed on your palette – all you will achieve will be a 'muddy' passage.

The watercolour *The Slipway/Newlyn Harbour* uses many of the above mixes:

- Cobalt Blue plus Raw Sienna, Cobalt Blue plus Raw Umber, Cobalt Blue plus Burnt Sienna, Ultramarine Blue plus Burnt Sienna, Cobalt Blue plus Raw Umber plus a little Viridian were all used in the harbour walls.
- For the slipway itself the beach/sand colours Raw Sienna, Cobalt Violet, Cobalt Blue and Permanent Magenta were used.
- The water was painted with a 'wet-into-wet', 'fused' wash using a combination of Cobalt Blue, Ultramarine Blue, Cerulean Blue, Viridian and Raw Sienna.

The mixes used for the harbour wall were introduced to the water while the paper was still wet. Look also for 'counterchange', which has been used extensively in this painting (*see* 'Tone' earlier in this chapter, page 65).

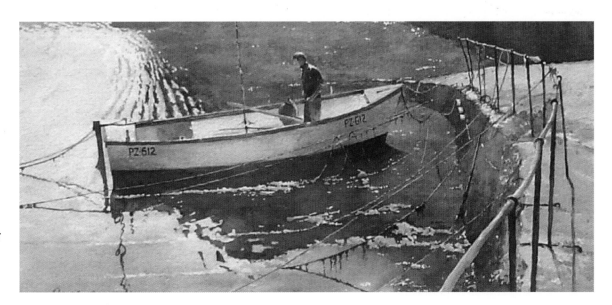

The Slipway/
Newlyn Harbour
Watercolour,
43 × 23cm
(17 × 9in).

Moorings/River Esk *Oil, 25 × 30cm (10 × 12in).*

PAINTING BOATS AND HARBOUR SCENES

There can be nothing more challenging or exhilarating for the coastal painter than boats and harbour scenes. Considering just boats on their own, the variety and choice for the painter is enormous, from small working fishing boats, pleasure craft, barges of all description, through to larger shipping including naval vessels.

The oil painting *Moorings/River Esk/Whitby* shows boats moored at low tide in glorious early morning sunlight.

Subjects such as the watercolour *Hazy Light/Whitby Harbour* offer the painter a mouthwatering number of options when considering painting a harbour scene. This subject has been painted on numerous occasions. The shapes created by the swing bridge and harbour wall can be seen from many vantage points, and there are always different boats moored below the harbour wall. In addition to these factors, when the time of day and ever-changing light conditions are taken into consideration, the possibilities are endless.

This particular painting was inspired by the low, soft, hazy light created on a winter's afternoon.

Harbours themselves are a real delight, from the small, quiet, intimate backwater, to the major harbours this country has such a wealth of, such as Southampton, Portsmouth and Liverpool to name just a few. All that is needed to improve on the subject matter available to you is the assistance of Mother Nature and

Hazy Light/Whitby Harbour
*Watercolour, 23 × 20cm
(9 × 8in).*

the throw of the dice regarding the weather, so vital for all painters to capture mood and atmosphere.

Such is the enormity of the subject matter available that this chapter will be concerned mainly with craft towards the smaller end of the spectrum – typically, small fishing boats that you would find pulled up on the beach or moored in most harbours, through to craft such as Thames barges and the larger vessels found regularly in any fishing fleet.

To add even more variety and flavour, if that's possible, consideration will be given to destinations such as Venice, Goa, Greece and many more places. Chapter 8 will discuss travelling with your paints in greater detail; however, some elements will be covered in this chapter.

Knowing your Subject

Before making a drawing or painting of any boat, large or small, it is helpful to have a little knowledge regarding their construction, shape and purpose. You must be aware of the essential parts of the boat so that you can decide what can be simplified or left out, and more importantly, what needs to be included.

The sole aim when painting boats should be to capture the essence and character of the craft. Although there are excellent examples given elsewhere for drawing 'stock' boat shapes, these formulaic renderings seldom satisfy the criteria necessary when painting the numerous varieties of craft you will come across. Over a period of time, observation, in conjunction with sketching and painting boats in any medium, will enable you to develop all the skills needed to capture the essential character of any vessel you encounter.

Bearing in mind the above advice, make as many sketches as possible; carry a small sketchbook and pencil around with you at all times, and when you come across a really promising subject, make several studies from different angles – remembering to take your time considering the best viewpoint.

As you begin to draw, pay particular attention to the position of all the major features such as cabins, masts and so on. Quick reference should always be made to the width of the boat in relation to its length and height. The width and height of any cabin or superstructure, including masts, should also relate accurately to the previous considerations. A compromise regarding the accuracy and detail of intricate masts and rigging often has to be made, so it helps to develop a shorthand method to simplify these elements without sacrificing the essence of the whole.

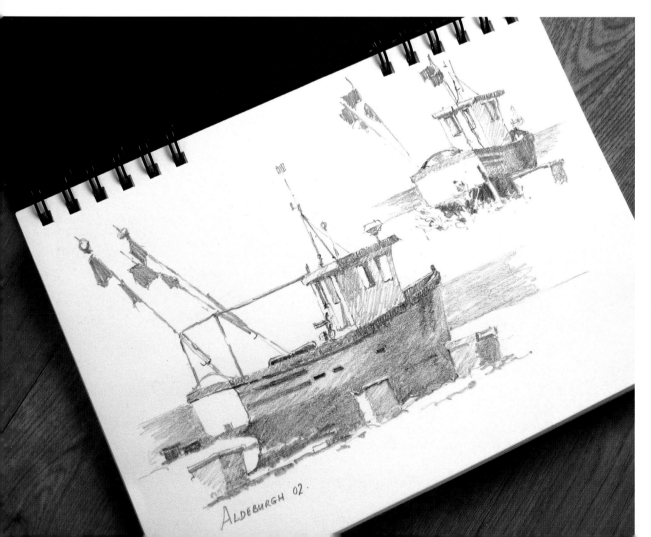

Sketch of boats at Aldeburgh.

Demonstration *Cobles/Whitby Harbour*

In watercolour, if you are not in trouble, then you're in trouble.

Selma Blackburn

These cobles were viewed *contre jour* from a slightly elevated situation. I was attracted to this subject primarily because of the quality of the hazy light, but the shapes of the timberwork on the jetty and the simple composition added to its appeal. The aim was to be fairly economical with detail, but to capture the overall mood and atmosphere and sense of place.

Step 1.

Materials

Paper:
Whatman 200lb 'Not' watercolour paper, chosen for its whiteness

Brushes:
- Nos 4, 6 and 8 round sables
- No. 2 rigger

Colours:
14ml tubes of Winsor and Newton, artist's quality watercolour in the following colours:
Raw Sienna, Raw Umber, Burnt Sienna, Cobalt Violet, Cobalt Blue, Cerulean, Ultramarine Blue

Miscellaneous:
- Masking fluid
- 2B pencil

Colour mixes
Raw Sienna plus Cobalt Violet
Raw Sienna plus Burnt Sienna (both for the 'warm' background light)
Cobalt Blue plus Raw Sienna
Cobalt Blue plus Raw Umber
Ultramarine Blue plus Raw Umber

- These prepared mixes should provide most of the colour for the entire painting, with only a few adjustments made as the painting progresses.
- You may decide to mix a few more colour pools or a few less, there are no rules; your own creativity is paramount and experimentation should be encouraged if you are to develop your own style.

Step 1: Drawing out
Use a 2B pencil to draw a simple outline of the subject, and carefully mask out the highlights.

Step 2: Prepare the following pools of colour
Pure colours
Raw Sienna
Cobalt Blue (one light and one darker)
Cerulean Blue
Cobalt Violet (one light and one darker)

Step 3.

Demonstration *Cobles/Whitby Harbour (continued)*

Step 3: Apply the first wash

- Wet the entire paper, and just as the shine starts to disappear from the paper surface, begin to introduce the colours from light to dark.
- A successful first wash is imperative for the development of the painting. This first wash should have a gradual diffusion throughout the painting surface, no hard edges and the full range of tones from light to mid tone.
- Don't be over-concerned with keeping the colour within the drawn areas; this bleeding/diffusion is essential for the creation of mood and atmosphere.

Step 4: Remove the masking fluid

- When the painting has thoroughly dried, carefully remove all the masking fluid from the boats, jetty and background. The masking fluid in the foreground water can remain until the next stage.
- Any unnecessarily hard edges created when the masking fluid has been removed will need to be softened at this stage. Work on the edges in question with a damp, clean brush and kitchen towel.

Step 5: Work on the boats and jetty

- You can now begin to develop the painting by working on the boats and jetty, using the slightly stronger mixes.
- Be extremely careful not to lose the diffusion from the first wash; too much resolution, together with inappropriate hard edges, will destroy the painting's integrity. Introduce these colours on dry paper, but still employing a wet-into-wet approach, softening edges as you go.
- When dry, the remainder of the masking fluid can be removed and any softening carried out.

Step 6: Develop the water, boats and jetty

- Introduce another wet-into-wet wash to the water, working around some of the previously masked areas and overpainting others.
- You may need to strengthen some of the mixes at this stage to develop the boats and jetty.
- Be extremely careful to glaze only clean, transparent colour over previously applied passages. It is very easy to lose transparency or turn the painting muddy at this time. If you are in any doubt regarding the transparency and freshness of your mixes, always mix fresh colour.
- Very pale and transparent colours can now be glazed over any areas that had been masked out and now appear too stark.
- Finally add small details to the boats and their reflections.

As always, now comes the time for evaluation and any subsequent alterations. Never frame your completed work without going through this process.

Step 5.

Step 6.
Harbour Reflections/Whitby *Watercolour, 20 × 15cm (8 × 6in).*

The sketchbook drawing *Sketch of boats* (*see* page 76), drawn with a 2B pencil, was made on a painting trip to the east coast of England. Simple sketches such as these take only half an hour or so to do, and are extremely useful for reference, and also as an exercise dealing with perspective and observational skills. These sketches proved useful as reference material when painting the small oil *The Beach/Aldeburgh* (*see* Chapter 3, page 43).

Another important factor to be considered is that any floating boat must sit convincingly in the water, and must never appear to be levitating above the water surface. Many otherwise competent paintings suffer from this common fault. Notice how the fishing boats in the watercolour demonstration painting *Cobles/Whitby Harbour* (*see* page 77) sit convincingly into their reflection and, more importantly, into the water. When painting these cobles, the exact waterline where each boat met the water surface could not be readily discerned, and so this common pitfall was easily avoided.

I have no interest in the dark and gloomy. To me, the delight of watercolour is in capturing the light within the white paper by surrounding it with successive washes of transparent colour.

Jean Grastorf

Small Boats and Pleasure Craft

The small yacht illustrated in the pastel painting *The Moorings/ Corfu Old Town Harbour* was moored below the towering walls of Corfu old fort, built during Venetian occupation.

Most small boats have several key components that make up their main structure. The hull is the main structural component of the boat and provides buoyancy. The roughly horizontal, but cambered structures spanning the hull of the boat are referred to as the deck, and generally speaking a small boat is unlikely to have more than one. Above the deck is the superstructure, and below the deck is the deck head.

Most enclosed spaces on a boat are referred to as cabins. The keel is a lengthways structural member to which the frames are fixed (sometimes referred to as a backbone).

The front of a boat is called the bow or prow, and the rear the stern.

Small boats come in an amazing variety of shape and size; they are a delight to paint, and can be found almost anywhere around our coast. Furthermore it is often easier for the artist to get closer to smaller boats as they are much more accessible to the general public. To become familiar with these smaller craft, it is extremely beneficial that you paint and sketch them from all angles as often as possible.

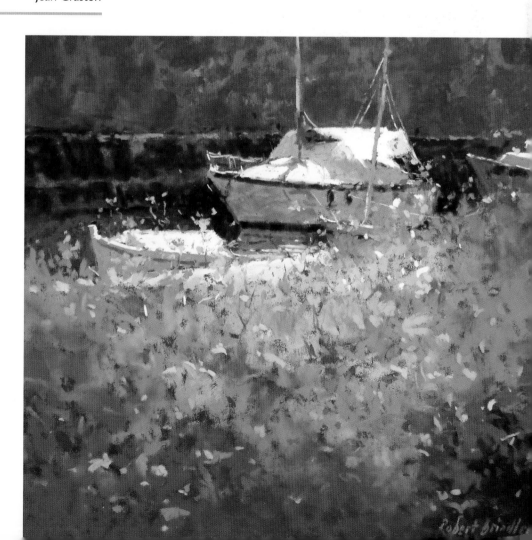

The Moorings/Corfu Old Town Harbour *Pastel, 21 × 21cm (8.5 × 8.5in).*

Demonstration *Boats at Runswick*

These cobles were viewed from a slightly elevated position and lit by an almost perfect pool of light. The subject is framed by dark foliage and strong shadows, making this a dramatic subject for such a small oil study.

Materials

Canvas board:
- Apply one coat of texture paste applied with a 25mm 'hog' brush
- Apply one coat of white acrylic primer
- Treat the board with a weak wash of Burnt Sienna and Raw Sienna diluted with painting medium or turpentine

Brushes:
- Nos 4, 6, 8 and 10 'hog' bristle
- No. 3 round sable rigger

Colours:
For this demonstration a 'warm' and a 'cool' version of each primary colour was used:
Permanent Bright Red, Alizarin Crimson, Cadmium Yellow Lemon, Cadmium Yellow, Ultramarine Blue, Cerulean, Alkyd Titanium White (to speed up drying time) and three greys mixed from the above primaries plus white:
- Grey 1: A warm, light-toned grey
- Grey 2: A cool, light-toned grey
- Grey 3: A dark neutral grey

Miscellaneous:
- Turpentine or low odour solvent, or white spirit
- 2B pencil
- Palette knife
- Copious supply of kitchen towel

Step 1.

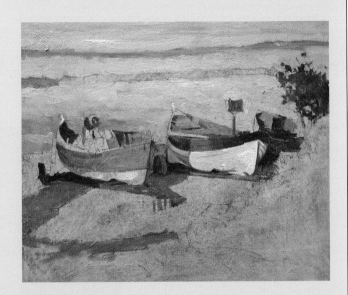

Step 2.

Step 1: Drawing out
Use a 2B pencil to draw a simple outline of the subject.

Step 2: Start with the largest shape and simple colour
- Look carefully at the subject; squint your eyes to decide on the major shapes. Begin blocking in the darks and mid-tones into the boat shapes. At this stage an accu-

rate rendering of colour and detail is not necessary, but the painting must be fairly accurate with regard to tone.
- Begin to establish the range of values in the painting by placing the lights on the boats. It is important to establish some of the 'lightest lights' at this early stage, thus ensuring that everything painted from this point on falls between the lightest light and the darkest dark. The lights of the boat are once again mixes of 'warm' and 'cool' greys. (The pre-mixed greys enable you to achieve these mixes far more quickly.)

- Mix yourself a series of greens ranging from light to dark and 'warm' to 'cool', and start to introduce the bush on the right. Warmer greens can be achieved by adding a small amount of red to the yellow before adding blue, and the cooler greens can be made using a combination of Cadmium Yellow Lemon, Cerulean and maybe the smallest touch of Permanent Bright Red.
- Experiment with your mixes, as there are numerous ways to achieve the greens needed from this palette of colours. Always be aware that by adding too much white to your colours you run the risk of 'cooling' the mix too much, or of making the mix appear 'chalky'.
- Start to paint the sea by using Cerulean, Ultramarine Blue, Titanium White, and smaller amounts of Cadmium Yellow Lemon and Permanent Bright Red.

Step 3: Develop the boats and foreground

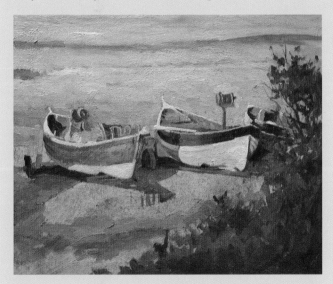

Step 3.

- Continue the overall blocking in, but at the same time turn your attention back to the boats. They are the focus of this painting, and it is now time to begin detailing them further and adding some highlights.
- The foreground foliage can now be developed using a variety of greens.
- Paint the foliage masses in an abstract manner with a combination of 'warm' and 'cool' greens together with 'lost and found' edges.

Step 4: Completion and final adjustments

- Block in the beach using a variety of 'warm' and 'cool' light tones, relating these tones to everything surrounding them. Paint the shadow of the boat in shades of blue-purple and a warm orange-grey.
- When painting shadows, always make the colour a slightly bluer version of the surface it is cast over, in this case the beach. Look for reflected light, which is often bounced into shadow areas from adjacent objects.
- Start to add detail where necessary; however, keep the painting 'loose'. The numbers on the boats can be painted and the foreground foliage areas sharpened up a little.

Now is the time for reflection; study your painting from a distance and ask yourself a few questions:

- How do the tones relate to each other? Consider the tonal balance for the painting as a whole, not just the adjacent blocks of tone.
- Does the focal point of the painting work? The areas around the edge of the painting should not distract from the centre of interest, which should be the boats in the centre of the painting, and in particular the white boat right of centre.
- Do any of the edges in the painting carry too much weight? If so you will need to soften them.
- Finally, try looking at the painting through a mirror; this will draw your attention to any imbalances or glaring errors in your work.

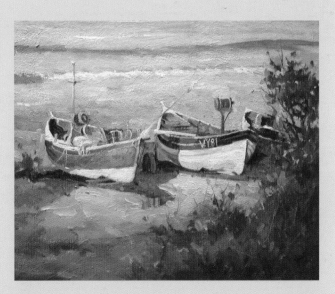

Step 4.

Cobles

Should you visit the north-east coast of England, anywhere between Filey in the south to Berwick-upon-Tweed in the north, you will be sure to find cobles. The coble is a type of open fishing boat, and its distinctive shape, with a flat bottom and a high bow, evolved to cope with the particular conditions prevalent in this area. The flat bottom allows these boats to be launched from and landed on shallow, sandy beaches, an advantage on this part of the coast where the wide bays and inlets provided little shelter from stormy weather. However, high bows were required to sail in the dangerous North Sea, and in particular to allow launching into the surf and landing on the beaches. The design has a Norse influence, though in the main it is of Dutch origin.

The boat illustrated in the oil painting *High and Dry/Staithes Beck* was moored at low tide, on a beautiful hazy afternoon. This boat is typical of the traditional, clinker-built vessel to be found on this stretch of coastline.

Cobles were clinker built (constructed using wooden planks) locally, without the use of plans. The high quality of craftsmanship on these boats gave them a long working life. They were notorious as being dangerous to sail for an inexperienced crew, but in the hands of experts could be both safe and fast. Today, surviving cobles are generally powered by diesel engines, removing the need for the distinctively shaped 'lug' sail. In a further concession to comfort, the bow is often covered by a tarpaulin shelter.

Pleasure Craft

Wherever you go these days you will find pleasure craft of all sorts. With increased leisure time, together with our continuing

High and Dry/Staithes Beck *Oil, 25 × 20cm (10 × 8in).*

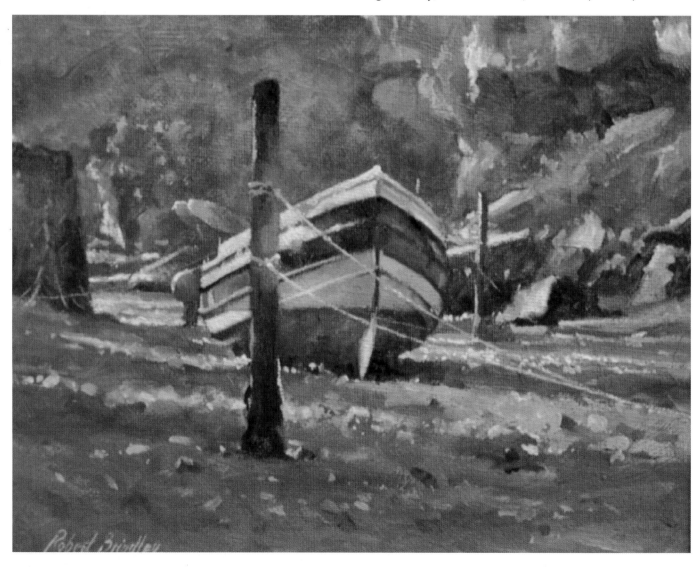

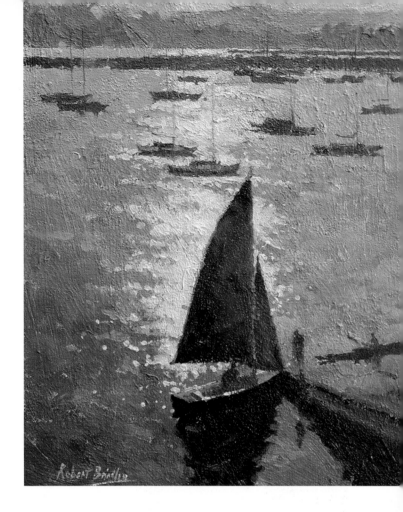

The Blue Sail/Penzance *Oil, 25 × 20cm (10 × 8in).*

passion for the sea and messing around with boats, this pastime has expanded enormously in the last twenty to thirty years. Once again, the variety of subject matter for the artist is vast, ranging from small sailboards to large luxury yachts. For many artists, the shiny, white, glass-reinforced plastic yacht holds no real attraction, especially when you are confronted with hundreds of them packed cheek by jowl into a modern harbour. However, because of the reflective quality of the surfaces, together with their design potential, these vessels often provide excellent subject material.

Should you be looking to add a little more drama, colour and design to some of your work, keep your eyes open for subjects that satisfy these criteria.

The painting *The Blue Sail/Penzance* was painted from an elevated viewpoint, looking down on a small boat with a deep blue sail and viewed against a backdrop of sparkling water. Some licence was taken when considering the colour to be used; after some thought, a range of subtle complementaries comprising warm blue-greys, oranges and yellows was decided upon.

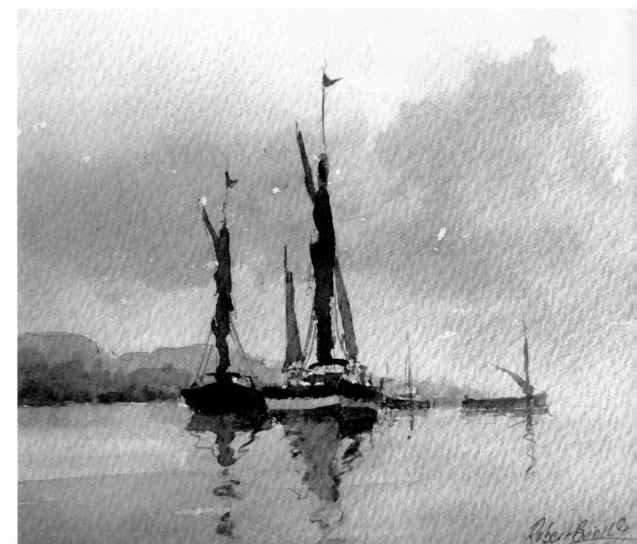

Thames Barges
Watercolour sketch,
15 × 14cm
(6 × 5.5in).

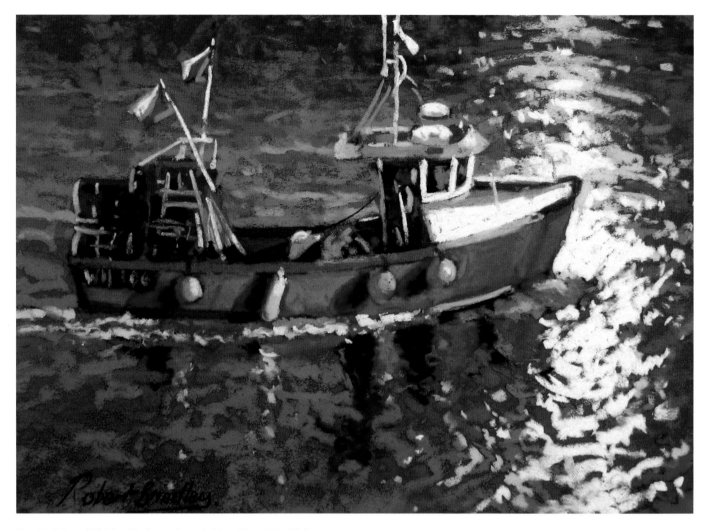

The Red Boat/Whitby Harbour *Pastel, 15 × 20cm (6 × 8in).*

Larger Fishing Boats and Sail

Larger Fishing Boats

Modern fishing boats have a more streamlined shape than some of the older vessels seen around our coasts fifty or sixty years ago. Although the older ones were probably more painterly, the range of fishing vessels for us to paint today still holds a great appeal. Nothing can be more satisfying than painting early in the morning or in the evening around a busy quayside when fish are being landed. These subjects tend to be complex, with lots of activity, so to simplify the image and add drama it sometimes pays to make these trips when the conditions offer some of the following factors:

• A *contre jour* situation where the subject is observed straight into the light, resulting in a simplified silhouette.
• Early morning or evening with low light.

• Hazy or misty conditions where distant shapes become reduced in detail and the foreground stands out in sharp relief.

The watercolour sketch *Thames Barges* illustrates the above points, where complex detail is reduced by painting the barges in a simple silhouette.

When you next visit a harbour, notice how the boats with a heavy cargo on board sit much lower in the water. When you draw or paint boats, take this factor into account: boats sit '*in*' the water and not on it.

The pastel painting *The Red Boat/Whitby Harbour* shows a bright red fishing boat returning from a day's fishing. To gain maximum impact from the strong colour and texture used in this painting, the image has been cropped from a photograph showing far more of the surrounding harbour. Look through your reference photographs for similar, colourful images that can be enhanced by cropping.

Demonstration *Fishing Boat off Whitby*

The tranquil, sunset pen-and-wash painting *Fishing Boat off Whitby* was painted in three simple steps. Should you wish to undertake your own version of this painting, then follow the instructions below.

Materials

Paper:
Hot pressed Arches watercolour paper on a block

Colours:
The following artist's quality watercolours were used:
Raw Sienna, Aureolin, Light Red, Cobalt Blue and a tube of white gouache

Miscellaneous:
- A bottle of black, waterproof Indian ink
- A sharpened stick of black bamboo for drawing; matchsticks, toothpicks or a sharpened twig will all work just as well
- No. 4 sable watercolour brush

Step 1: Drawing out
- Make the drawing using the bamboo stick and the Indian ink. Should you decide that your drawing would

benefit from a greater range of line width, sharpen yourself another stick of bamboo.
- Add water to the Indian ink and make three tones: light, medium and dark. Introduce these tones on to the paper, working from light to dark.

Step 2: Paint the initial wash
- As this is only a small watercolour there is no need to pre-mix colour pools. Gradually introduce the colours 'wet-into-wet' and from light to dark, covering the entire surface of the paper and finishing with a soft diffusion of colour.
- The 'warm' colours in the sky and water are easily achieved by using combinations of Raw Sienna plus Light Red, Aureolin plus Light Red, and Light Red plus Cobalt Blue.
- This will be the initial wash only.

Step 3: Paint in 'form' and details
- Let the paper dry thoroughly and then overpaint certain areas such as the sky, distant headland and waves, this time creating 'form'. Remember, the ink drawing will provide all the tone and structure needed for this painting.
- Finally, use several mixes of white gouache and Aureolin to paint in the setting sun and its path across the sea.

Step 1.

Step 3.
Fishing Boat off Whitby *Watercolour, 15 × 19cm (6 × 7.5in).*

Sail Boats

There is something really magical about sailing craft, which makes them so attractive to both artists and buyers of art alike. Maybe it's the feeling of freedom that all sailing craft conjure up in people's minds; to be able to go anywhere the wind carries you is an extremely romantic notion.

Over the centuries, probably more sailing craft have been painted than any other type of vessel. Some of the finest drawings and paintings produced in the last century were done by Arthur Briscoe (1873–1943), a wonderful painter and a member of the Royal Society of Marine Artists. His works are a remarkable record of all manner of craft during this period.

Since Briscoe's passing there have been many notable marine painters, but for simplicity and economy of brushwork, both Edward Seago's and Edward Wesson's paintings take some beating.

Today there is never a shortage of sailing vessels to be painted wherever you travel, and even the modern, fairly standard yacht looks breathtaking under full sail and in the right lighting conditions.

The watercolour painting *Sparkling Light/Iselmeer/Holland* shows two yachts on an evening sail on the Iselmeer. The sun was low in the sky, creating a wonderful 'sparkling' light effect. This studio painting was made from sketches and reference photographs brought back from a Royal Society of Marine Artists' trip to Holland.

Sparkling Light/Ijsselmeer/Holland *Watercolour, 44 × 20cm (17 × 8in).*

Boat Shed Interiors

Suitable boat shed interiors are quite difficult to find, as good ones are generally few and far between. If you do locate one that is suitable and are given permission to paint inside, take full advantage of the situation as it provides a unique opportunity to develop your boat-painting skills. Painting complex interiors, often in a cramped, uncomfortable, poorly lit working environment, can be a real challenge; however, working sketches, or even better a completed painting, will be hugely valuable because they will be quite unique. Any successful works produced from locations such as this are extremely useful for exhibition purposes, especially those submitted for selection by a panel of judges. Your paintings, if well executed, will often be chosen in preference to other artists' works, on the basis that they will add variety to an exhibition.

The watercolour painting *Boat Building Shed/Whitby* was painted from a small, 'on site' oil painting and sketches. The light streaming in from the window created a soft, diffused atmosphere achieved by fluid, 'wet-into-wet' washes and subsequent softening of some of the over-insistent edges; this was done by lifting out the pigment.

When evaluating the merits of any interior you come across, look for those that will interest the viewer and at the same time capture the atmosphere and sense of place. Very tidy, 'clinical' interiors never work as well as an old and cluttered, traditional boat shed. Keep your eyes open for dark, atmospheric interiors where a shaft of intense, warm light from a window or door illuminates important features and creates drama. Occasionally you may find a wonderful interior to paint, but where the light available is very poor. Nevertheless, if the subject is very promising, you may have to go ahead and hope

that the work produced looks acceptable in better light back in the studio.

On other occasions a promising interior may need slight adjustments to be made, with regard to composition and lighting. In these situations you may need to use imagination and a little 'artist's licence' to rearrange things and adjust the light source.

The perfect interior, just ready for you to paint, probably doesn't exist!

Before you begin the painting process, settle down and spend a few moments tuning yourself in to the environment. Plan your painting carefully, and look for any reflected light, which is often found in the most surprising places. Interiors reveal reflected light everywhere; it bounces into almost every shadow and hidden corner, creating unexpected interest and colour. And should you be fortunate enough to be able to incorporate a working figure or two into your painting, it will really be something special.

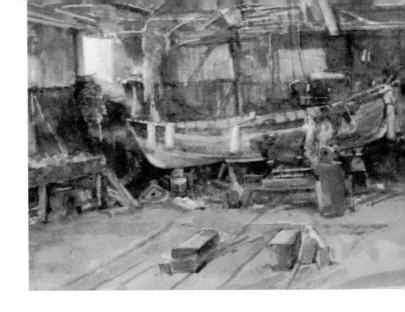

TOP RIGHT: Boat Building Shed/Whitby *Watercolour,*
25 × 20cm (10 × 8in).

BELOW: Tractors and Boats/Skinningrove *Oil,*
30 × 40cm (12 × 16in).

Miscellaneous Subject Matter

Occasionally you may come across a wonderful coastal subject that has little or no commercial appeal. The oil painting *Tractors and Boats/Skinningrove* is this type of subject, depicting a jumble of crab pots, tractors and boats on a small area of unkempt ground at this 'timeless' village on the north-east coast. It has an abundance of interesting shapes and textures, providing an enjoyable challenge for any artist to paint.

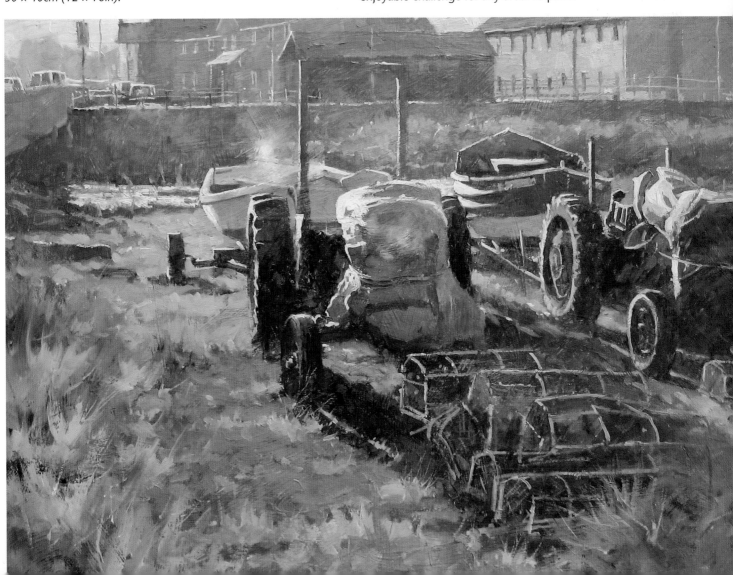

Towards Whitby from Sandsend *Watercolour, 45 × 13cm (18 × 5in).*

PAINTING BEACHES AND COASTAL SCENERY

This chapter deals with many aspects of painting beaches and coastal scenery, at home and overseas in its many forms, from wide vistas to intimate cameo studies, altogether providing a staggering variety of subject matter. Some of the smaller features that make beaches such wonderful places to paint will be considered, such as breakwaters, groynes, rock pools, streams running out to sea, rocks, cliffs, breaking waves, figures, and much more.

The painting *Towards Whitby from Sandsend* shows this beautiful stretch of beach at low tide. Sandsend beach lies on the east coast two miles north of Whitby, and is featured many times throughout this book. The extended landscape format chosen for this painting captures the character of this location, with the distant headland of Whitby enhanced by the timber breakwaters.

Beaches

Traditional Beach Scenes

This section looks at how to paint that initial overall impression of the traditional beach scene, without the consideration of the smaller elements that combine to make every beach scene unique.

The watercolour painting *June Sunset/Sandsend* shows a tranquil, early summer evening on the beach at Sandsend. This simple sunset painting, with the breakwaters in silhouette, will hopefully encourage you to try a similar subject matter. Many painters avoid this kind of subject, put off by the often gaudy display, but not every sunset is unpaintable: look for a good composition, together with convincing colour and a striking light effect.

June Sunset/Sandsend
*Watercolour, 18 × 13cm
(7 × 5in).*

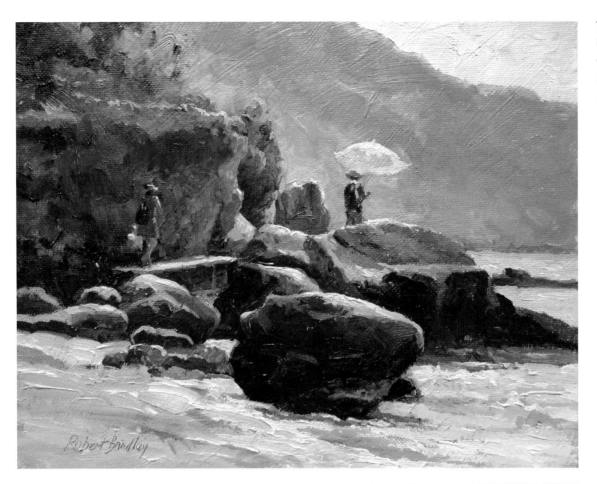

The Beach
Umbrella/Agious
Gordis *Oil,*
25 × 20cm
(10 × 8in).

Wet Sand/
Sandsend Beach
Watercolour,
48 × 35cm
(19 × 14in).

Viewpoint was discussed in an earlier chapter, and is a vital element to be considered in painting a beach scene. Each location will generally present you with a variety of different options – unless it is a long, straight, flat stretch of beach; however, a beach that is edged or partially enclosed by cliffs, possibly forming a bay or cove, will offer more choice, and will be a more dramatic and demanding subject.

The oil painting *The Beach Umbrella/Agious Gordis* illustrates the above perfectly. The two figures dressed in red were spotted walking down the beach, and offered a wonderful subject for a future painting; the problem was deciding how they should be used to gain maximum impact. Many photographs were taken, and eventually the decision was made to paint them against the light, with the light coming through the fabric of the umbrella. The rocks were repositioned slightly, and other figures were omitted to produce this composition. The other photographs taken of these two figures will be used again in future paintings.

It is important that you consider carefully all the options available to you before commencing any painting. One or two simple tonal pencil sketches could prove beneficial in these instances.

The painting *Wet Sand/Sandsend Beach* illustrates the significant advantages of a higher viewpoint. The subtle colour changes and the soft light in this huge expanse of wet sand were accentuated in this painting by viewing the subject from an elevated position, incorporating a high horizon.

The paintings *Beach Patterns/Sandsend* and *Breakwaters/ Sandsend* show the same view, but because they were observed from beach level, they resulted in very different paintings.

Beach Huts and Windbreaks

Beach huts make marvellous subjects, either on their own or as part of the overall scene. The British have a long-standing love

ABOVE: **Beach Patterns/Sandsend** *Watercolour, 53 × 18cm (21 × 7in).*

BELOW: **Breakwaters/Sandsend** *Watercolour, 45 × 15cm (18 × 6in).*

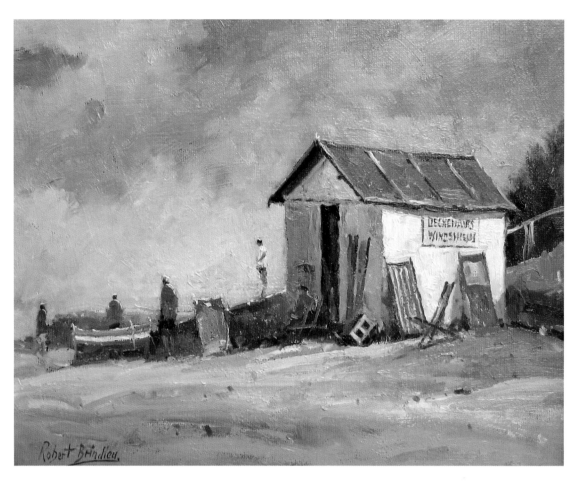

The Beach Hut/
Sandsend *Oil,
25 × 30cm
(10 × 12in).*

BELOW: Hazy
Light/Sandsend
Beach *Watercolour
sketch, 20 × 13cm
(8 × 5in).*

Windbreaks/Sandsend Beach 1 *Gouache sketch, 25 × 9cm (10 × 3.5in).*

affair with them, and they remain a feature of many of our seaside resorts; however, they are becoming fewer in number. They can be found in locations throughout England, but in particular on the east coast of England, from Tynemouth in the North East all the way south to Frinton-on-Sea. They are used for a variety of different purposes, such as sales offices for windbreaks and deckchairs, and a base for ice-cream vendors and beach photo-

graphers, to name but a few. Their traditional purpose is to provide a changing facility for families, who would have either their own, or a hired hut. The best examples are often privately owned, personalized, and very colourful, and make wonderful painting subjects. Once again, should you decide to include them in a painting, take time to consider all your options with regard to composition and viewpoint.

Windbreaks/Sandsend Beach 2
*Watercolour, 30 × 23cm
(12 × 9in).*

The oil painting *The Beach Hut/Sandsend* features a beach hut as the main subject, supported by figures to add life and interest. However, the small *plein air* watercolour sketch *Hazy Light/ Sandsend Beach* has a much broader range of interest, including a distant, hazy view to Whitby.

Any painter who wants to incorporate design, colour and dramatic light effects into their work should give serious consideration to the inclusion of windbreaks into their paintings. Viewed *contre jour*, with intense sunlight bursting through their fabric, they often provide a magical subject. The modern windbreak is made using a staggering array of colours: Mediterranean blues, greens and yellows, to vibrant reds, greens and purples. Figures are always in evidence, walking to and fro, busying themselves with beach activity and providing the artist with plenty of movement and interest. In addition to windbreaks there is also bound to be a vast assortment of colourful bags, lunch boxes, buckets and spades, pushchairs, and much more paraphernalia for you to incorporate into your paintings.

Should you be attracted to painting this type of subject matter, familiarize yourself with the work of Ken Howard RA, who produces many beach scenes of this type and is a complete master of capturing light effects.

The colourful gouache sketch *Windbreaks/Sandsend Beach 1* was painted on site and proved to be a most enjoyable experience. The aim was to capture the strong colour and 'tonal' contrast in evidence on the day. Gouache dries very quickly, and being an opaque medium, each layer of colour can be overlaid, producing speedy and striking results.

The *contre jour* watercolour painting *Windbreaks/Sandsend Beach 2* illustrates how to paint the light effect created by light passing through windbreaks. The windbreaks themselves, together with other areas of light, were carefully masked out before the usual 'wet-into-wet' washes were applied. Careful tinting and colouring was carried out on the windbreaks after the complete tonal sequence for the painting had been resolved. When painting subjects similar to this, it is essential to ensure that you retain the light early on, surrounding it progressively by carefully considered tones, and eventually capturing the observed light effect.

Windbreaks/Sandsend Beach 3 depicts a colourful, bustling beach scene, hopefully capturing the atmosphere, warmth and colour of a hot summer's day.

Windbreaks/Sandsend Beach 3 *Watercolour, 30 × 20cm (12 × 8in).*

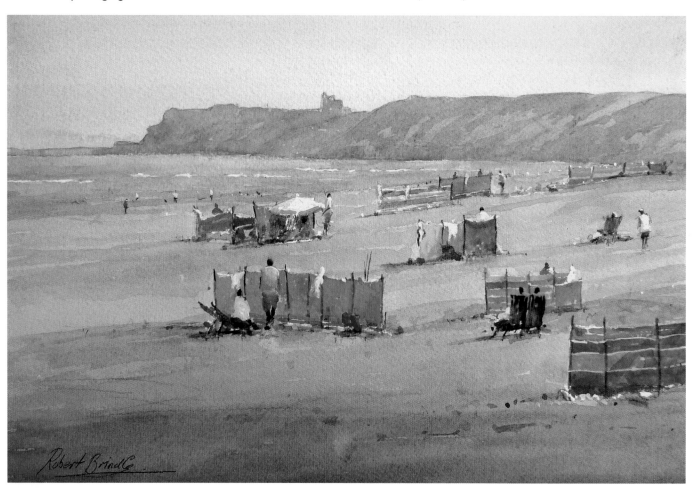

Demonstration *Sparkling Light/St Ives*

This image was painted from photographs taken many years ago on the beach at St Ives in Cornwall. The aim was to capture the movement in the figure together with the light and atmosphere, which combine to produce this striking, evocative subject.

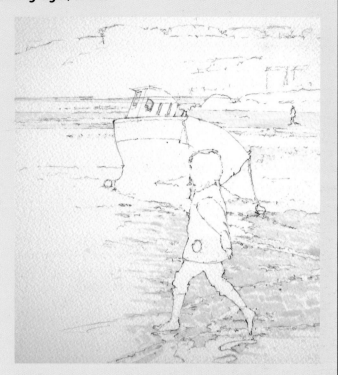

Step 1.

Materials

Paper:
Saunders Waterford 140lb 'Not' watercolour paper

Brushes:
* Nos 4, 6 and 8 round sables
* No. 2 rigger
* A worn 'hog' oil-painting brush to soften the edges made by the masking fluid

Colours:
14ml tubes of Winsor and Newton artist's quality watercolour in the following colours: Raw Sienna, Raw Umber, Burnt Sienna, Cobalt Violet, Cobalt Blue, Cerulean, Ultramarine Blue, Permanent Magenta and Viridian

Miscellaneous:
* Masking fluid
* 2B pencil
* Two or three ceramic mixing palettes
* Kitchen towel

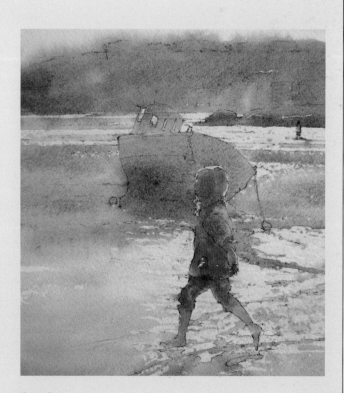

Step 2.

Step 1: Drawing out
* Use a 2B pencil to draw a simple outline of the subject.
* Mask out all the areas of sparkling light using an old or partly worn No. 2 synthetic brush.

Step 2: Prepare colour pools and apply an overall 'wet-into-wet' wash
* Prepare several colour pools using Raw Sienna, Raw Umber, Cobalt Violet, Cobalt Blue and Ultramarine Blue; you will probably need at least five or six pools of colour for this stage, however, study the painting carefully and mix more if you feel they are necessary.
* Wet the paper and introduce the colour, from light to dark, as quickly as possible, though make sure the colour is placed accurately and with due consideration given to subtle colour and tonal shifts.

Demonstration *Sparkling Light/St Ives (continued)*

- Be as bold as you dare with tone at this stage. Generally speaking, the more you achieve at this time, the less layering of colour will be needed later, which will result in a purer, more transparent result.
- The red lifejacket can be carefully painted into the damp washes using Cadmium Red and a little Cobalt Blue.

Step 3: Develop the distance and begin working on the boat

- When the paper has completely dried, remove the masking fluid with a clean dry finger.
- Develop the distant landscape by introducing washes of Raw Sienna plus Cobalt Blue, Raw Umber plus Cobalt Blue, and Raw Sienna plus Ultramarine Blue.
- Where the landscape meets the sky, diffusion can be encouraged by dampening the sky in places. At the same time a little Cobalt Violet can be added while the paper is still damp.
- The bottom section of the boat's hull can now be tackled using mixes of Ultramarine Blue plus Burnt Sienna and Burnt Sienna plus Ultramarine Blue.

Step 3. Detail.

- Note how the colours and tones used in the boat pass seamlessly into the area of cast shadow and reflection with a very even transition, barely revealing the line where the boat sits in the shallow water. This smooth transition is critical in order to ensure that the boat sits convincingly on the beach.
- When the distant landscape has thoroughly dried you may decide to add a little hazy atmosphere to the distance. By dampening small areas and carefully removing some pigment using a soft kitchen towel and a damp sable brush, you will be able to reproduce effects such as low cloud, smoke, or in this case a hazy atmosphere (*see* detail above). Take care when trying this procedure for the first time, as it is very easy to remove too much pigment or to create hard, unsympathetic lines or stains. It may be beneficial to practise this technique on a scrap of paper, prior to using it on your painting.

Step 4: Further develop the boat, figure and beach, working to completion

- Spend a little time at this stage softening some of the masking fluid edges with a damp brush, taking care not to damage the paper.
- Introduce Raw Sienna, Cobalt Violet, Permanent Magenta and Cobalt Blue in soft glazes to the beach area. Try to use these slightly darker tones to enhance

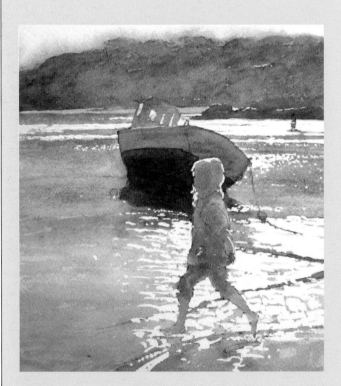

Step 3.

the sparkling light effect on the wet beach, and not to lose it. It is very easy to lose this effect if the masked areas are excessively over-painted.

- Add further carefully considered glazes of Cobalt Blue, Cerulean, Cobalt Violet and Viridian to the sea. The same comment regarding preservation of the light effect applies here also.
- The boat can be completed by a combination of transparent glazes and darker washes. Be patient and build up these final tones gradually.
- The figure is completed by further applications of colour, being especially careful not to lose the 'halo' effect of light around the hair. Use the following colours for the figure:
 - Raw Sienna, Cobalt Violet, Burnt Sienna and Cobalt blue for the hair
 - Slightly stronger mixes of Cadmium Red and Cobalt Blue for the life jacket
 - Ultramarine Blue and Burnt Sienna for the trousers
 - Burnt Sienna plus Cobalt Blue for the flesh tones

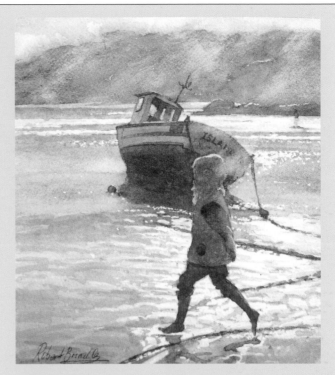

Step 4.

Figures

Figures add interest, life, movement and colour to any painting, and in particular beach scenes. A somewhat ordinary subject can be greatly enhanced by including a few carefully composed figures. Their correct placement in a painting is critical to its success, as composition and balance can be drastically affected by incorrect positioning. Never include figures just for the sake of it; when used correctly they are an integral part of the painting, but they become an unnecessary distraction if they are not needed.

Consider the following factors when you decide to use figures in any of your paintings:

Figures are useful for scale comparison You will automatically recognize the height of people and therefore be able to relate this known element to create distance and perspective in your work.

Decide very early on where to place major figures Small figures can often be placed fairly late in the painting process, or even after the painting has been completed if necessary. However, larger figures or groups need to be given much more thought.

Ask yourself why you are using the figures If you are concerned only with adding a little life to your painting by including one or two distant figures, then provided they are used sensibly there are not too many pitfalls. Do make sure, however, that they take nothing away from the overall 'feel' of the painting, and be aware that incorrect tone, scale or colour can ruin an otherwise successful piece of work. A well positioned figure can be used to establish or reinforce the focal point; however, don't be tempted to use a brightly coloured figure (especially in red), which then becomes too intrusive. This ploy very rarely works, and is often used in desperation.

Ensure a hierarchy of figures Should you be more concerned with using a number of figures as an integral part of your composition, make sure that you give priority to one particular figure, or group of figures only, thus ensuring a hierarchy within your painting. By littering the painting with too many figures of equal importance, scale or size, your viewer will be overwhelmed, their eyes will be unable to travel through your painting, and any impact will be lost. When drawing or painting foreground figures, more careful observation is needed and the statement should carry a little more information. However, be wary of over-detailing.

Using individual subjects Occasionally you may come across just one or two figures that would make a wonderful subject on their own. It could be a simple study of a child playing in a rock pool, or building sandcastles, as illustrated in the watercolour painting *Building Sandcastles*. Another good example of this type of subject matter is shown in the watercolour painting *Fishing off the Todden*. This wonderful subject of a father and son fishing together was observed on the top of the cliffs at Cadgwith Cove in Cornwall, and was an immediate attraction. Vital information was gathered by quick sketches and photographs without disturbing or intruding on the privacy of the two individuals.

Where possible use figures as a compositional device This will lead the viewer into and through your painting.

Use odd numbers of figures When considering the use of groups of figures, always be aware that odd numbers work better than even numbers: therefore always use three, five, seven and so on. Overlapping shapes also work better: several evenly spaced individual figures are never as aesthetically pleasing as a composed group or groups.

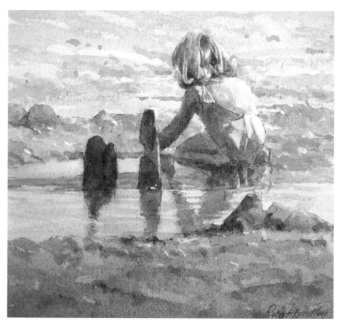

ABOVE: Building Sandcastles *Watercolour, 19 × 18cm (7.5 × 7in).*

BELOW: Fishing off the Todden *Watercolour, 30 × 25cm (12 × 10in).*

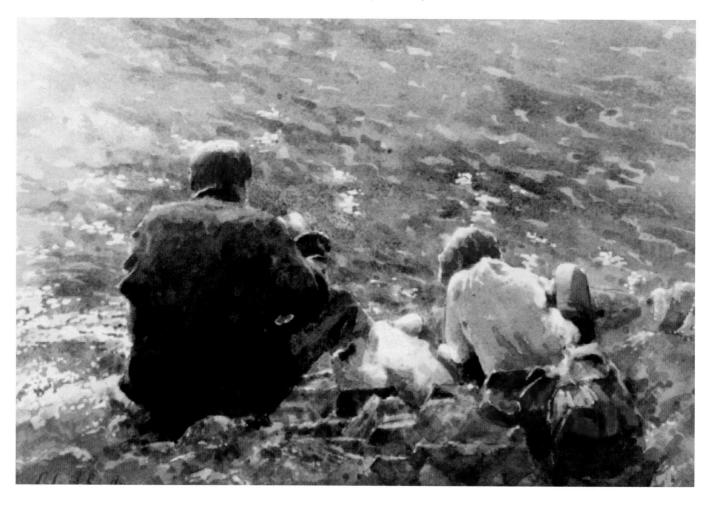

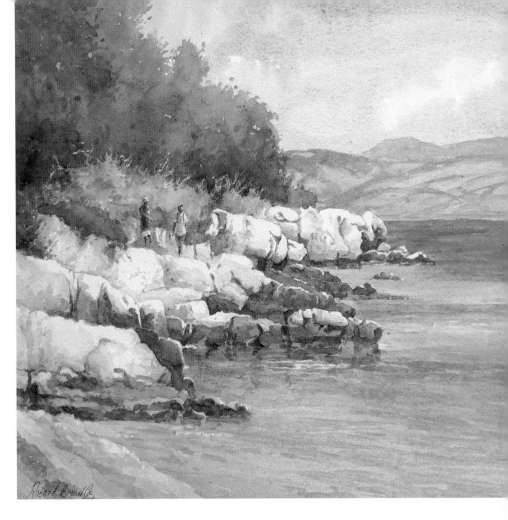

Footpath to the Beach/Kassiopi/Corfu
Watercolour, 30 × 30cm (12 × 12in).

Poorly drawn and badly conceived figures should never be used This may sound obvious, but figures showing these failings appear with unfortunate regularity in many paintings that would otherwise be considered successful works. Remember, especially when painting figures, 'loose' does not mean 'sloppy' and conversely, 'well drawn' does not necessarily mean 'tight' or over-detailed. There is no need for over-elaboration when drawing heads, features, hands and feet. These elements should not be over-stated; after all, we are not concerned with portrait painting. A successfully drawn figure only needs to have the correct proportions, stance and attitude to be totally convincing.

To obtain a feeling of movement, blur the legs slightly just above the ground, and never attempt to paint the feet at all in distant figures. Look carefully at any figure you have drawn; if necessary view the painting through a mirror, or ask someone you trust to be honest with their opinion. If any figure looks lifeless, too rigid, or out of proportion, changes should be made. Never be content with the age-old saying 'It will do'.

Painting figures *plein air* When painting *plein air* it is often extremely difficult, even for the more experienced painter, to capture fleeting figures in their work. Even if you feel confident enough to make quick and accurate figures in your *plein air* work, it still makes sense not to rush – it is far better to be patient. On many occasions a suitable figure will come along

and settle down for a while, giving you the opportunity to capture them in your painting.

Keep a sketchbook or photographs Until you develop a shorthand method that enables you to introduce convincing figures in your outdoor work, keep a sketchbook for making quick studies, or build a library of photographic references. These will be invaluable in the studio for future paintings, in which you want to include figures. Remember, as usual, practice makes perfect.

Coastal Scenery

The scope for painting coastal scenery is wide-reaching, ranging from cameo scenes, such as views looking down on to the sea and rocks from a cliff-top vantage point, to large open vistas viewing the coastline for several miles. You will discover many wonderful subjects to paint, from high, breathtaking viewpoints, such as those to be found along the west coast of Scotland, to the flat coastal scenery to be found below the Wash on the east coast of England.

When you also take into account the transient light effects, different weather conditions and your location, whether in this country or abroad, the possibilities are endless.

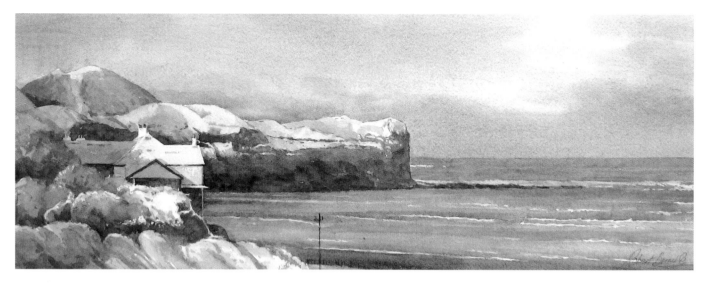

ABOVE: Snow/Sandsend Ness *Watercolour, 50 × 18cm (20 × 7in).*

BELOW: Red Cliffs/The Algarve *Oil, 30 × 40cm (12 × 16in).*

The following paintings reflect many of the attributes described above. The inspiration for painting them, together with an analysis of the completed painting, is discussed in full.

Footpath to the Beach/Kassiopi/Corfu

This watercolour painting is concerned primarily with sunlight, colour, and the texture of the rocks. The painting was executed in the studio from on site sketches and photographs. Particular care was given to preserving the light on the white rocks.

Snow/Sandsend Ness

This watercolour was painted from the window of a warm studio on a cold winter's day with broken light. The subject suits a panoramic format, and the 'sun-struck' snow exaggerates the unusual shapes of the Ness.

Red Cliffs/The Algarve

The oil painting *Red Cliffs/The Algarve* was a demonstration for a group of artists attending a workshop. In essence the painting is fairly simple, and was painted within the two-hour time frame. However, it was selected primarily for the wonderful colour and texture in both the rocks and their reflections; this was made far easier to achieve by working on a board prepared with texture paste and painted with a 'warm ground' mixed with Permanent Bright Red and Cadmium Yellow Lemon.

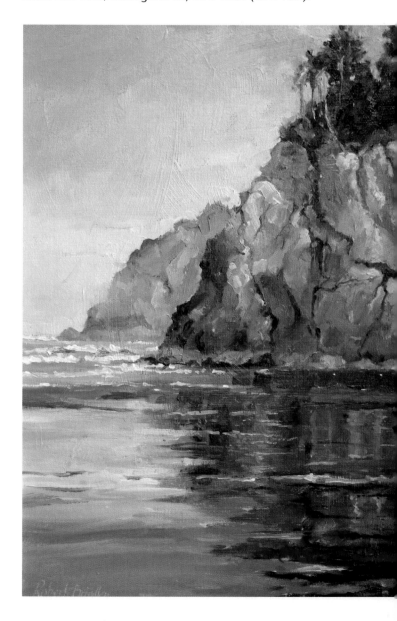

Summer/
Sandsend Ness
Watercolour,
40 × 35cm
(16 × 14in).

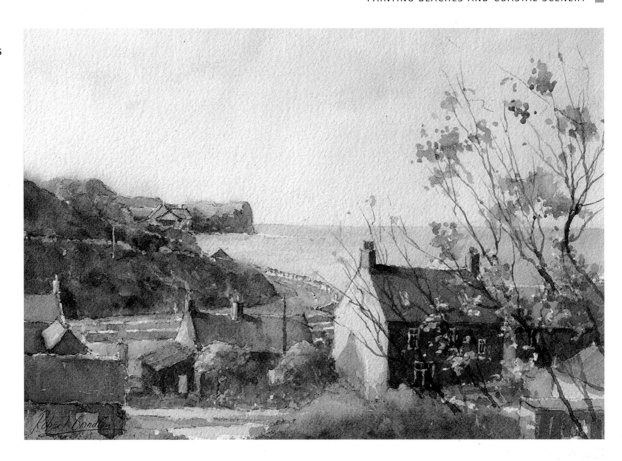

Summer/Sandsend Ness

Many coastal views are not spectacular vistas, and the watercolour painting *Summer/Sandsend Ness* falls into this category. The inspiration came from wanting to paint a well known local scene, but from an angle and elevation not available to most artists. It was a thoroughly enjoyable process, painted on a glorious spring day from the studio garden.

The medium of watercolour suited the subject matter perfectly. The sea and sun-struck foliage was developed by 'wet-into-wet' transparent applications of colour. The white of the gable end is pure white paper. The bold, but still transparent darks used for painting the large cottage on the right were achieved by mixes of Ultramarine and Burnt Sienna.

The composition, although not straightforward, works fairly well by leading the viewer's eye through the painting via the white gable end, finishing up on the distant Ness. The branches and leaves that enter the painting on the right were included as a 'stopper' to keep the viewer's eye in the painting. In the majority of cases, branches like this would have been omitted; however, they work surprisingly well in this instance.

Boats at Runswick

The watercolour painting *Boats at Runswick* shows a slightly

elevated view towards Kettleness from Runswick Bay in North Yorkshire. This painting was undertaken on a warm, sunny June day, and captures the beauty of this wonderful location with the added interest of boats, calm sea and distant landscape.

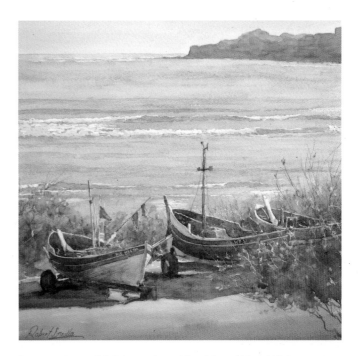

Boats at Runswick *Watercolour, 30 × 28cm (12 × 11in).*

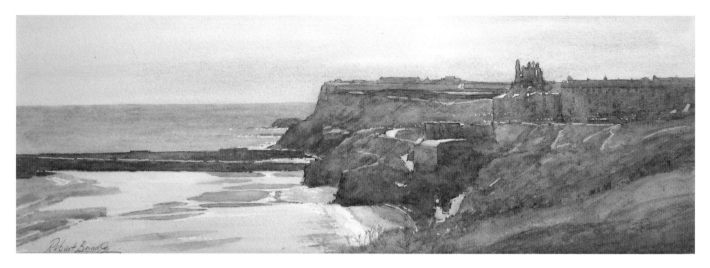

Morning Light/Whitby

Consider painting the occasional wide, narrow panorama, such as this watercolour *Morning Light/Whitby*. When hanging an exhibition, several paintings in this format can be extremely useful, acting as punctuations.

This subject, by its very nature, suited an elongated landscape format. Added drama has been introduced as a result of the elevated viewpoint. Scenes such as this readily lend themselves to a variety of formats in addition to the panorama used in this instance; for instance, a square format could be used to place additional emphasis on the beach patterns, whereas the more regular landscape format would allow consideration to be given to all the elements – the sky, land and sea.

Location sketches were made between 7.30 and 9am on an early summer's morning, when the low light illuminated the beach and created wonderful highlights in rooftops and road surfaces.

The subject is primarily a tonal study and therefore a limited palette of just five colours was used: Raw Sienna, Raw Umber, Cobalt Violet, Cobalt Blue and Ultramarine Blue. Masking fluid

ABOVE: Morning Light/Whitby *Watercolour, 48 × 18cm (19 × 7in).*

BELOW: Towards the Ness from Kettleness *Watercolour, 40 × 18cm (16 × 7in).*

was used to protect all the lit areas, whilst a 'wet-into-wet' initial wash was applied.

Towards the Ness from Kettleness

This watercolour shows another panoramic view, however this time observed from beach level. The flat, rocky 'scaurs' of the beach are a perfect foil to the rugged, vertical shapes of the cliffs, changed by man through alum mining during the nineteenth century.

Extreme care must be taken when working in a location such as this due to the rapid tide changes.

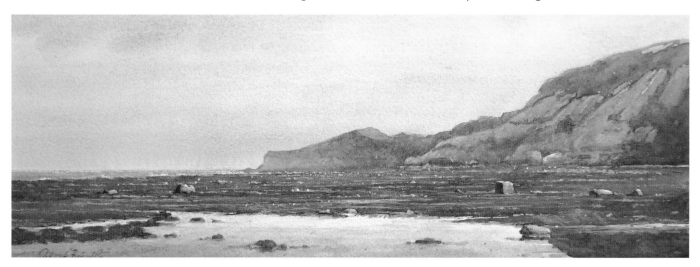

Short *Plein Air* Demonstration *High Aspect/Staithes*

This watercolour and acrylic demonstration was painted from a high vantage point above the village of Staithes; the time of year was late September when the light was clear and crisp. This magnificent view has everything: imposing cliffs, buildings, beach, water and rocks. One of the advantages of painting from this location is that very few people are likely to pass while you are working, so all your concentration can be given to the painting.

This composition works extremely well, as the sweep of the beach in conjunction with the forms of the diagonal jetty and waves lead the eye naturally to the base of the cliffs.

Step 1.

Materials

Paper:

Arches 140lb 'Not' paper on a block

Brushes:

* Nos 4, 6 and 8 round Acrylix brushes by Pro Arte
* No. 2 rigger

Colours:

* The following watercolours were used: Raw Sienna, Permanent Rose, Burnt Sienna, Cobalt Blue and Lemon Yellow
* The following acrylic colours were used: Ultramarine Blue, Cerulean Blue, Primary Red, Primary Yellow and Titanium White

Miscellaneous:

* 2B pencil
* Kitchen towel

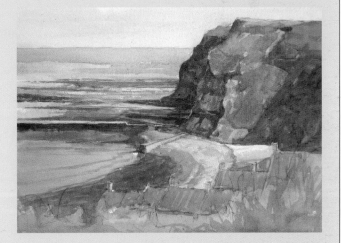

Step 2.

Step 1: Drawing out and first washes

* Undertake a simple outline drawing without any consideration to detail using the 2B pencil.
* Make pure colour pools using only the individual colours. The colours should be mixed on the paper 'wet-into-wet' for the initial diffused wash.
* Introduce the colour to the dry paper encouraging a little diffusion in places. Remember to apply the colour from light to dark.
* When the surface of the paper has been covered with loose, diffused washes, allow everything to dry out.

Step 2: Introduce acrylic paint and develop form, colour and tone

* Now is the time to develop form, colour and tonal masses by overlaying further watercolour washes for each individual area, such as the cliffs, sea or rooftops. Concentrate on keeping the painting loose; don't be over-concerned with small imperfections at this stage. (Time is at a premium when working on site, and any minor faults can be easily corrected. More serious faults can be corrected later by using acrylic paint.)
* While the painting is drying, take advantage of the time by considering what you have achieved, and planning the next stages.
* When fully dry you can continue to develop form, colour, and in particular tone, using acrylic paint. The

Short *Plein Air* Demonstration *High Aspect/Staithes* (continued)

use of acrylic paint will allow you to continually change form, tone and colour; however, it is easy to overwork the painting, losing freshness and the feeling of spontaneity.

- Tackle the cliffs and beach area first, gradually working from light to dark. Be careful when assessing the darkest tones in the cliff: if you overdo these they will dominate, and could influence the tonal relationships throughout the remainder of the painting.
- Dry brushwork can be used on the beach to introduce broken texture. Load the brush generously and apply the paint by dragging the brush at an angle almost parallel with the paper surface. Practise this technique on a scrap of paper if you are not familiar with it, because a light touch is required.

Step 3: Complete the painting with further washes and final details
- This final step continues with the same procedure described in Step 2, but with ever more consideration given to the risk of over-painting. Remember, wherever the initial 'wet-into-wet' washes have worked successfully, leave well alone!
- Very little additional work should be required to the painting. Limit yourself to minor, well considered

washes of colour that you feel will enhance your work. An additional application of watercolour can be introduced to the sea.
- Add the highlights to the rooftops, chimneys and beach. Introduce two or three carefully positioned fishing boats to the shallow water using acrylic paint. If it helps, draw the boats very faintly with a 2B pencil before committing yourself to paint.

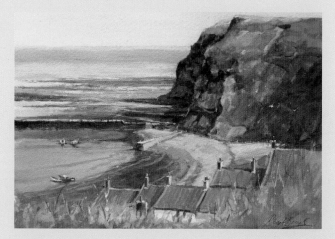

Step 3.
High Aspect/Staithes *Watercolour and acrylic, 30 × 20cm (12 × 8in).*

Demonstration *Bird's Eye View/Staithes*

When out and about seeking suitable subject matter, be aware of the alternatives available to you. You may originally have set out to paint the larger coastal view; however, you may be attracted to a more interesting and challenging subject such as portrayed in this watercolour *Bird's Eye View/Staithes*. This image was painted from sketches and reference photographs taken on a beautiful hazy morning in Staithes, North Yorkshire.

Materials
Paper:
Saunders Waterford 140lb 'Not' watercolour paper

Brushes:
- Nos 4, 6 and 8 round sables
- No. 2 rigger

Colours:
14ml tubes of Winsor and Newton artist's quality watercolour in the following colours: Raw Sienna, Raw Umber, Burnt Sienna, Cobalt Violet, Cobalt Blue, Cerulean, Ultramarine Blue, Permanent Magenta and Viridian

Miscellaneous:
- Masking fluid
- 2B pencil

Step 1: Drawing out and masking
- Using a 2B pencil, draw out the composition, paying particular attention to the seagull and the buildings. It is essential that these two elements are drawn

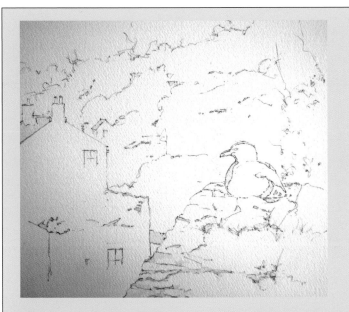

Step 1.

accurately to ensure correct placement of colour and tones when applying the 'wet-into-wet' wash.

- Using a damp No. 2 synthetic brush, apply the masking fluid accurately to the highlights, once again paying particular attention to the 'rim' lighting around the seagull.

Step 2: Prepare colour pools and apply an overall 'wet-into-wet' wash

Look carefully at the illustration Step 2 and decide which colours you would use to achieve a similar initial, diffused wash. The colour pools used for this demonstration are listed below, however there are many combinations of colour to be made from this palette, and you may decide to create your own interpretation of the scene. These colour pools will be used for the entire painting and will only require minor adjustments as the painting progresses.

Pure Colours
Raw Sienna, Cobalt Violet, Cobalt Violet and Cerulean Blue

Colour mixes
- Cobalt Blue plus Raw Sienna, Cobalt Blue plus Raw Umber, Cobalt Blue plus Permanent Magenta (used for buildings)
- Raw Sienna plus Cobalt Violet, Raw Sienna plus Cobalt Blue, Raw Sienna plus Viridian, Raw Umber plus Cobalt Blue and Cobalt Blue plus Permanent Magenta (used for distance and foliage)
- Raw Sienna plus Permanent Magenta and Cobalt Blue plus Permanent Magenta (used for the rocks)

- Pre-wet your paper and introduce the colours as quickly as possible, generally from light to dark. Work as wet as possible and don't worry about the washes diffusing into each other as this diffusion creates the underlying 'looseness' and atmosphere.
- When the paper is thoroughly dry, remove the masking fluid.

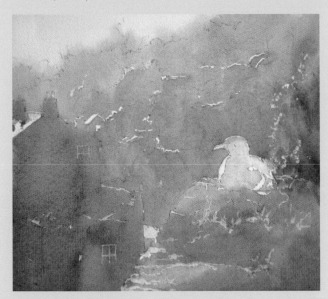

Step 2.

Demonstration *Bird's Eye View/Staithes (continued)*

Step 3: Develop the buildings and main foliage masses

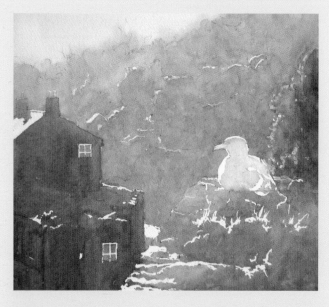

Step 3.

- Use the mixes discussed in Step 2 to develop the buildings and main areas of foliage.
- You may need to strengthen the original mixes in places.

Step 4: Soften the edges created by the masking fluid and further develop main masses

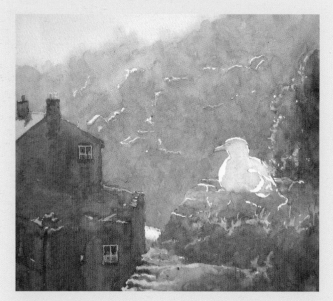

Step 4.

- Before taking the painting any further, soften some of the hard, unwanted edges created by the masking fluid using a damp brush and great care.
- Some of the harsh lights, also resulting from the use of masking fluid, such as the windows, can now be carefully painted over with a transparent wash of Cobalt Blue plus a touch of Raw Sienna. This wash will 'set' them into the shadow area.
- Using the colour pools, gradually develop other areas of the painting giving particular attention to the 'tonal sequence'.

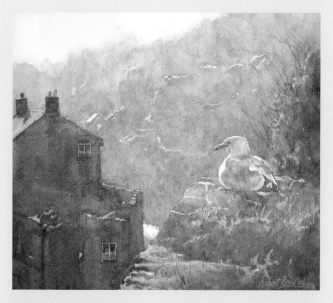

Step 5.
Bird's Eye View/Staithes *Watercolour, 23 × 20cm (9 × 8in).*

Step 5: Paint the seagull and add final details
- You can now paint the seagull using blue-greys mixed from Cerulean, Cobalt Violet, Cobalt Blue, Permanent Magenta, Raw Sienna and a small touch of Permanent Rose for the beak.
- Take extra care to achieve a variety of 'soft' and 'hard' edges.
- Very transparent glazes of Cobalt Blue, Cobalt Violet and Raw Sienna should be applied to the entire background, diffusing the previously applied washes and creating a hazy atmosphere.
- Similar glazes should also be applied to the foreground section of the cliff to reduce contrast and detail.

The Red Groyne/South Shields *Pastel, 20 × 30cm (8 × 12in).*

Lighthouses, Piers and Groynes

Lighthouses, piers and groynes are familiar coastal features that offer the coastal painter a variety of subject matter. Lighthouses are vital to the protection of shipping around the coastlines of the world and are situated in many, varied and spectacular locations; this, together with their diversity of design, means that they are an essential subject for any painter.

The pastel painting *The Red Groyne/South Shields* shows the pier at South Shields adorned with its attractively painted red groyne.

Demonstration *Groynes/Sandsend Beach*

This image was painted from sketches and reference photographs taken on a painting expedition to Sandsend near Whitby. The aim of this painting was to capture the colour and texture of the groynes as simply as possible, without too much unnecessary detail.

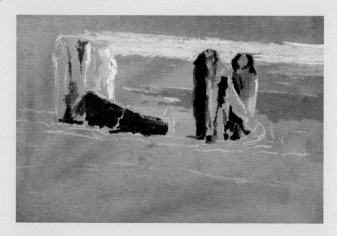

Step 2.

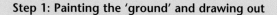

Materials

Paper:

Grey Hermes glass paper, mounted on stiff card

Pastels:

- All pastels were 'Unison'. A selection of yellows, oranges, blues, subtle greens and greys were selected. To aid simplification, select only two or three tones of each colour
- A white pastel pencil by Conte for drawing out
- A tube of red and yellow acrylic paint

Step 1: Painting the 'ground' and drawing out

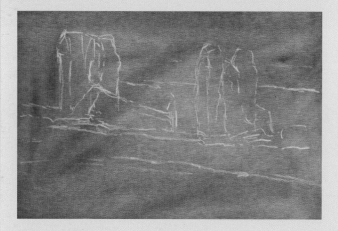

Step 1.

Paint the 'ground' using a watery mix of red and yellow acrylic paint.
Draw a simple outline using the white pastel pencil.

Step 2: Begin blocking in

- Begin blocking in, starting with some of the darkest darks.

- Before taking these darks too far, establish the tonal sequence by introducing a few adjacent lights for comparison.
- Take care at this stage not to over-load the texture of the paper.

Step 3: Continue blocking in and introduce the water

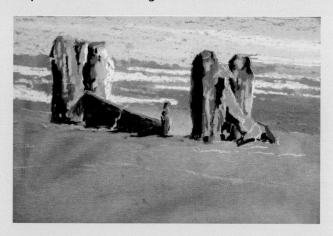

Step 3.

- Continue blocking in by completing all the darks, followed by the introduction of mid-tone yellows, greys and subtle greens.
- Start to paint the sea using two closely related, pale blue-greens.
- Notice how blue has been introduced into the 'warm darks' on the timber in the centre of the painting. These

touches of colour help to break up the dark area and introduce a little reflected light.

Step 4: Complete blocking in the breakwaters and develop the beach

Step 4.

- Complete the 'blocking in' of the timber breakwaters.
- Move on to the beach area using yellows and blue-greys.
- The Cerulean Blue nylon ropes can also be introduced at this time.

Step 5: Add the final details
- The beach was completed in a very simple manner, only a bare minimum of marks being needed to satisfy the eye without drawing attention away from the breakwaters. All the final touches and details can be added now without adding too much detail.
- Use strong colour on the ropes and flotsam and jetsam, to draw the eye into the painting.
- The lightest lights can now be introduced by using confident marks.

- You must now consider whether or not you want to use blending in some areas of the painting. There is always a danger of over-blending when using pastel, which can result in the loss of impact. In this case it is probably safest to use a little blending in the background water and the more distant timbers out of the focal area.
- Final consideration should be given to the edges: some may need softening, whilst others will need to be sharpened up.

Now comes the time for evaluation and reflection. As always, ask yourself questions, such as:

- Does the composition work? (Giving special consideration to the visual path into the painting, and the 'focal point'.)
- Do the tonal sequence and colour harmony work?
- Do any of the edges require further strengthening or softening?
- Make any necessary adjustments.

Step 5.

Sunset on the Lagoon *Pastel, 38 × 23cm (15 × 9in).*

PAINTING WATER, SKIES, MOOD AND ATMOSPHERE

Water, skies, mood and atmosphere, in conjunction with your ability to interpret the subject before you, are the perfect recipe for a successful painting. However, a word of caution at this stage: many inexperienced painters often invent or over-dramatize their skies in an attempt to create mood and atmosphere; this seldom works, however, so be sure that the sky you paint is sympathetic to the subject. If you decide to create a sky to fit your subject, err on the side of caution; it should always be convincing in relation to the rest of the painting, and should never become a dominating feature.

The pastel *Sunset on the Lagoon* depicts a dramatic sunset, full of light, mood and atmosphere.

A successful painting must run deeper than mere representation. It should be a communicating process that alone should move the viewer.

Scott Christensen

Evening Spurn Point *Watercolour, 18 × 14cm (7 × 5.5in).*

Painting Water

Water is one of the most difficult elements to paint successfully, however it is probably one of the most exciting subjects for an artist to attempt. Capturing the gentle movement and reflections in a harbour scene where the water surface has an almost 'oily' quality, or depicting the violent nature of a rough sea, remains a challenge to even the most accomplished artist. Constantly moving, its very nature makes painting it successfully both demanding and rewarding.

Water is forever changing, both physically, and also in its appearance in differing light conditions. For instance the colour and apparent transparency of water can alter repeatedly in a relatively short period of time due to changing light and weather conditions. Even standing water, as found in rock pools, is subject to many changes; evaporation will take place, it will be disturbed by wind and rain, or – probably the most important of all – will reflect light and all of nature's moods.

The watercolour painting *Evening Spurn Point* was painted from on-site sketches and reference photographs. It depicts the effects of rapidly changing light, and scudding clouds on the River Humber just before sunset.

Due to the complexity of painting water, this section discusses first still water, then moving water.

Still Water

Still water is an extremely complex subject on its own, therefore only the basic essentials will be covered here.

Reflections are the mirror-like ability of water to reproduce shapes and colours, and a little time spent studying and sketching them will assist in understanding how they are created. It is also important to understand that your location in relation to them determines what you see.

Reflections/Staithes Beck *Watercolour, 23 × 18cm (9 × 7in).*

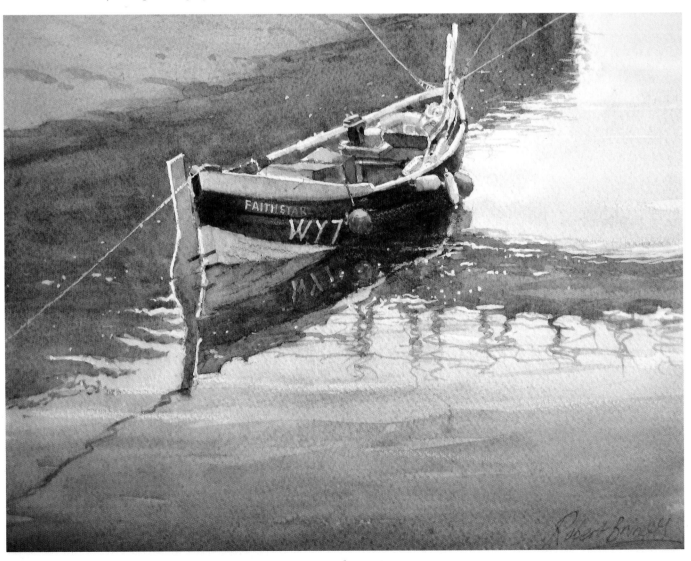

TOP RIGHT:
Reflections/Corfu Town
Harbour 1.

BOTTOM RIGHT:
Reflections/Corfu Town
Harbour 2.

Viewpoint and its Effect on Reflection

The watercolour painting *Reflections/Staithes Beck* was painted from a slightly elevated position, and illustrates some interesting reflections in relatively calm water. Notice that not only are the reflections of the coble reproduced, but also those of features not in the painting, such as the harbour wall and the footbridge over the beck.

When a subject is viewed on a level plane, for example from the water's edge or from the water surface, an almost exact duplication of the subject will be reflected; see the photograph *Reflections/Corfu Town Harbour 1*.

However, if the same subject is viewed from an elevated position, then the resultant reflection will be subject to some distortion; the photograph *Reflections/Corfu Town Harbour 2* illustrates this point. By looking carefully at the centre boat, you will see that the reflected bow is far deeper than its actual depth, appearing to have been stretched.

When looking across an area of water in a harbour or similar setting, study the reflections of the harbour wall, jetty and so on. Any mooring post, handrail or object very close to the edge will once again be reflected almost perfectly. However, objects that are set a little way back from the water's edge will be only partially reproduced, and objects that are set well back from the water's edge will not be reflected at all. These points are illustrated in *Reflections/Corfu Town Harbour 3*, where the boats and harbour wall are fully reflected, but the grassy bank and

Reflections/Corfu Town Harbour 3.

mid-distant shrubbery are not reflected at all. Only the top of the distant, very high wall in the top left of the photograph has been reflected in the bottom right-hand corner.

Colour and Tone in Reflection

Colour and tone in reflections also merit discussion at this stage. Without close observation you could be forgiven for thinking that these two elements are reproduced perfectly in reflection; however, colour more often than not appears to be slightly greyer in the reflection. Tone is affected to a greater degree, resulting in a narrowing of the tonal range; thus lights are reflected slightly darker, and darks slightly lighter in their reflection.

Although a perfectly flat water surface will produce an almost perfect reflection, it is often better to introduce a slight disturbance to the water as this adds movement and design to

the painting, and removes any possibility of its having a static quality.

Transparency in Reflection

Transparency is another factor to consider when painting still water. If the conditions are right, rocks and other underwater features will be visible, presenting the opportunity for you to capture this effect in your work.

From a practical point of view, it is often more successful to paint the bottom of the water first, followed by the suggestion of a slightly disturbed water surface over the top. This method works reasonably well when painting in oils or pastel; however, a more considered 'wet-into-wet' approach may be needed when using watercolour. Capturing the transparency of still water can be difficult, but a successful rendering of this effect can transform an ordinary painting into something special.

The photograph *Transparent Water/Corfu Harbour* shows the beauty and magical quality of clear, transparent water – but the conditions seen here make the boat appear to levitate above the water surface, and if you decide to paint a subject such as this, you will need to be very careful: it may be very appealing, but viewers could be very critical of your interpretation of such an image without the support of the original photographic reference.

People accept without question the reality of the photographic image, but will immediately challenge the artist's often accurate interpretation of the very same image. This photograph illustrates perfectly just such a situation.

In some instances, especially when the water surface reflects the sky or when you look across the water surface from a low angle, all transparency will be lost. However, when you look directly down from a harbour wall or into a rock pool, transparency will be revealed for you to paint.

Transparent Water/Corfu Harbour.

Moving Water

Painting water in all its forms is a challenge; however, by studying and hopefully capturing the fluidity of moving water, you will be rewarded by the feeling of movement in your work.

Moving water that is slightly broken by wind action, or in the other extreme, disturbed by turbulent waves, conforms to the same rules as still water with regard to reflections. However, the constantly changing horizontal planes of water will produce broken, disturbed reflections. These reflections not only partially reflect the objects above the water surface as previously discussed, but also the sky.

The oil painting *Thames Nocturne* shows how a moderately disturbed water surface breaks up the reflections of the sky and distant shoreline.

The numerous planes and varying degrees of reflection in disturbed water will respond to other factors, often bouncing light back from the sea bed below, creating further nuances of tone, shape and colour for consideration.

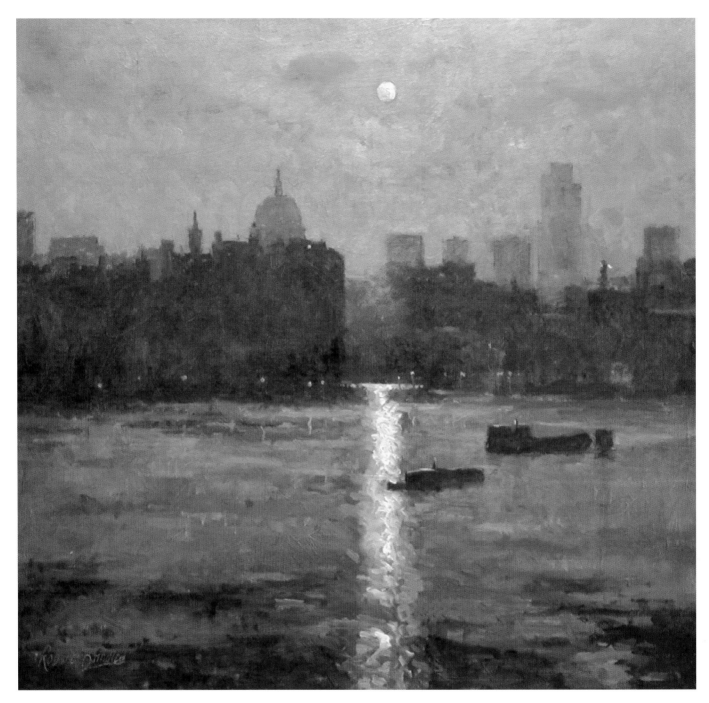

Thames Nocturne *Oil, 38 × 40cm (15 × 16in).*

Reflections and Cast Shadows

Before leaving the subject of reflections, a word of caution is offered regarding the difference between reflections and cast shadows. Many painters believe that they are painting reflections in their work when in fact they have been painting a cast shadow. In some instances, depending on the direction of the light source, a shadow can be completely coincidental with a reflection; however, it is more likely that it cuts across a section of the reflection. Where the two coincide you will notice a darkening of the tone and often a loss of transparency. The greatest problem is encountered where a shadow cuts across part of the reflection, resulting in three different areas for you to resolve: one for the reflection, one for the shadow, and finally the area where the two elements coincide. In each of these areas changes in tone, colour and transparency should be observed and interpreted. On some occasions there will also be a problem with regard to composition,

Reflection and Shadow/Corfu Harbour.

especially where the shapes and tones created become too insistent.

The photograph *Reflection and Shadow/Corfu Harbour* illustrates this situation perfectly. Observe the lowering of tone and loss of transparency where the shadow and reflection coincide.

As you can imagine, capturing this occurrence convincingly can be difficult, and in some cases the end product results in confusion and over-complication. If this is the case, look elsewhere for a less demanding subject.

The oil painting *The Moorings* has both reflections and shadows, however the two elements coincide only on the left-hand side of the painting, causing no design problems or confusion for the viewer.

Painting Fast Moving Water

Capturing moving water is always an exciting challenge, and without doubt painting breaking waves will present you with many problems to solve, especially if you are working on site. Should you have little experience of painting fast moving water, the best way to learn and hone your powers of observation is to carry out numerous on-site sketches and drawings. These will prove to be invaluable, as sketching not only builds confidence, but speeds up your ability to transfer accurate information to a painting. The following demonstration was created from on-site sketches and digital photographs.

The Moorings *Oil, 25 × 30cm (10 × 12in).*

Demonstration *Breaking Waves*

The oil-painting demonstration *Breaking Waves* illustrates how incoming waves in conjunction with a simple sky and setting sun can provide you with a wonderful small painting. Try numerous similar subjects at different times of the day using different colour combinations.

This subject was painted from a digital photograph and on-site sketches using five primary colours plus white.

Step 1.

Materials

Board:
- Apply one coat of texture paste to a 10 x 12in canvas-coated board with a 25mm 'hog' brush; when dry, treat with one coat of white acrylic primer.
- Prepare the board with a weak wash of Ultramarine Blue and Permanent Bright Red diluted with painting medium or turpentine.

Brushes:
- Nos 6, 8 and 10 'hog' bristles
- No. 3 round sable rigger

Colours:
Permanent Bright Red, Alizarin Crimson, Cadmium Yellow Lemon, Cadmium Yellow, Ultramarine Blue and Titanium White

Miscellaneous:
- Low odour solvent
- Sepia-coloured pencil
- Palette knife
- Copious supply of kitchen towel

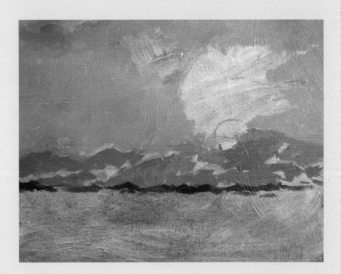

Step 2.

Step 1: Drawing out
Use the sepia pencil to draw a simple outline of the subject. You may choose to use a pencil, a brush with diluted oil paint, or even just go straight in with paint. The decision is yours; however, try not to draw any unnecessary detail, as once the blocking in commences much of the drawing work will be lost.

Step 2: Start with a simple block-in
- Choose the darkest shapes to begin with, in this case the wave forms, laying in only dark and medium tones. These colours are a series of closely related 'warm' and 'cool' greys, made from combinations of Ultramarine Blue, Permanent Bright Red, Alizarin Crimson, Cadmium Yellow and Titanium White.
- Now turn your attention to the evening sky. A range of colours, from very pale yellow through to a deep red-orange, was prepared and laid on to the board. Prepare these mixes with Cadmium Yellow Lemon, Cadmium Yellow, Permanent Bright Red, Alizarin Crimson, a very small amount of Ultramarine Blue (to be used in the darker, cooler extremities of the sky) and Titanium White.

Demonstration *Breaking Waves (continued)*

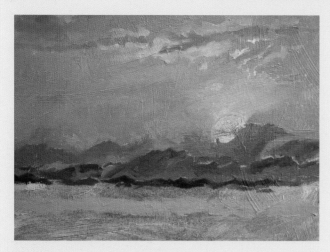

Step 3.

Step 3: Continue the block-in

- Continue to develop the sky, paying particular attention to the tonal sequence when laying in the colour. The lightest tone in the sky will surround the sun, and the darkest tones will be found the further you move away from the sun.
- Look for subtlety in your colour mixes. Garish, bright colour will turn your painting into a chocolate box scene.
- Begin to apply colour to the sea. Once again, aim for restraint when mixing these colours; they should be quite close tonally, and range from soft lavenders through to cool grey-greens. Ultramarine Blue and Titanium White will be the dominant base colours for these mixes, with slight inclusions of the two reds and Cadmium Yellow Lemon.

Step 4: Completion of the block-in

- Lay in all the colours for the sea, changing emphasis all the time, playing 'warm' against 'cool' colour.
- Don't over-work your brush strokes at this time, and keep them expressive, trying to capture the movement in the shallow water.

Step 5: Assessment and completion

- Now comes the most important time for assessment. Take a break and study your painting for any weaknesses in tone, colour or drawing.
- Once you have made any necessary adjustments, begin to look critically at all the edges that have been created in your build-up.

TIP
Never be tempted to paint too accurately at this stage; a rough block-in is all that is required, as time and effort will be wasted on unnecessary and premature detailing.

- Convincing and visually pleasing paintings are often achieved by a combination of 'hard' and 'soft'/'lost and found' edges. Using a clean, soft brush, or preferably your finger, blur and soften some of the edges that may appear too harsh.
- At the same time make sure that the gradation of the sky is convincing. There should be a gradual transition from light to dark across the sky, broken only by the cloud forms.
- Your attention can now turn to sharpening up some of the edges where more emphasis is required.
- Add the highlights to the waves, and a little discrete texture into the water.
- Complete the picture by 'painting in' the sun using Cadmium Yellow and Titanium White; however, don't be tempted to use pure white. Just the slightest touch of yellow in the 'lightest light' will be far more convincing than stark white.

Set the painting aside for a day or two, where you are likely to keep coming across it accidentally; this is often the best way to notice anything that may require further attention.

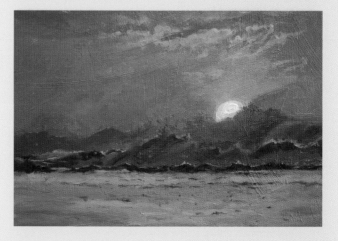

Step 5.
Breaking Waves *Oil, 25 × 20cm (10 × 8in).*

Skies

The sky is the soul of all scenery. It makes the earth lovely at sunrise and splendid at sunset. In the one it breathes over the earth a crystal-like ether, in the other a liquid gold.

Thomas Cole

The sky is the key to most landscape or seascape painting, reflecting the conditions and moods of nature. The only exceptions are those paintings where greater attention is given to the land mass; however, even in these cases, the sky as a light source will be almost entirely responsible for the initial appeal of the subject to the artist. The pastel painting *Sunset/Camber Sands* illustrates how a dramatic sky such as this can be used as the main feature of the painting, at the same time showing its effect on the thin strip of sea below.

As an artist you will also be affected emotionally by the same elements, and should be able to respond in a positive, sensitive and creative manner. Always acknowledge the importance of the sky by making every effort to interpret its influence in all of your paintings.

Clouds and Cloud Shadows

A certain amount of knowledge regarding any feature to be included in your paintings will always be of assistance, and this applies to skies, and particularly to clouds. There are various names for cloud types, amongst them cirrus, cumulus and nimbus. You don't need to be an expert on the classification of clouds, but a little background knowledge will add to your appreciation and interpretation of their form.

A cloudless or solid overcast sky presents no problems for the painter; however, these skies rarely offer excitement or interest, so remember to use them in a scenario where all the interest lies in other areas.

Whenever you are outside, make a conscious effort to study the sky. Notice the recession within the sky – generally speaking, more distant clouds are smaller than the ones overhead.

Sunset/Camber Sands *Pastel, 38 × 25cm (15 × 10in).*

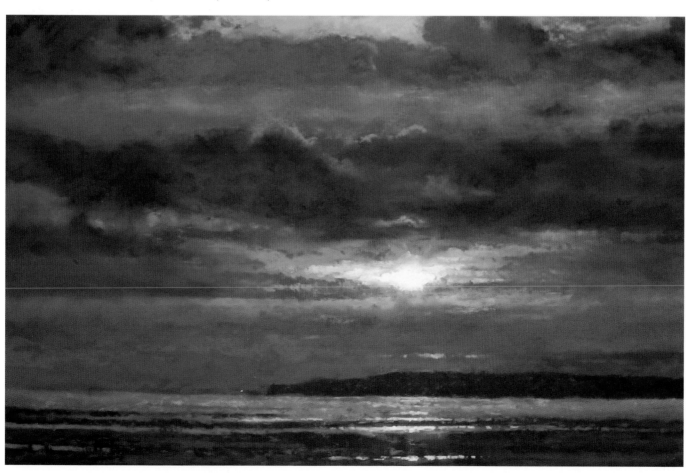

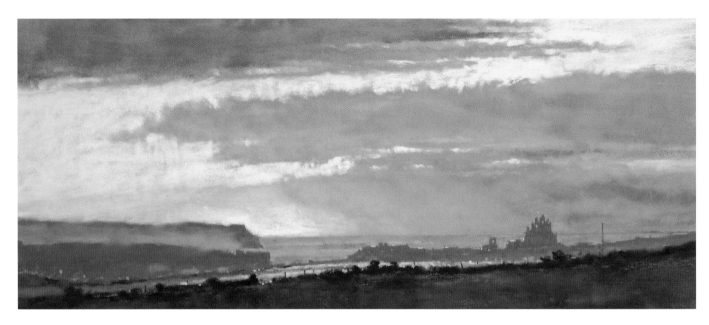

Towards Whitby from Hawsker *Pastel, 50 × 23cm (20 × 9in).*

This one observation alone will assist in creating a real feeling of depth within your paintings. Cloud shadows, often scudding across the sea, are also extremely important. They can be used effectively to divide large expanses of water or sand into smaller areas, providing you with a wonderful, flexible compositional element. Try using cloud shadows in a creative fashion to add drama to your paintings, as in the pastel painting *Towards Whitby from Hawsker*, where a cloud shadow has been used in the foreground to accentuate the thin sliver of light on the sunlit field.

The following suggestions may stimulate your imagination and creativity, and are merely the first of endless possibilities:

- Dramatize a brightly lit foreground by setting it against a background completely in shadow.
- Do exactly the reverse by painting the foreground in deep shadow and the middle distance and/or the far distance sharply illuminated. Think of yourself as a director on a film set where all options are available to you. Imagine pointing a powerful spotlight anywhere you like within the boundaries of your painting. Such a brightly lit area or areas can be used to focus the viewer's attention exactly where you want it.

Clouds are fascinating to paint because they are the only genuinely free element in landscape, having the ability of free movement, which makes the sky a place of constant change. Although the sea is similar in this respect, waves tend to repeat themselves, a very useful quality for observation purposes. It may help you to remember that clouds float, not only at tremendous heights, but also very near to the earth, and sometimes hang across it (as in the case of fog or a sea fret).

The fact that the sky is a vast void where clouds of all kinds float freely, creating wonderful patterns on a backdrop of ever-changing gradations of colour, should inspire any artist.

Relative Tone and Colour Values

Study the relative values of clouds and the land; this will enable you to capture their lightness and to paint them in a more convincing way. Try not to paint dark clouds darker than earth values. Dark clouds obstruct the light that would otherwise fall upon the landscape, causing the earth value to become darker than usual. Many painters fall into this trap, and for that reason the clouds in their paintings appear to be too heavy to remain suspended in the air.

In some instances the sky, although it is the source of light, appears as a strong, dark contrast against brightly illuminated surfaces, however never let the sky become too dark otherwise you will exhaust all means of producing intensity and the range of values needed in the rest of the painting.

Consideration should be given to the gradation in the sky which begins overhead at the zenith, with quite a strong blue (Cobalt or Ultramarine with a touch of red or ochre seems to work quite well), lightening and warming progressively towards the lower part of the sky, often with a hint of green. The sky at the horizon takes on a warmer, pearly grey 'haze', sometimes with a hint of yellow or pink.

Evening towards San Giorgio *Watercolour, 50 × 20cm (20 × 8in).*

Careful observation will reveal not only a vertical gradation of the sky, but also subtle lateral colour gradations. These tonal and colour variations, though only slight, will recede in value as they move away from the light source. If the light source is 'warm', there will be a cooling of the tones, and vice versa. The watercolour painting *Evening towards San Giorgio* doesn't have a clear blue sky; however, it does illustrate subtle gradations quite well. Notice how there is a lightening of the sky from top to bottom, and also how it changes in colour and tone as it moves away from the warm light source on the right.

Reflected Light from the Earth

When searching for the 'true' colours in the sky, look carefully for the reflected colours from the land. Such reflected colours produce a real difference in the sky. For instance, where you may have broad expanses of sand, a great deal of warmth will be reflected into the sky, and in a similar way the colour of the sea will reflect into the sky influencing its colour in many different ways.

Reflected Light from the Sky

This light can often be difficult to detect, however consider the effect of a brilliant sunset, where a warm orange glow is often cast over everything. By studying the more obvious examples of reflected light from the sky, you will be better able to assess the more subtle influences.

Reflected light from the sky is a little more complex when related to the sea, as so much depends on the amount of movement in the water. A flat expanse of water or sea, wet sand or any wet surface will generally be highly reflective and therefore influenced by the colour of the sky. The amount of reflective influence the sky has on any plane depends upon how the plane relates to the viewer's eye, and also the reflective capacity of the plane. For example, dry surfaces have a low reflective capacity and little sky colour will be reflected. However, when the same surface passes into shadow, the sky colour is reflected more strongly; this explains why shadows always appear cooler on sunny days.

Waves and moving water can be wonderful to paint on a bright, sunny day as the more horizontal planes facing the sky will reflect much of the sky colour, whilst all other planes, depending on their relative angles to the sky, will reflect the corresponding degree of colour.

Paint What You See

A cautionary warning with regard to relying on formulas to paint skies should be made at this point. Although you may have produced a successful sky in one of your recent paintings, it will very seldom work when reproduced in another. Relying on any one method to reproduce a 'stock' sky tends to produce a 'mannered' result, which should be avoided at all cost. Always paint your interpretation of what is actually before you, and never settle for a formulaic, 'safe' option.

Demonstration *Towards Rum and Eigg*

This demonstration was selected not only for its light and atmosphere, but more especially because it illustrates the sky's influence upon the sea. Although this is only a small painting, the subject could easily be interpreted for a larger oil. A simple painting like this is also a good exercise in 'blocking in' without the use of a preliminary drawing.

The recommended palette for this demonstration is three primaries and white, with the addition of a couple of greys used to modify colour and tone.

Step 1.

My motto has always been to keep it simple: a few colours, a paintbrush, and a surface to work on.

Candida Alvarez

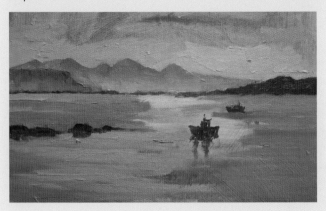

Step 2.

Materials

Board:
- An 8 x 10in proprietary oil board
- Apply one coat of texture paste in the usual way, and when dry, treat with one coat of white acrylic primer

Brushes:
Nos 8 and 10 'hog' bristles
No. 3 round sable rigger

Colours:
- Permanent Bright Red, Cadmium Yellow Lemon, Ultramarine Blue, Titanium White
- In addition, 'muck' off the palette from a previous painting was used, and in this case the resultant colour was a mid-toned grey-green

Miscellaneous:
- White spirit
- Kitchen towel

Step 1: Map out the layout
- Because of the simplicity of this painting it is not necessary to draw out the subject.
- Begin blocking in the basic shapes using an underpainting mixed from Permanent Bright Red, Cadmium Yellow Lemon and Ultramarine Blue.

- Thin out these mixes using white spirit so that you are only tinting the board.

Step 2: Commence blocking in
- Start blocking in the distant hills and the lower part of the sky. All that is needed at this stage is a narrow strip of sky to enable you to make an accurate tonal comparison with the distant hills.
- The hills were painted with mixes of Ultramarine Blue, a small amount of Permanent Bright Red, even less Cadmium Yellow Lemon and Titanium White. The quantity of white in the mixes reduces as the hills become nearer, and slightly more red is used in the closest hills. If you are inexperienced with colour mixing be extremely careful not to overdo the amount of red and yellow in your mixes. Look carefully and you will see that all the colours applied are slightly different shades of blue-grey.
- Continue the process of blocking in for the sea, rocks and boats using the same colours; however, try to intro-

duce more variety to your mixes. This can be achieved by adding a little more yellow in some of the mixes, resulting in a range of subtle grey-greens. More red can be used in other mixes to create 'warm' pearly greys.

- The rocks and boats are painted using varied mixes of predominantly Ultramarine Blue and Permanent Bright Red. A touch of Cadmium Yellow Lemon can again be used, but not in excess.

- Use Permanent Bright Red plus Cadmium Yellow Lemon to paint the warm orange glow on the bow of the nearest boat.

- Be careful not to do too much blending and detail at this stage.

Step 3: Block in the sky and continue with the water

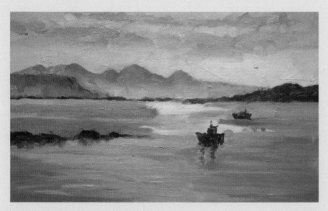

Step 3.

- At this stage, where you have established the greater part of the water, you can now start painting the sky. You should be aiming for subtlety, and therefore care needs to be taken. You could easily be tempted into painting an overdramatic, colourful sky, thereby destroying the harmony and tranquillity of this scene. Don't give in to these temptations, and stick with your original concept, as often more can be achieved with less colour.

- When painting the sky, allow the 'warm' under-painting to show through in some places, and use a touch more red in some of the cloud mixes to hint at a very soft sunset.

- To achieve depth and realism in your sky, paint the clouds using rapid brush marks, applying thick 'impasto' marks to some of them.

Step 4: Add sparkling light, and work on edges
- You will now need to work on the 'magic' part of the painting – the sparkling light on the water. The main

area of light and the smaller 'twinkling' flecks of light should be applied with 'impasto' (thickly applied) paint. When light strikes this thickly applied paint, the effect of sparkling light will be created.

- Try to avoid the use of pure white when applying these effects. There is no pure white in nature and it seldom looks convincing when used in a painting. Add very small amounts of yellow, red, orange or blue to the white, and you will achieve more realistic effects. You will need to experiment with these mixes and their application to achieve success.

- Now that you have covered the entire painting surface, step back from your work to assess and evaluate. Consider the success of the composition and whether your eye is led convincingly into the painting. Do any edges need enhancing or softening? Generally speaking, reserve most of your sharper, cleaner edges for the 'lead in' and 'focal point', and soften overly insistent edges around the extremities of the painting. The main boat and sparkling water should have the sharpest edges and highest contrast; the rocks, their reflections and the distant hills have softer edges.

- If you feel you need to make any alterations, do so now, then add the final details, such as the masts and sails.

Paint as many of these simple paintings as possible. Use a limited palette of primary colours, and without compromising the quality of your work, try to speed up your decision making and execution. All painters work at different speeds, and how long a painting takes to complete is not generally that important. However, should you want to develop your abilities as a *plein air* painter, speed becomes an important factor. Aim to complete a painting such as this within one to one-and-a-half hours.

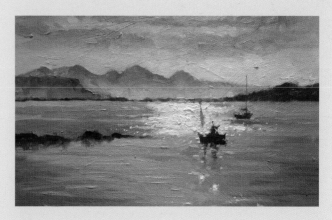

Step 4.
Towards Rum and Eigg *Oil, 25 × 20cm (10 × 8in).*

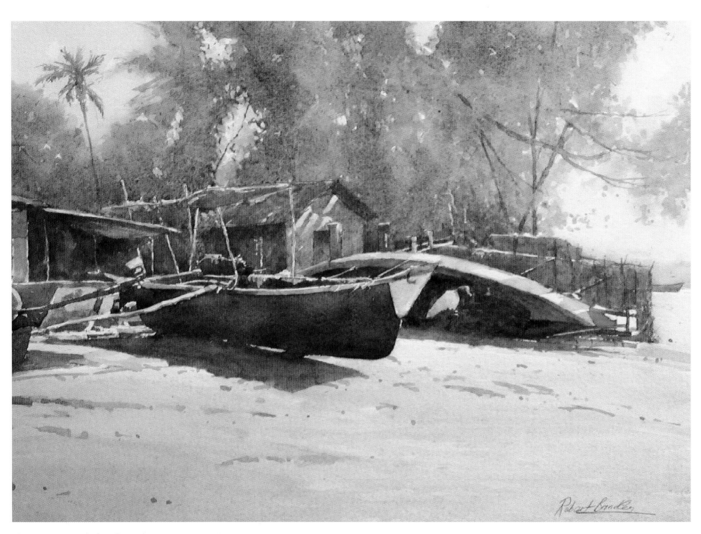

Cocoa Beach/Goa *Watercolour, 38 × 25cm (15 × 10in).*

TRAVEL AND PAINTING TRIPS

There is nothing like travel to stimulate an artist's creativity. It provides the opportunity to expand your knowledge and develop your skills in numerous ways. Broadly speaking the British Isles offer a variety of subtle light and colour to the painter; in particular Cornwall, the west coast of Scotland and a few other locations have a combination of really special light, colourful seas and beaches. This light and colour drew many groups of artists to Newlyn and St Ives in Cornwall around the turn of the twentieth century, and even today Cornwall remains a magnet for artists.

There is nowhere better in the world than the British Isles for the watercolour artist with the desire to paint mood and atmosphere, rich green landscapes and close-toned winter scenes. But should you want to paint a variety of more exotic coastal scenery with the qualities of intense light and colour, this can generally only be found in other countries around the world.

This chapter will cover travel, both at home and abroad, discussing locations that offer a wide range of subject matter to the coastal painter. Recommendations for painting locations, advice on any alternative materials you may need when painting abroad, together with step-by-step demonstrations for you to follow, will be included. In addition, a little background history of the places will be given, together with any special qualities they may offer to the painter.

Goa

Goa is a wonderful place to visit, especially if you love painting coastal scenery. It is an Indian state with many long, sweeping beaches, crammed full of all manner of interesting subjects to paint. Many of the fishing boats are constructed from hollowed-out tree trunks, and painted in an amazing array of colours. Figures dressed in colourful silks or dazzling white linen are always to be found walking on the beaches, or playing in the surf. In addition, numerous cows wander freely, looking for a tasty treat from holidaymakers' beach bags.

The Goan people are extremely friendly, and welcome all visitors with open arms, so when you are painting it is not uncommon to attract a large group of onlookers, especially children. They are all extremely polite and genuinely interested. Children will be very pleased and excited to receive biros or pencils.

The best time of the year to visit Goa is from November to March when the heat and humidity are bearable; at any other time of the year the climate could prove too hot for most painters.

The watercolour *Cocoa Beach/Goa* is typical of the type of subject matter found along the Goan coastline. The boats are viewed from a low viewpoint against a backdrop of colourful beach huts and hazy light.

Venice

Venice is sometimes described as the 'most beautiful city in the world', and most artists would have no argument with this bold statement. Renowned painters such as Turner, Whistler, Sargent and, in more recent times, Ken Howard have been inspired by Venice, returning many times. The oil painting *Towards the Dogana/Venice* depicts the sparkling early morning light looking across the mouth of the Grand Canal; this busy location has been the subject of many paintings over the years.

The city offers a huge variety of subject matter, which takes on different moods and atmospheres at different times of the year. The spring can be a delight, with days of long sunshine interspersed by cloudier days that still offer good light for the painter. Autumn can be quite special, with moody morning mists allowing the rising sun to filter through, bathing everything in a golden haze. The watercolour painting *The Lagoon/San Lazzaro Island/Venice* shows a typical autumn morning with the haze just lifting from the lagoon. It is also in the autumn that what Venetians call *aqua alta* occurs, when the seasonally high tides flood certain areas of the city, and tourists and locals alike have to cross them on duckboards, several feet above the water surface.

Built on many small islands and dissected by hundreds of canals, the entire city is subject to the tide. It is divided

Demonstration *Goan Boat*

This demonstration is of a brightly painted fishing boat, pulled on to the beach, in front of one of the many shacks to be found on every Goan beach. The very low viewpoint accentuates the drama in the composition by thrusting the prow of the boat high into the picture plane, boldly crossing the line made where the beach meets the trees.

Step 1.

Materials

Canvas board:
- Apply one coat of texture paste applied with a 25mm 'hog' brush
- Apply one coat of white acrylic primer
- Treat the board with a weak wash of Burnt Sienna diluted with painting medium or turpentine

Brushes:
Nos 4, 6, 8 and 10 'hog' bristles
No. 3 round sable rigger

Colours:
Permanent Bright Red, Cadmium Yellow Lemon, Ultramarine Blue, Titanium White, and three greys mixed from the above primaries plus white:
- Grey 1: A 'warm' light-toned grey
- Grey 2: A 'cool' light-toned grey
- Grey 3: A dark neutral grey

Miscellaneous:
- Low-odour solvent
- 2B pencil
- Palette knife
- Copious supply of kitchen towel
- A glass palette, 38 x 54cm, that is easy to keep clean

Step 2.

Step 1: Drawing out
- Use a 2B pencil to draw a simple outline of the subject.
- Don't be concerned with any unnecessary details, because once 'blocking in' commences much of the drawing work will be lost.

Step 2: Start with the largest shape and simple colour
- Choose the largest and most important shape, in this case the boat, generally using only dark and medium tones. These tones are a series of warm and cool greys, plus the first indications of the reds and yellows that decorate the boat.
- Don't be tempted to paint too accurately because this is only the blocking in stage.

Step 3: Add lights to establish the range of values
- Begin to establish the range of values in the painting by placing the 'lights' on the boat. In this particular painting it is essential to do this at an early stage so that virtually everything that is painted from this point on will fall between the lightest light and darkest dark already used.

Step 3.

- The 'lights' of the boat are once again mixes of warm and cool greys. (The pre-mixed greys enable you to achieve the required mixes far more quickly.)
- Mix yourself a series of greens ranging from light to dark and 'warm' to 'cool'. For the warmer greens, add a small amount of red to the yellow before adding blue. The cooler greens almost mix themselves because the Cadmium Yellow Lemon is a cool yellow.
- Be careful not to over-use white when lightening your mixes; it's very easy to make them appear chalky. Instead, try using a little more yellow in the mix, thus raising the chroma slightly.

Step 4: Develop the background

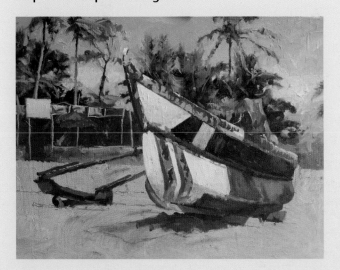

Step 4.

- Notice that each shape is developed in relation to the adjacent one. Bearing this in mind, begin to block in the background trees, sky and beach shack. The foliage masses should be treated almost abstractly, and some edges should be softened into the sky to make sure that this area doesn't attract too much attention.
- Block in the beach shack, making sure that the rich darks inside the shack relate tonally to the darks on the boat. Keep them slightly lighter in tone to maintain tonal balance.

Close-up.

- The close-up shows how to handle the foliage masses. Treat the foliage in an abstract manner with some blended edges. Note also how well the 'warm' Burnt Sienna ground works underneath the blue of the sky.

Step 5: Complete blocking in and make final adjustments
- Block in the beach using a variety of warm and cool light tones, relating these tones once again to everything surrounding them.
- Paint the shadow of the boat in several shades of blue-purple, ensuring that the shadow becomes lighter the further it is from the boat. When painting shadows always make the colour a slightly bluer version of the surface it is cast over, in this case the beach. Look for reflected light, which is often bounced into shadow areas from adjacent objects.
- Spend some time adding detail where necessary, without getting over-fussy. The name on the boat and the sign writing are important details; however, remember that if you over-detail these elements and your painting is loosely rendered, a mismatch of styles will result.

Demonstration *Goan Boat* (continued)

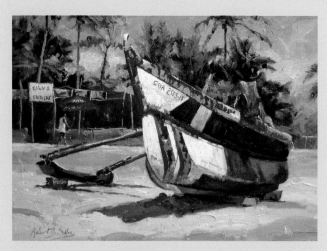

Step 6.
Goan Boat *Oil on board, 30 × 40cm (12 × 16in).*

- Give attention to the blending and softening of edges, as a painting with too many sharp, eye-catching distractions never quite works.
- In the close-up, notice how the textured, under-painted board assists the brush marks used, thus creating textural interest in the beach and shadow. Note also the colours and tonal changes used in painting the shadow. Also indicated is a small area of reflected light, or 'light bounce', in the bottom of the boat. This is caused by the colour of the sand being reflected back up into the shadow area.
 - Keep your eyes open for reflected light in all your subjects. In some cases this effect is more dramatic, and subsequently more important to the success of your painting.

There is strong shadow where there is much light.
Johann Wolfgang von Goethe

Time Out for Assessment

At regular intervals throughout the painting process take several minutes to assess whether or not your painting is developing on the right lines. Ask yourself:

- Is the composition working?

- Does the tonal sequence work?
- Is there too much emphasis in areas of least importance?
- Does the eye travel through the painting?
- Do any of the colours jump out too much?

If you are not satisfied with any of these points, make the necessary changes immediately. To attempt to correct too many faults at a later stage will be much more difficult, and in some cases may require you to repaint the entire picture. Use a mirror to help you to evaluate your painting. A mirror laterally inverts any image, making you see the painting completely differently, and it often highlights any problem with the drawing, composition or any imbalance in the painting.

Step 6: Further evaluation and reflection

- After several days living with the painting and reflecting on the success or otherwise of the completed piece, you may decide to make changes. Never worry about making changes to your work, many artists do this, and it is often said that a painting is never finished, just in a state of flux.
- In the case of this painting, the following changes were made after the painting had been hanging on the studio wall for several weeks:
 - A plastic soft drinks crate was added to support the boat's outrigger.
 - A figure was added to give life to the scene.

Reflected Light

Shadow and texture.

Towards the Dogana
Oil on board,
25 × 30cm
(10 × 12in).

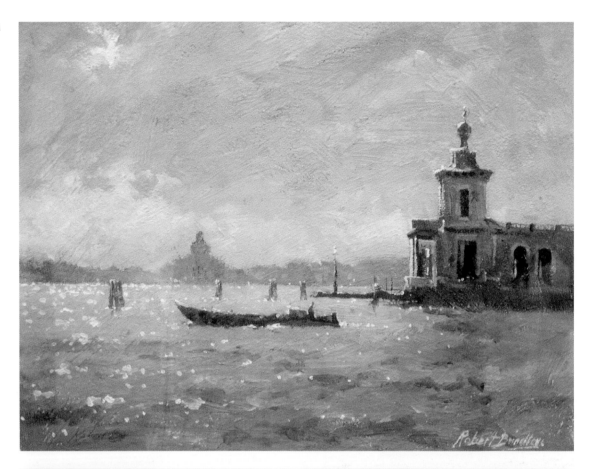

The Lagoon/
San Lazzaro Island/
Venice *Watercolour,*
38 × 25cm
(15 × 10in).

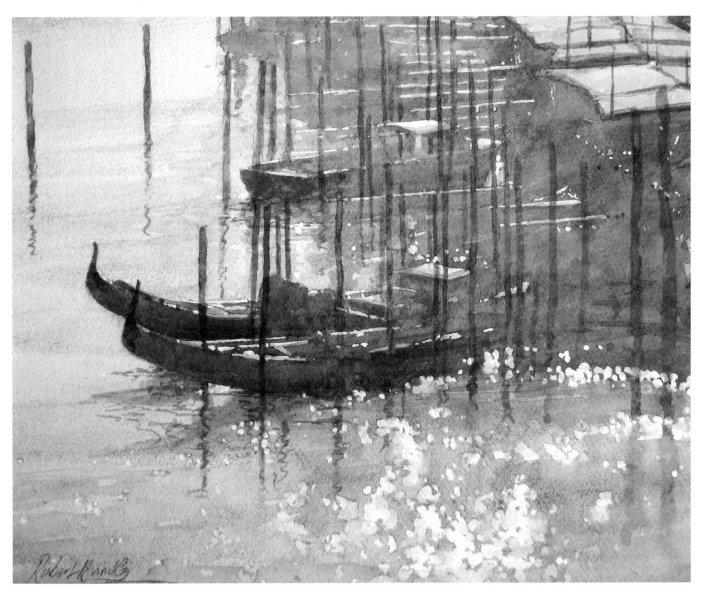

Sparkling Light/Rialto *Watercolour, 25 × 20cm (10 × 8in).*

into six areas, known as *sestieri*: San Marco, Castello, Cannaregio, San Polo, Santa Croce and Dorsoduro. Many of the well known landmarks and sights lie in the areas of San Marco, San Polo and the Dorsoduro and are therefore often overcrowded by tourists. The watercolour painting *Sparkling Light/Rialto* depicts the sparkling light that can be observed from the Rialto Bridge on any clear evening throughout the year: a truly magical effect. However, there are numerous painting subjects to be found in the quieter areas of the city, and in many cases these locations offer refuge to the more reserved painter from onlookers and tourists who may disturb their concentration.

For the coastal painter who loves to incorporate buildings and structure into their work, Venice is a 'must visit' location. If it is your first visit, aim to stay for at least five days because you will need time to explore and acclimatize before you begin any serious work.

You will be amazed at how many secret side canals are to be found, all offering the painter wonderful subjects.

The Lagoon

A trip on the lagoon is recommended, and the following locations offer a variety of subject matter that is completely different to that found in the city.

Demonstration *Sparkling Light/Grand Canal/Venice*

This step-by-step watercolour demonstration is an example of light similar to that depicted in *Sparkling Light/Rialto*, but in this case observed at around eight o'clock in the morning from Calle del Dose da Ponte, which gives access to the edge of the Grand Canal at water level. This location is perfect for the painter who prefers to work in peace and quiet, and is the only place from where this particular view can be observed. Light effects such as this never last too long so you would need to work quickly if you are working on site.

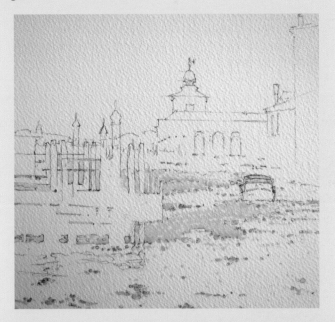

Step 1.

Materials

Paper:
Arches block of 140lb watercolour 'Not' paper

Brushes:
- Nos 4, 6 and 8 round sables
- No. 2 rigger
- A worn 'hog' oil-painting brush to soften the edges of masking fluid

Colours:
14ml tubes of Winsor and Newton artists' quality watercolour in the following colours: Raw Sienna, Burnt Sienna, Cobalt Violet, Cobalt Blue, Cerulean, Ultramarine Blue, Viridian and Light Red

Miscellaneous:
- Masking fluid
- 2B pencil
- Eraser
- Kitchen towel

- Consider very carefully where you need to apply the fluid, as intermediate lights, surrounded by darks, may also require masking out.

Step 2: Mix colour pools and apply the 'wet-into-wet' overall wash

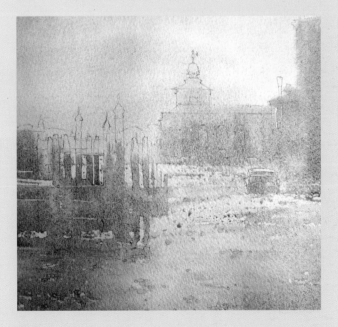

Step 2.

Step 1: Drawing out
- Use a good quality 2B pencil to draw out the subject. For a successful and accurate rendering of the first wet-into-wet application of colour, a good drawing will be required to ensure there is no hesitation when placing the colour at this vital stage.
- At this time study the photograph very carefully and decide whether or not you will use masking fluid to hold the 'lights' in your painting. Should you decide to paint very wet-into-wet you will almost definitely have to use masking fluid.

Demonstration *Sparkling Light/Grand Canal/Venice (continued)*

- In order to respond rapidly when the painting process begins, the following colour pools were prepared in advance:

Pure colours
Raw Sienna, Cobalt Violet (one weak and one slightly stronger), Cobalt Blue, Cerulean, Viridian

Colour mixes
- Raw Sienna plus Cobalt Violet
- Two mixes of Raw Sienna plus Light Red (one strong and one weak)
- Two mixes of Cobalt Blue plus Light Red (one strong and the other weak)
- Ultramarine Blue plus Burnt Sienna
- Burnt Sienna plus Ultramarine Blue

The final two mixes should be mixed much stronger than all the others as they will be used in the jetties and nearer buildings.

- The paper can now be dampened with clear water. This will allow you to introduce the colours, from light to dark, weak to strong, at a controlled pace with enough time to avoid any hard edging or run-backs.
- Raw Sienna, Cobalt Violet and the mixes of Raw Sienna plus Light Red were added to the bottom of the sky, with Cobalt Blue added to the top of the sky. All the above colours can be applied at this stage, with the exception of the last two stronger mixes.

TIP

- Work as quickly as your experience allows in this wet-into-wet stage.
- Always apply your colour mixes from light to dark and weak to strong.
- Never add a weak mix to a drying stronger mix, or continue adding colour if the paper begins to dry out, as this always leads to hard edging or run-backs.
- You can suspend the introduction of colour at any time should any staining occur. If the staining worsens during the natural drying of the paper, dry the painting off quickly by using a hairdryer in order to speed up the drying time and halt the staining.
- Remember to be positive, don't panic, and never try to correct hard edging or run-backs by 'fiddling' on drying paper with a very wet brush.

Step 3: Introduce colour mixes to distant landscape and buildings
- When the painting is completely dry, introduce a varying wash of Cobalt Blue and Cobalt Violet to the distant landscape.
- When this wash has dried, introduce the following mixes to the buildings: Cobalt Blue plus Light Red (both mixes), Ultramarine Blue plus Burnt Sienna, and Burnt Sienna and Ultramarine.

Colour pools.

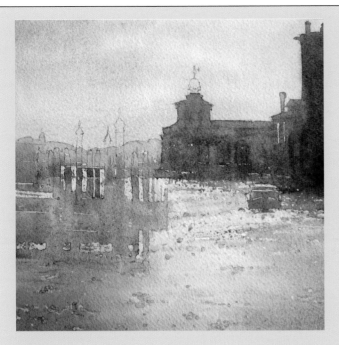

Step 3.

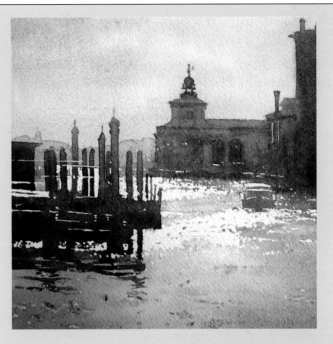

Step 4.

- All colours can be applied on to dry paper at this stage, but remember to introduce one mix into, or against another to create variations of tone and colour at all times. Use your own discretion to retain areas of the first wash untouched by this application of colour. Learn to recognize when your previous washes 'say' everything you intended them to, and therefore need no further application of colour.

Step 4: Introduce colour mixes to the jetty and its reflections
- Apply the following mixes in the order listed to dry paper: Cobalt Blue plus Light Red (stronger mix), Ultramarine Blue plus Burnt Sienna, and Burnt Sienna plus Ultramarine Blue.
- Encourage the mixes to fuse naturally on the paper without over-working.
- When the paper is completely dry, carefully remove the masking fluid from the top two-thirds of the painting.
- Develop the windows of the Dogana at this stage.

Step 5: Soften the edges of the masking fluid and complete the painting
- Dampen the hog brush with clean water and carefully soften some of the harsh edges where the masking fluid has been removed. At the same time introduce a little Cobalt Violet and Raw Sienna to some of these softened

edges. This technique diffuses edges and places a 'glow' to these softened edges.
- Repeat this procedure for some of the sharpest edges on the jetty and boat.
- Using Cobalt Blue, Viridian and Cobalt Blue plus Light Red, introduce additional broken washes into the foreground water to simulate movement and small waves.

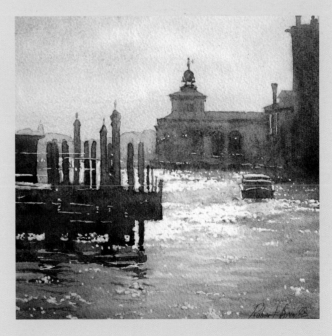

Step 5.

The Lido

The Lido, although only a fifteen-minute waterbus ride from Venice, has a completely different feel and was once looked upon as a bulwark against the Adriatic Sea. The long stretches of open, sandy beach may be appealing to some painters, especially during the summer months when they are bustling with activity. Many of the beaches are private, but some are available for public use. The bustling waterfront where visitors arrive from Venice could be the inspiration of a painting, capturing the to-ing and fro-ing of a huge variety of watercraft.

Pellestrina

Not far from the Lido, via Alberoni, is the small, picturesque fishing village of Pellestrina. The fishing boats moored in Pellestrina are beautifully coloured and a delight to paint.

Chioggia

The bustling port of Chioggia can be reached by a short ferry ride from Pellestrina. It lies on the southern lagoon attached to the mainland. Fishing has always been its major industry, with families setting huge store by their boats, the *bragozzi*, flat-bottomed, colourful craft about twelve metres long. The old town spreads out over two islands, separated by the Canal Vena. Artists flock to Chioggia from all over the world to sample its beauty and variety of subject matter. It is a popular destination for organized painting holidays, and groups of students can often be seen painting with their tutor.

All the above destinations could quite easily be visited in one day.

Burano

Burano is a small island tucked away in the northern lagoon. Its canals are flanked by gaily painted, low-rise houses, making it a special attraction for painters. Tradition says that the fishermen painted their houses in blues, reds and golds so they could distinguish them when they were out fishing. The village will give you a real flavour of life in a Venetian fishing community.

The wonderful combination of pure colour together with fishing boats moored alongside the canals ensures that you will find many painting subjects in this beautiful village. Consider using pastels to represent the strong colours of the houses and fishing boats.

Towards Burano from Torcello *Oil, 25 × 30cm (10 × 12in).*

The Blue Boat/Mesongi *Oil on board,*
18 × 13cm (7 × 5in).

Torcello

This remote, marshy island lies in the northern lagoon, close to Burano. To avoid the many tourists visiting the island, take an early or late boat from Burano; you will then be able to paint without distraction.

From the Byzantine Basilica, the oldest building in the lagoon, a 360-degree view of the lagoon can be observed. From the top, Venice can be seen clearly in the distance. The narrow, weaving network of canals dividing the island provides a demanding challenge to the painter when viewed from above. There are many quiet waterside locations where you will be able to settle down to paint in perfect peace.

The oil painting *Towards Burano from Torcello* was painted from the Campanile on a beautiful sunny morning, looking across the lagoon.

Corfu

The island of Corfu lies in the north of the Ionian Sea and, unlike many other Greek islands, is noted for its lush greenery – it is reported to have more than three million olive trees – flower-strewn countryside and breathtaking coastal scenery. It is known as the 'Garden Isle'. The seas are deep blue and crystal clear.

The north of the island, and in particular the east coast, offers the coastal painter a mouth-watering kaleidoscope of rugged, tree-covered cliffs, wonderful coves, coastal villages and beaches. Look out for painting locations with exhilarating views from the clifftops; these subjects often provide a much better design and enable you to accentuate perspective, thus creating a more exciting painting. The remote parts of the south and west coasts reflect a timeless charm where painters can work undisturbed for hours.

Should you like to paint sunsets, head for the west coast in the early evening and be prepared to work quickly to capture some of the most spectacular light effects you will have ever experienced.

The following locations are suggestions where you will be sure of finding the most rewarding subject matter. There are, of

Demonstration *Kalami/Corfu*

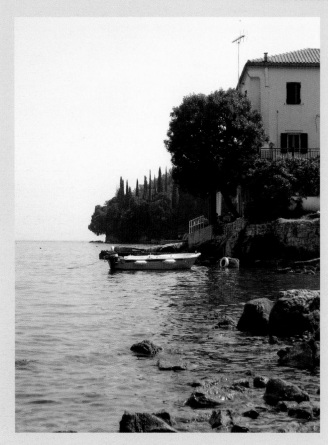

The reference photograph for Kalami/Corfu.

The imposing white building in this painting of Kalami was the home of Lawrence Durell at the time he was writing *Prospero's Cell*. It is now a famous restaurant. The photograph was taken around midday, with high, direct light.

Materials

Paper:
Whatman 200lb 'Not' watercolour paper

Brushes:
- Nos 4, 6 and 8 round sables
- No. 2 rigger
- A worn 'hog' oil-painting brush to soften the edges of masking fluid

Colours:
- 14ml tubes of Winsor and Newton artists' quality watercolour in the following colours:

Raw Sienna, Burnt Sienna, Raw Umber, Cobalt Blue, Cerulean, Ultramarine Blue, Permanent Magenta and Viridian
- A 14ml tube of Holbein Cobalt Violet

Miscellaneous:
- Masking fluid
- 2B pencil
- Eraser
- Kitchen towel
- A tube of white gouache
- Derwent pastel pencils in Naples Yellow, White, Light Grey, Medium Grey, Magenta

Step 1: Drawing out
- The whiteness of Whatman paper was a determining factor when considering this watercolour painting, because the intense overhead midday light demanded the lightest of papers available.

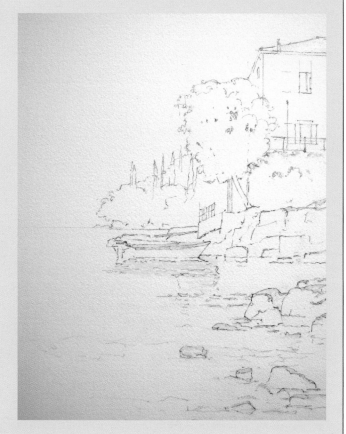

Step 1.

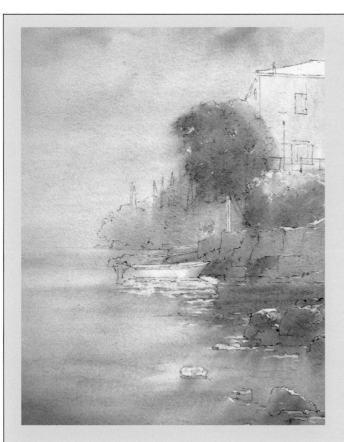

Step 2.

- Use a good quality 2B pencil to draw out the subject. As usual, a good drawing will be required to ensure that there is no hesitation when placing the colour.
- Apply the masking fluid to all the obvious lights, such as the top of the boat and its reflection, the tops of all the rocks, and the small number of 'sky holes' in the large tree. In this instance masking fluid was also applied to the orange roof (preventing the sky wash contaminating this area), and the lighter areas of the foliage and stone wall.

Step 2: Mix colour pools and apply a 'wet-into-wet' overall wash

Pure colours
Raw Sienna, Raw Umber, Cobalt Violet (one weak and one slightly stronger), Cobalt Blue, Cerulean, Ultramarine Blue, Viridian

Colour mixes
- Raw Sienna plus Cobalt Violet
- Raw Sienna plus Permanent Magenta
- Cobalt Blue plus Permanent Magenta
- Raw Sienna plus Burnt Sienna
- Two mixes of Burnt Sienna plus Cobalt Blue (one strong and one weak)
- Burnt Sienna plus Ultramarine Blue
- Ultramarine Blue plus Burnt Sienna
- Cobalt Blue plus Permanent Magenta plus Raw Sienna

- The above mixes are listed starting with the weakest and ending with the strongest mixes. As usual the pre-dominant colour is named first.
- The paper can now be dampened with clear water and the colours introduced, from light to dark, weak to strong.
- Raw Sienna and Cobalt Violet were added to the sky and distant hazy trees.
- Cobalt Blue, Cerulean, Viridian and the mixes of Cobalt Blue plus Burnt Sienna and Cobalt Blue plus Raw Sienna were added to the water.
- The greens in the trees were introduced by adding the following unmixed colours to the damp paper: Raw Sienna, Raw Umber, Cobalt Blue and Ultramarine Blue.

Step 3: Modelling distance and the middle ground

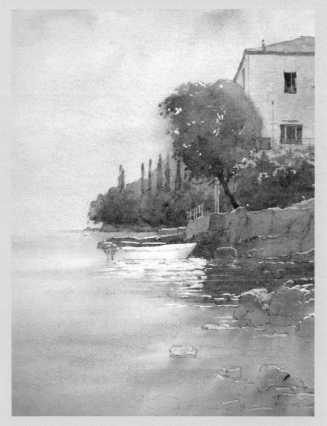

Step 3.

Demonstration *Kalami/Corfu (continued)*

- Working on dry paper, introduce Raw Sienna plus Cobalt Violet, and Cobalt Blue and Raw Sienna to the distant trees.
- When dry, remove the masking fluid within the foliage and tree areas, then introduce Raw Sienna, Cobalt Blue, Viridian and Ultramarine Blue, allowing the colours to blend softly, ensuring that no hard edges are created within the volume of the foliage masses.
- At this stage, distance is created in the painting by using dark mixes and sharper edges on the left-hand side of the main tree. Whilst adding colour to these foliage masses, some of the hard edges left by the removal of the masking fluid can be softened.
- Still working on dry paper, begin to develop the stone jetty behind the boat and the sea wall using washes of Raw Sienna, Raw Sienna plus Permanent Magenta, and Cobalt Blue plus Permanent Magenta.
- The deep reflections below the sea wall can be added using Cobalt Blue, Raw Sienna plus Viridian, and Cobalt Blue plus Permanent Magenta.

- The distant cypress trees should be completed using Cobalt Blue plus Raw Sienna, and the roof of the white house painted using Raw Sienna and Burnt Sienna.
- Finally paint in the windows using two mixes of Ultramarine Blue plus Burnt Sienna, one weak and one strong. Make sure these two mixes lean more towards Blue. The 'Derwent' pastel pencils may be used for some of these details.

Step 4: Develop the foreground
- Develop the rocks using the mixes of Raw Sienna plus Cobalt Violet, Burnt Sienna plus Raw Sienna, Burnt Sienna plus Cobalt Blue, and the two mixes made from Burnt Sienna plus Ultramarine Blue.
- To achieve convincing rock forms, the accurate rendering of tonal relationships, and 'warm' and 'cool' colour, is essential.

Step 5: Completing the painting
- This stage deals with the completion of the painting

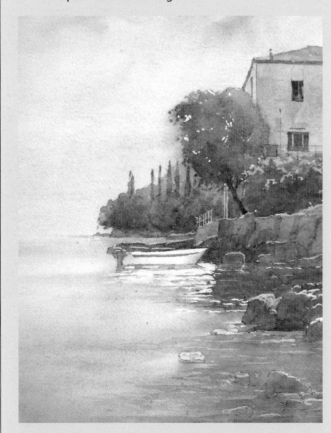

Step 4.

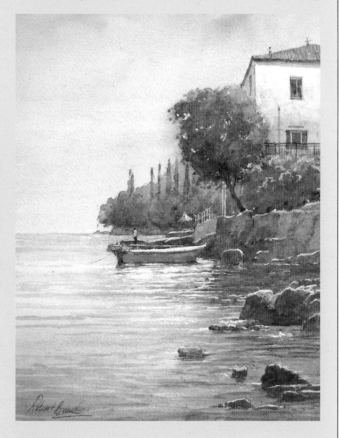

Step 5.
Kalami/Corfu *Watercolour, 23 × 28cm (9 × 11in).*

using many of the colour mixes and methods outlined in the previous steps. Before you apply any further paint, all the remaining masking fluid should be removed.

- Continue to work on the rocks and their reflections as described above, but at the same time softening some of the hard edges left by the removal of the masking fluid.
- Revisit the sea wall and add texture, creating the illusion of blocks of stone. This can be achieved by adding Cobalt Blue, Raw Sienna and Cobalt Violet in transparent glazes on dry paper. It may be that you need to let some of these applications of colour dry before adding more; on the other hand, you may be able to get the desired effect by painting the colours into each other 'wet-into-wet'. Experiment with the suggested colours and their application, either 'wet-into-wet' or 'wet-on-dry', to achieve the desired results.
- The boat can now be painted with Raw Sienna, Burnt Sienna and Cobalt Blue. Be careful not to use too much Cobalt Blue when painting the shadow and reflected light from the water, as the boat will lose its purity of colour. You may find this easier to achieve by introducing the Raw Sienna and Burnt Sienna first, and then letting the paper dry. Once dry, a very transparent, clean wash of Cobalt Blue can be carefully glazed over the top where needed.
- You will now need to complete the water. To do this, reapply clean washes of Raw Sienna, Cobalt Blue, Cobalt Violet, Cerulean, Viridian and Cobalt Blue plus Permanent Magenta. Once again some of these colours need to be introduced 'wet-into-wet' and others 'wet-over-dry' to create the correct balance of movement and tranquillity in the water surface.

- The wall of the building should be completed at this stage by glazing Cobalt Blue plus Cobalt Violet into the shadow under the eaves, and the shadowy textured area towards the bottom.
- Finally add a little more detail to the windows, and introduce a little texture to the roof suggesting the pan tiles.

On completion of any painting consider the following:

- Does the painting satisfy you with regard to your original expectations? If the answer is no, then you need to consider in what respect it falls short. Start by re-evaluating the composition; sometimes small adjustments can make all the difference.
- Your next consideration should be tone, colour and shape. You may decide that one area of your painting is either incorrect tonally, too 'warm/cool', or maybe some of the edges may need attention. Whatever your conclusion, you will probably need to re-work that area.
- Before making hasty adjustments, look for any less obvious errors, possibly in a quieter passage of the painting, which may be causing problems.

TIP

Before making any adjustments, remember that every action has a reaction. Even the smallest alteration can have a knock-on effect that could prove disastrous, so be sure of your evaluation before taking action.

course, many omissions from this list, but you will experience far more pleasure by discovering them for yourself. As always, early morning and evening are the best time to paint, when the sun is lower in the sky and the temperature more comfortable; occasionally, however, direct overhead light can produce spectacular results.

The small oil study *The Blue Boat/Mesongi* was painted on site at the beautiful coastal village of the same name. This stretch of coast provides the painter with numerous opportunities to paint in a magnificent setting without the distraction of the busier resorts. The board was treated with a generous application of texture paste to enhance the brushwork, and a rich pink ground from a mix of Raw Sienna plus Permanent Bright Red was decided upon to complement the turquoise sea and green foliage.

Kalami

This beautiful, quiet resort should provide any painter with a wealth of subject matter. Around the shoreline are a few palms interspersed amongst the numerous cypresses, olives and eucalyptus trees, and a small jetty with a scattering of fishing boats enhances the setting. The most impressive view is from the top of the hill above the village at the Kalami/Kouloura junction.

Across the channel lies Albania, its coastline made quite dramatic by its majestic peaks.

Demonstration *High Aspect/Paleokastritsa*

The reference photograph for the painting High Aspect/ Paleokastritsa.

This painting was inspired by the breathtaking views on approaching Paleokastritsa from the south, and was an exercise in colour and texture. Some artistic licence was taken when composing the painting by moving the rock stack on the left-hand side further into the painting, thereby reducing the large empty space in the centre. The rock stack was also painted from a second source photograph because it had more sparkling light around its base.

Materials

Board:
Canvas board 16 x 20in
- Apply one coat of texture paste with a 25mm 'hog' brush
- Apply one coat of white acrylic primer

Brushes:
- Nos 4 and 12 'hog' bristles
- No. 3 round sable rigger

Colours:
Permanent Bright Red, Cadmium Orange, Cadmium Yellow Lemon, Ultramarine Blue, Cerulean Blue, Phthalo Blue, Titanium White

Miscellaneous:
- White spirit
- Palette knife
- Kitchen towel

Step 1: Drawing out
- Work loosely using a No. 12 brush and thinned down Cadmium Orange, Permanent Bright Red and Ultramarine Blue for the drawing and initial blocking in.
- The Cadmium Orange and Permanent Bright Red are complementary to the turquoise sea and green foliage, therefore any patches of under-painting left showing through the subsequent layers of paint will add vibrancy to the overall effect.

Step 2: Block in the main dark and medium tones
- To establish the major elements in this painting, mix dark and medium tones for the cliff and rocks using Ultramarine Blue, Permanent Bright Red, Cadmium Orange and Titanium White.
- Even at this early stage look carefully for the 'warm' and 'cool' colour changes in the shadow planes.
- Without too much consideration for accuracy, begin to work on the areas of foliage. At this stage work with

Step 1.

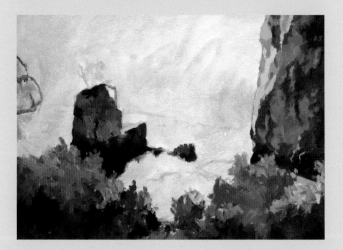

Step 2.

around three or four tones; however, look carefully for changes in colour temperature. Mediterranean trees are quite a vibrant green, so don't be too concerned with the strength of colour, but concentrate on the 'cool' and 'warm' variations.

Step 3: Develop the Sea

- The sea can now be started, enabling you to assess the

> **TIP**
>
> Use bold brush strokes at this stage of the painting, and don't be concerned with blending or detail. Paint in loose blocks of changing tone and colour only.

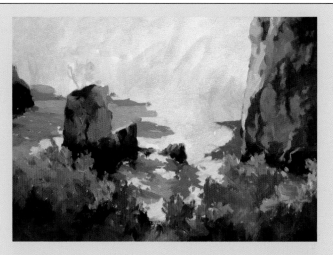

Step 3.

three major elements together. Concentrate on broad brush strokes and simplicity, and don't try to mix too many subtle colour variations.
- Use all the palette of colours for this stage, with the emphasis on blue and blue-greens.
- Use both the yellow and the red sparingly.

Step 4: Complete blocking in and refine shapes and edges

- In this step you will need to finalize the 'block in', place some of the highlights, and begin to add colour variations to all the larger shapes. At the same time soften any edges that appear to be too strident. Attention can also be given to refinement of the drawing if necessary.
- Whenever you can, take regular time out for reflection. This reduces the chances of any obvious errors creeping into your work. This is not always possible when working frenetically against the clock outdoors, and in all honesty is often overlooked completely.

Wonderful things can happen if you put your brush down and let your painting be the teacher.

Charles Reid

Step 5: Further adjustments and reflection

- Begin to work on the smaller shapes, and also introduce more subtle colour changes.
- Add the sparkling water, and pay further attention to the highlights on the rocks and trees.
- Carefully blend in the distant expanse of water, and add the boats and the softer, sparkling water.

143

Demonstration *High Aspect/Paleokastritsa (continued)*

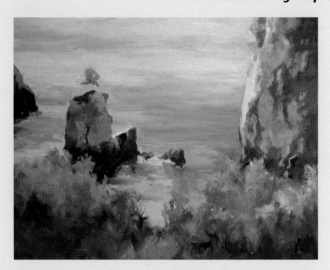

Step 4.

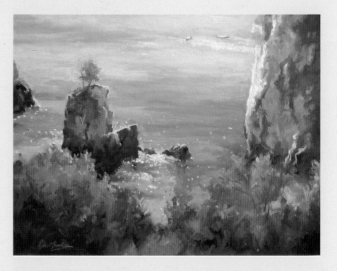

Step 5.

- Add the final touches to the small trees on the top of the rock stack, and a few understated branches to the tree in the bottom right-hand corner.

Step 6: Adjustments after time for reflection
- After several weeks and considerable reflection, a number of issues needed to be resolved concerning composition, tone and colour. The main problem concerned the visual weight, shape and colour of the foliage running along the bottom of the painting. The visual impact of this area was reduced by using lighter, sunstruck greens, and by lowering and splitting the foliage mass, creating a 'way into' the picture and giving more importance to the rock formations.
- The other problem concerned the tonal value of the small outcrop of rock on the extreme left: the tone was reduced, making it less intrusive.
- The 'sparkling' light around the central rock stack was enhanced.
- Further texture and highlights were added to all the rocks.
- A yacht was painted, creating more interest.

The lessons to be learned in this instance concerned impatience, complacency, and the over-reliance on photographic reference. The initial painting reproduced too literally what was actually there, and not enough thought was given to the composition with regard to balance and the creation of a 'path' leading into the painting. The desire to begin painting with insufficient thought resulted in a poorly conceived piece of work with many compositional flaws.

TIP

To enhance your highlights, lay the colour on quite thickly using 'impasto' paint.

To make the water sparkle and the edges of the highlights glow, add a little Cadmium Orange and Cadmium Yellow Lemon to the white.

Step 6.
High Aspect/Paleokastritsa *Oil, 40 × 50cm (16 × 20in).*

Paleokastritsa

Set in the north-west of the island, this location must be a top priority on any painter's agenda. Although it is Corfu's most visited resort, its benefits far outweigh this disadvantage. The resort consists of six beautiful turquoise coves carved out of the rocky shoreline, nestling at the foot of the Arakli hills, on the edge of tumbling olive groves. This resort offers the painter an amazing choice of subject matter, and despite tourism you would have no problem finding many quiet painting locations.

A visit to the monastery, high above the resort, must not be missed; the breathtaking views from the monastery grounds will provide many subjects for you to choose from.

Lakones

This village is very close to Paleokastritsa and its elevated location provides magnificent panoramic views of the spectacular coastline towards Liapedes.

Agious Gordis

This small resort nestles beneath a spectacular outcrop of rock which forms part of the incline to Mount Garouna. The small but beautiful bay is a spectacular painting subject, with white sands beneath soaring cliffs.

Boukari and Messongi

These two coastal villages lie in the south-east of the island, both offering many quiet coastal painting locations along the narrow strips of sandy beach that run between the two resorts.

A Corfu Sketchbook

This section examines and discusses the merits of a selection of small sketchbook studies completed on a holiday in Corfu. Sketches such as these are invaluable reference material for use back in the studio. They can be executed in a very short time, probably spending no more than forty-five minutes on each one.

Although one or two of the sketches have some merit they were not intended to be completed works, just sounding boards and memory joggers for future studio paintings. Two of the sketches under discussion have been developed into completed paintings and are therefore discussed in greater depth and the results analysed.

Breaking Waves *Watercolour sketch.*

Watercolour Sketch Breaking Waves

This sketch was painted on the tideline from a comfortable position on adjacent rocks. The slightly elevated viewpoint was selected to observe the movement and patterns created as the water spilled over the rocks into the foreground.

This type of study is strongly recommended for those of you who wish to paint rocks and moving water. A limited palette of Windsor Blue, Raw Sienna, Lemon Yellow and Alizarin Crimson was used, together with white gouache to create the highlights.

Watercolour Sketch Above the Beach/Corfu Town

This quick watercolour sketch of one of Corfu Town's beautiful small beaches was made from an elevated viewpoint and has all the essential elements needed for a successful painting: rocks, sea, beach, figures, and even an aesthetically pleasing small tree. The elevated viewpoint gives depth and drama to the scene.

LEFT: Above the Beach/Corfu Town
Watercolour sketch.

BELOW: Sparkling Light off Old Corfu Town
Watercolour sketch.

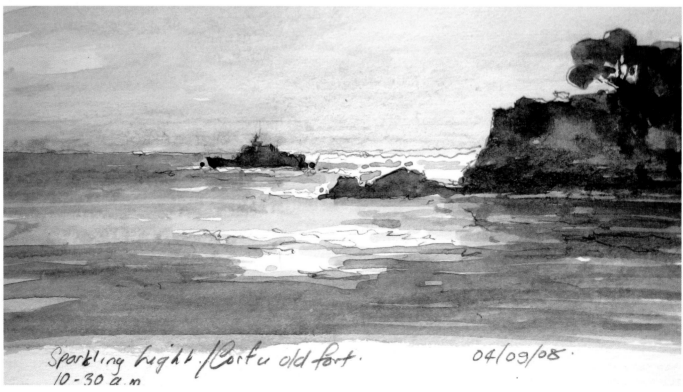

Sparkling Light / Corfu old fort.
10-30 a.m 04/09/08.

Watercolour Sketch Sparkling Light off Old Corfu Town

This watercolour sketch was painted in mid-morning, and surprisingly the water surface was still sparkling, an effect that usually occurs much earlier or later in the day. The shimmering light, hazy distance and deep turquoise water have not been captured very convincingly in this sketch, however the process of making the sketch and backing it up with photographic reference are all that is required back in the studio.

Sketch Rock Formations/Agious Gordis

This sketch is a small study that will be used for a studio painting at a later date. The sketch was drawn using a sepia waterproof pen, and tinted with watercolour for colour notes. Photographs were also taken at the same time, which can be referred to along with the sketch to provide all the information needed back in the studio.

Two Studies of Rock Formations on Agious Gordis Beach

The two sketches Rock Formations/Agious Gordis 1 and Rock formations/Agious Gordis 2 are more studies of the wonderful rock formations on Agious Gordis beach, this time on the north, and much quieter beach. The watercolour sketch is a more considered study and therefore contains a little more information than some of the other sketches. The experience of sketching on site is not only extremely enjoyable, but also very rewarding. There is no substitute for the direct interaction between artist and the subject, and sketches such as these stimulate memory and future inspiration.

Rock Formations/Agious Gordis *Watercolour sketch.*

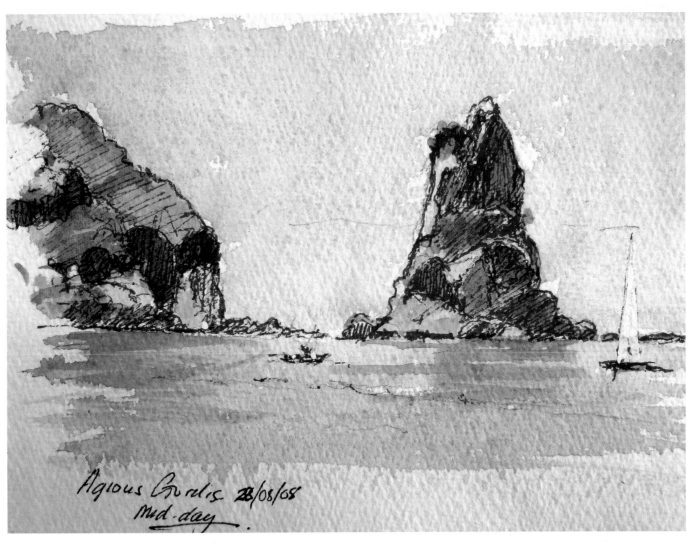

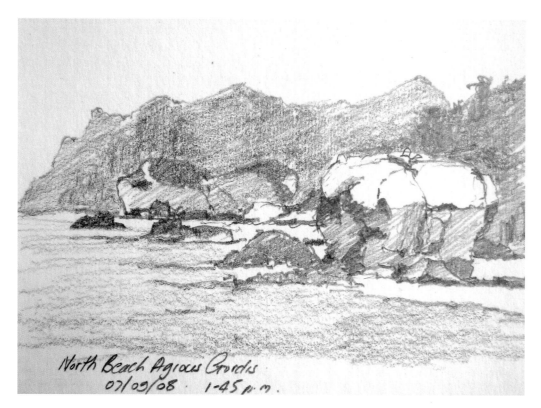

Rock Formations/Agious Gordis 1 *Pencil sketch.*

Rock Formations/Agious Gordis 2 *Watercolour sketch.*

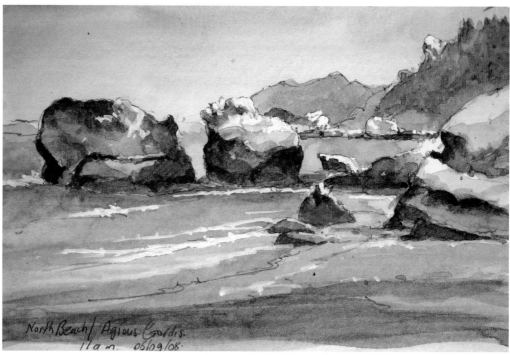

Watercolour Sketches Beach 1 *and* Beach 2

These sketches *Beach 1* and *Beach 2* were sketched on two different papers: white watercolour paper, and beige, heavily textured 'Khadi' paper. The difference between the two paintings is quite striking: *Beach 1* was painted on white paper and is far more transparent than *Beach 2* where 'Khadi' paper and white gouache (applied for the highlights) were used, producing a far bolder and more textural result. By exploring these differences for yourself you will be able to decide which approach to use for different subjects.

Beach 1 *Watercolour sketch on white paper.*

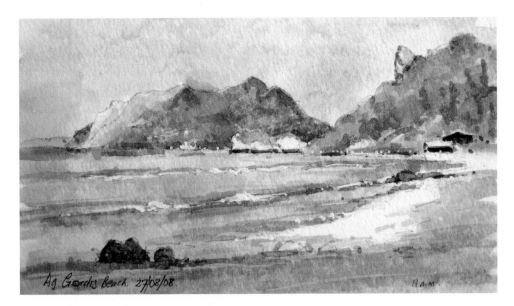

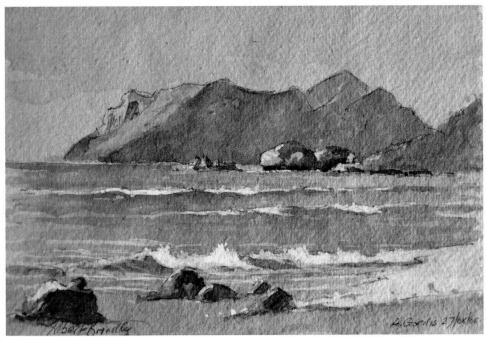

Beach 2 *Watercolour sketch on beige 'Khadi' paper.*

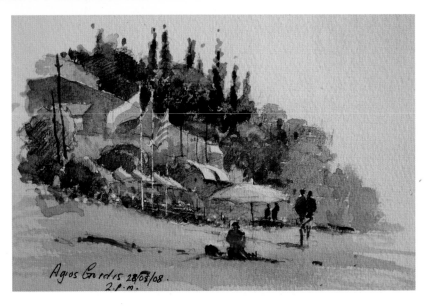

Umbrellas and Flags, Agious Gordis *Watercolour sketch.*

Watercolour Sketch Umbrellas and Flags/Agious Gordis

Umbrellas and Flags/Agious Gordis was created in response to the variety of shapes, colours and figures present. The composition is enhanced by the vertical shapes of the background trees, which in turn are echoed by the tall flags, umbrellas and figurative interest. There were many more figures and umbrellas in the actual scene, but this information, if needed, could be extracted from the photographic reference gathered.

Oil Painting Umbrellas and Flags/Agious Gordis

This oil painting was developed from *Corfu Sketch 9*, and reference photographs. The hazy blue-green background hill was simplified and used as a foil to the tall cypress trees. The painting was loosely handled to capture some of the immediacy of the sketch.

Umbrellas and Flags, Agious Gordis *Oil, 25 × 30cm (10 × 12in).*

Watercolour Painting Excursion Boats/Corfu Town Harbour

This small watercolour was painted in front of the subject. There was an almost overwhelming amount of blue present in the scene, and the only evidence of 'warmth' in the painting comes from the distant coastline of Albania, which looms out of a haze, and the small areas of Raw Sienna and Burnt Sienna used in the boats.

Sketch Beach Study/Agious Gordis

This sketch was painted in an attempt to capture the brilliant colours evident in the scene. The soft blue-greens in the hazy distance create the impression of distance in the sketch, compared to the 'warmer' greens in the mid-distance. These warmer greens, together with the orange-green trees, work extremely well against the deep turquoise of the sea, which in turn has the same impact against the foreground beach.

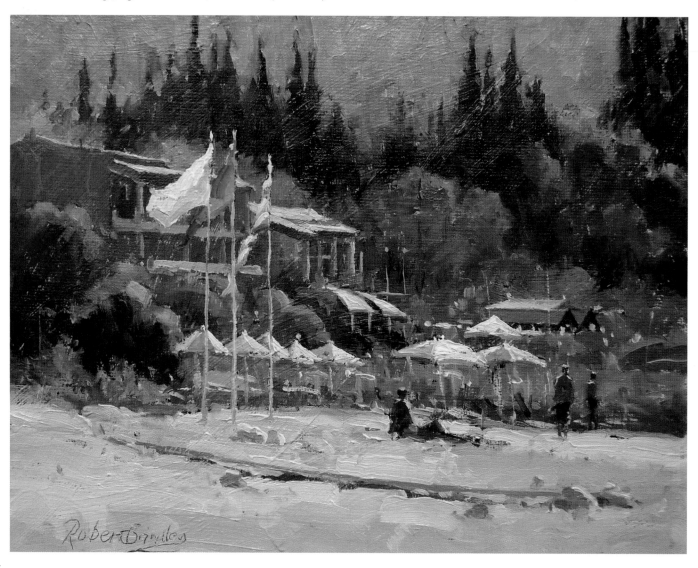

Excursion Boats/Corfu
Town Harbour *Watercolour,
20 × 15cm (8 × 6in).*

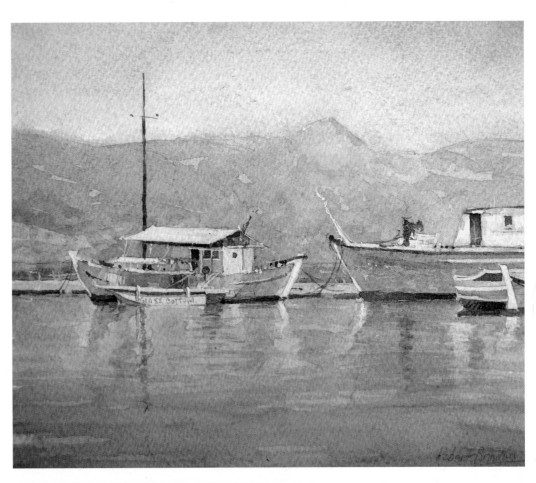

Ag. Gordis Beach looking North. Mid-day.
30/08/08.

Beach Study/Agious Gordis
Watercolour sketch.

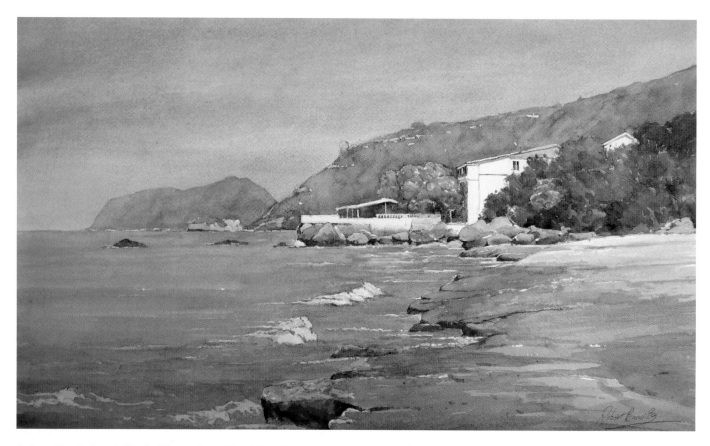

Agious Gordis Beach/Corfu *Watercolour, 50 × 30cm (20 × 12in).*

Watercolour Painting Agious Gordis Beach/Corfu

This painting was developed from sketches *Beach 1, Beach Study/Agious Gordis* and reference photographs. The two sketches were carried out on different days with differing qualities of light. The rocks on the water's edge act as a compositional device by leading the eye into the focal point. The oranges and blue-greens present in *Beach Study/Agious Gordis* were used for the colour harmonies.

On reflection, the painting was a rewarding and fairly successful exercise, capturing the subtle complementary colours and sense of place. The composition works particularly well, the viewer's eye moving effortlessly through the painting to the derelict, white-painted building positioned on the 'golden third'.

Holland

A painting trip around the Wadden Sea and the Ijsselmeer is highly recommended. The Ijsselmeer (pronounced Eye-ssel-mar) is a huge, man-made lake of 1,380 square miles (3,574sq km), the biggest in Western Europe. Formed out of the ancient Zuider Zee, it lies north and east of Amsterdam, which in the nineteenth century was on its shore. In 1932, the Netherlands completed a 19 mile (30.5km) long, barrier dam-dike (Afsluitdijk), blocking off the northern entrance into the Zuider Zee, renamed the Ijsselmeer.

The area can be toured easily by car, boat or cycle. The timeless beauty of the coastal villages, bisected by canals and waterways beneath huge, ever-changing skies, makes this an essential place to visit for any painter. For those with a particular interest in painting a huge variety of boats and sailing barges, new and old, there can be very few places worldwide that offer anything similar within such a small area.

The following small towns and villages abound with subject matter, and a visit is recommended.

Heeg

The beautiful village of Heeg is surrounded by the Frisian lakes and is ideally suited as a base for painting and exploring the area. The large harbour/marina is worthy of exploration, as it provides moorings for many boats, both old and new.

Stavoren

The historic town Stavoren was established in the fifth century BC, making it one of the oldest of the eleven Frisian cities. It remains a busy port today and offers a diversity of subject matter.

Workum

This village is a real 'find' for any painter. The windmill, situated in a field alongside the canal as you enter the marina, makes an excellent painting subject. Unusually this subject is perfect for both an early morning study, with direct sunlight, and a more dramatic, evening study when, in favourable light, the windmill and the distant countryside melt into a deep purple silhouette.

The oil painting *Quiet Moorings/Workum* shows two barges moored at a boat-building workshop, and was painted back in the studio from sketches and photographic reference.

Gaastmeer

This small backwater, set inland amongst the Frisian canals and lakes, is ideal for the painter looking for peace and quiet. The location offers the opportunity to paint sailing barges set in the Dutch landscape. Sails cutting dramatically into huge, fast-moving skies make impressive subjects, as anyone who has admired the paintings of Edward Seago and Ted Wesson will know only too well. The sails punctuate the flat landscape and can be seen for miles.

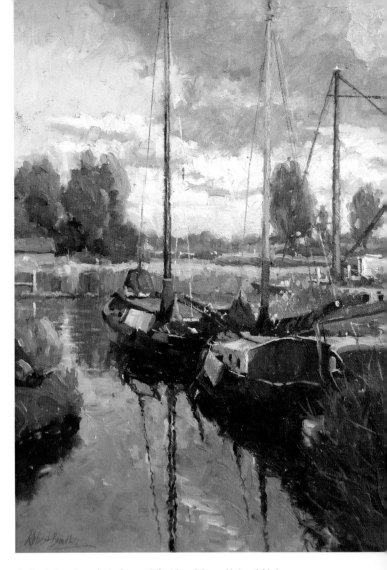

Quiet Moorings/Workum *Oil, 40 × 30cm (16 × 12in).*

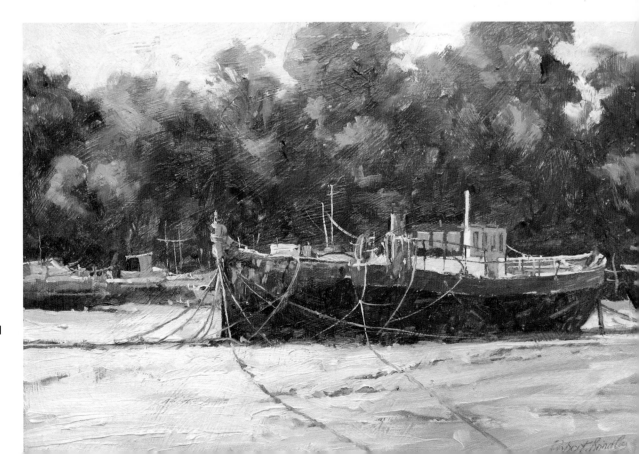

Low Tide/Pin Mill
*Oil, 20 × 30cm
(8 × 12in).*

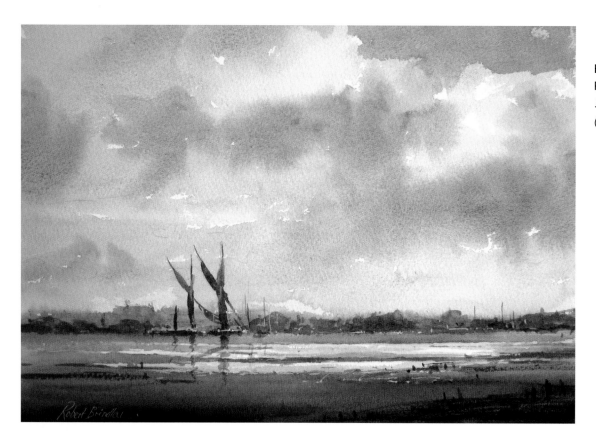

Barges/Blackwater River *Watercolour, 30 × 20cm (12 × 8in).*

England, Scotland and Wales

The East Coast from Maldon to Southwold

The east coast of England from Maldon to Southwold is rich in subject matter and will provide varied painting locations to suit most painters. The area has many attributes: fishing villages, harbours, beaches, and a huge variety of boats to paint. Should you prefer to work in peace and quiet, this area could well suit you. The combination of a relatively flat landscape and big skies lends drama to the coastal scenery.

The oil painting *Low Tide/Pin Mill* is typical of the subject matter to be found in many locations in this area.

Maldon

Maldon is a historic hill town on the Blackwater estuary and has a strong maritime tradition; the town itself has over two thousand years of history. The quayside offers the painter many interesting subjects to work from, and is one of the few places where you are almost sure to find Thames sailing barges.

Heybridge Basin

Located at the end of the Chelmer and Blackwater navigation, the basin was cut out of the marshland to form the sea lock leading to the Blackwater estuary. Today, Heybridge is a haven

for pleasure craft of all ages and sizes. The best time to paint at this location is in the early morning or evening, and at low tide when the dazzling light bounces off the wet mud, as illustrated in the painting *Barges/Blackwater River*. This subject ideally suits the watercolour medium, enabling the artist to capture an atmospheric sky and a fleeting light effect.

A little artistic licence was used when painting this picture by introducing the barges to provide a focal point. The immediate foreground was darkened to create added drama by containing the light effect on the water.

Pin Mill

On the banks of the River Orwell the hamlet of Pin Mill is at the heart of one of Suffolk's areas of outstanding natural beauty. Situated on the Shotley peninsula, this timeless haven of tranquillity is every painter's dream come true. There has been some controversial 'tidying up' done recently, and a few decaying wrecks have been removed, which is a pity, as in some respects the wrecks embodied the character of the place. However, it still remains a unique location where subject matter abounds.

Aldeburgh

Aldeburgh is situated on the River Alde, its name meaning 'Old Fort', although much of this, along with much of the Tudor

Demonstration *The Moorings/Pin Mill*

This tranquil scene of a Thames barge moored at low tide was developed from a small watercolour sketch where tone, colour and composition were tried out before committing to the larger studio painting. Tone and composition were eventually considered a priority, with colour playing a secondary role; therefore only a limited number of colours were used.

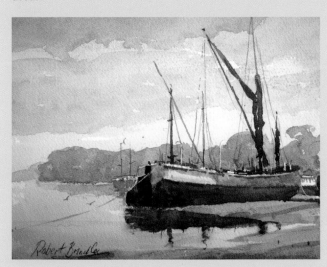

Sketch for The Moorings/Pin Mill *Watercolour,
18 × 14cm (7 × 5.5in).*

Materials

Paper:
Arches block of 140lb 'Not' watercolour paper

Brushes:
- Nos 4, 6 and 8 round sables
- No. 2 rigger

Colours:
14ml tubes of Winsor and Newton artist's quality watercolour in the following colours: Raw Sienna, Burnt Sienna, Light Red, Cobalt Blue, Cerulean, Ultramarine Blue

Miscellaneous:
- Masking fluid
- 2B pencil
- Eraser
- Kitchen towel

Step 1: Drawing out

Step 1.

- Draw out the image with a 2B pencil as usual.
- Make your own decisions on the areas you will need to mask out for protection whilst introducing the first washes; try using no masking fluid at all, if that suits you.
- The water just below the line of distant trees, the dagger-shaped area of water in the foreground, together with a few highlights on the barge, were masked out for the purpose of this demonstration.

Step 2: Mix colour pools and apply the first 'wet-into-wet' overall wash

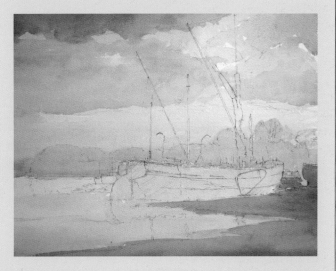

Step 2.

Demonstration *The Moorings/Pin Mill (continued)*

- Prepare the following pools of colour in readiness for the first 'wet-into-wet' wash:
 - Raw Sienna
 - Cobalt Blue
 - Cobalt Blue plus a little Light Red (for clouds in the bottom of the sky)
 - A stronger mix of Cobalt Blue plus Light Red (for other clouds higher in the sky and the backdrop of trees)
 - An even stronger mix of Cobalt Blue plus Light Red (for other clouds higher in the sky and the back-drop of trees)
- Wet the paper all over and apply the above mixes.
- If you decided not to mask out, partially pre-wet the paper where you require some diffusion, and carefully, but as quickly as possible, add colour to your painting making sure that you retain your highlights.
- When the paper has completely dried, paint the clouds and the beach with the mixes itemized above. Never overwork the paint as it is laid on the paper, but allow one wash to flow and intermingle into an adjacent wash freely and naturally.
- Mix Ultramarine Blue plus Light Red and begin to develop the boats on the extreme right of the painting.

Step 3: Begin to paint the barge and develop the background trees

- Carefully remove all the masking fluid, if used, and soften some edges with a damp brush and kitchen towel.
- Mix the following additional colours (these will all be used for painting the barge):
 - Cobalt Blue plus Light Red
 - Ultramarine Blue plus Light Red
 - Two pools of Ultramarine Blue plus Burnt Sienna (one weaker and one stronger)
 - Light Red plus Ultramarine Blue
- Develop the background trees with the mixes from Step 2.
- Paint the barge, applying the paint from light to dark using the 'wet-into-wet' approach, and 'wet-on-dry' wherever each is applicable.

Step 4: Paint the reflections and complete the barge and all its details

- Develop the barge further using all the above mixes. Remember to use the mixes of Burnt Sienna plus Ultramarine Blue, Light Red plus Ultramarine Blue and Ultramarine Blue plus Burnt Sienna to render the sails.
- Paint in the reflections using the same mixes.
- Cerulean Blue was used sparingly to add colour to the stern of the barge, small details on its deck, and on the cabin of the small boat.
- Finally add all the details including rigging, mooring ropes and so on.

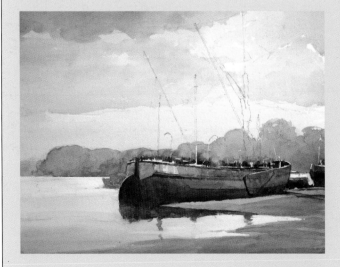

Step 3.

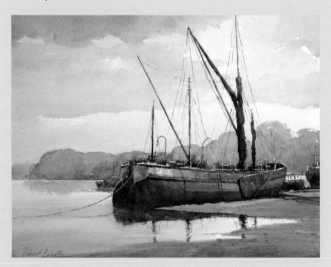

Step 4.

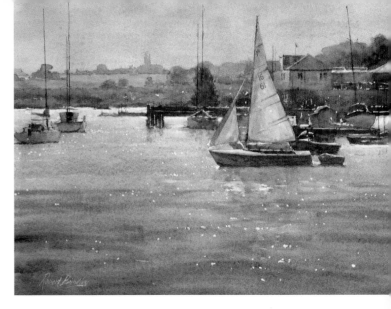

town, has now been lost to the sea. Aldeburgh was a leading port, and had a flourishing ship-building industry. It survived principally as a fishing village until the nineteenth century, when it became a popular seaside resort.

The gently sloping shingle beach, littered with boats and old fishing huts, provides a wealth of painting material.

Woodbridge

Standing on the banks of the River Debden, Woodbridge has a 1,400-year history. The early, restored tide mill, one of only four in the UK, is a prominent feature of the town, and a mill was first recorded on this site in 1170. The community was originally Saxon, and Woodbridge developed into a market town. Ships for the Royal Navy were built here at one time; however, boatbuilding is now restricted to the construction of pleasure craft. The town was also famous for the manufacture of sailcloth and rope.

The initial washes for the watercolour *The Yellow Sail/ Woodbridge* were painted on site, and the painting completed back in the studio. The low evening light illuminated the sail and created a wonderful sparkling effect on the placid water.

Southwold

The beautiful North Suffolk town of Southwold is situated on the Suffolk Heritage Coast. Bounded by the North Sea to the east, the River Blyth and Southwold harbour to the west and by Buss Creek to the north, it is almost an island.

The town offers much of interest to the painter, including its working lighthouse, beach huts, pier, and a wonderful harbour almost unchanged by time.

Walberswick

This renowned painter's paradise has been painted by many familiar names from the past, Edward Wesson and Edward Seago to mention just two. They were both *plein air* painters in oil and watercolour, and revelled in the subject matter to be found in this location.

The village is situated on the Suffolk coast, across the River Blyth from Southwold. Coastal erosion and the moving of the mouth of the River Blyth meant that the neighbouring town of Dunwich was lost as a port in the thirteenth century, and Walberswick therefore became a major trading port until World War I. The village, with its surrounding beach and marshland,

Sparkling Light/St Ives *Watercolour, 25 × 18cm (10 × 7in).*

The Yellow Sail/Woodbridge *Watercolour,*
30 × 23cm (12 × 9in).

has long attracted visitors and painters alike, although it remains a haven of peace and quiet.

Cornwall

Cornwall has some of the most spectacular and diverse coastal scenery anywhere in the United Kingdom. Its wild, rocky coastline boasts wonderful expanses of sandy beaches and quiet coves, and the coastal towns, villages and harbours are without exception 'painterly'. As if this wasn't enough, the tidal creeks and rivers, where you could paint for a whole lifetime, are places where subject matter abounds.

There are hundreds of locations to visit and paint in Cornwall, however the locations described below are strongly recommended.

St Ives

St Ives is a seaside town and port in the Penwith district of Cornwall. The town lies north of Penzance and west of Cambourne, and much of its outskirts are built on steep terrain. It has a picturesque harbour where numerous boats can be

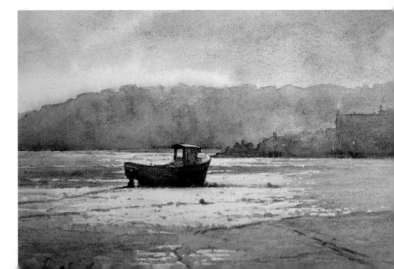

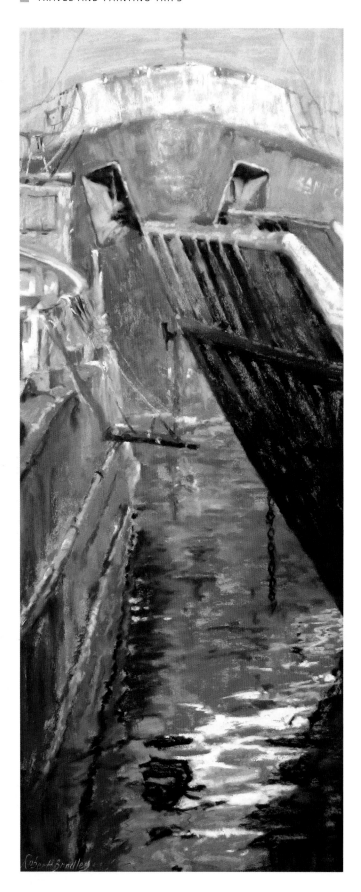

Sand Snipe/Penzance *Pastel, 56 × 23cm (22 × 9in).*

found pulled up on the beach, and it is also well known for its good surfing, on the Porthmeor beach. In past times it was commercially dependent on fishing, but the decline in this industry has caused a shift in commercial emphasis and the town is now primarily a seaside resort.

Since early in the twentieth century, St Ives has become renowned for the number of artists that have been attracted there by its mild climate, wonderful light and coastal scenery.

In 1928, the Cornish artist Alfred Wallis, plus his friends Ben Nicholson and Christopher Wood, met at St Ives and laid the foundation for the artists' colony of today. In 1993, a branch of the Tate Gallery, the Tate St Ives, opened here. The Tate also looks after the Barbara Hepworth Museum and her sculpture garden.

Penzance and Newlyn

Penzance is a town and port in the Penwith district of Cornwall. Situated in the shelter of Mounts Bay, the town faces south-east on to the English Channel, and is situated adjacent to the fishing port of Newlyn. The town's location gives it a temperate climate that makes it warmer than most of the rest of Britain. The pastel painting *Sand Snipe/Newlyn* is typical of the subject matter to be found in and around the harbour at Penzance. It also illustrates how an interesting and unusual subject can be created by imaginative cropping. Always look for something a little different when selecting your subject matter, and never be satisfied with the first, and probably more obvious choice.

Newlyn is a town in south-west Cornwall; it forms a small conurbation with neighbouring Penzance. The principal industry in Newlyn is fishing, and the town relies upon its harbour.

This bustling town has always been a large fishing port and even as recently as 2004 it was the largest in England. The fishing fleet boasts many different fishing methods: beam trawling, trawling, gill netting and potting. Until the 1960s the port was a major catcher of pilchards; today just a small number of vessels have resumed pilchard fishing.

Newlyn became famous in the 1880s and 1890s for its Newlyn School of Artists, including the painters Thomas Cooper Gotch, Albert Chevallier, Henry Scott Tuke and later Laura and Harold Knight. The largest collection of work by the Newlyn School is held by the Penlee House Gallery and Museum in Penzance.

Mousehole

Mousehole is a typical Cornish coastal village. Once a small thriving fishing community, it is now a busy tourist attraction which also offers much to the coastal painter.

The painting *A Good Read, Mousehole* was painted some years ago. Most of the painting is in soft, hazy shadow, which helps to emphasize the light pouring through the gap between the cottages in the centre of the picture. The diagonal of the harbour wall ensures that the viewer's eye moves on past the girl reading her book, and towards the figures positioned around the area of light.

Pembrokeshire

Pembrokeshire, and in particular its coastline, has much to offer – though some of the more spectacular scenery on this fascinating coast can only be seen and appreciated by those who are prepared to walk the coastal paths. The often deserted beaches, cliffs and rock formations combine to make this stretch of coastline a 'must visit' destination for any painter.

The towns and coastal villages are varied and rich with subject matter. The locations described below can be particularly recommended.

Solva

Solva harbour lies on the north side of St Bride's Bay in North Pembrokeshire and on the coastal path. It lies in a deep ravine at the mouth of the River Solva, and the rocks at the mouth of the river make it one of the most sheltered anchorages between Fishguard and Milford Haven.

For any artist who loves painting all manner of small boats, this location is almost unbeatable. At low tide numerous boats sit on the sand, often leaning at amazing angles, and subsequently providing the creative painter with a vast array of possibilities. On a bright sunny day when the sun is low in the sky, the wet sand and river sparkle, making the conditions ideal for *contre jour* painting.

The watercolour painting *Low Tide/Solva Harbour* was painted in these conditions.

Marloes Beach

This secluded beach should suit any painter searching for spectacular rock formations. The beach, with its mile-long expanse of clean, flat sand and breathtaking views out to sea, can be reached by an easy cliff-path walk. The beach has fascinating, jagged rocky outcrops and rock pools, all providing the painter with an abundance of subject matter.

A Good Read, Mousehole *Watercolour, 25 × 45cm (10 × 18in).*

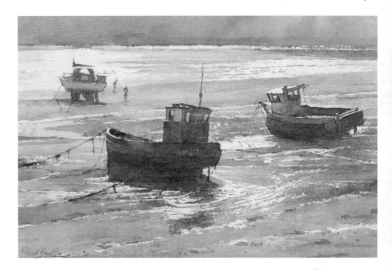

Low Tide/Solva Harbour *Watercolour, 38 × 28cm (15 × 11in).*

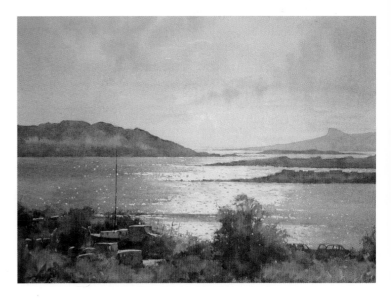

Evening Light/Arisaig *Watercolour, 40 × 28cm (16 × 11in).*

Tenby

This small coastal town is steeped in history; today it is a popular seaside resort. It has wonderful sandy beaches and a magnificent harbour overlooked by multi-coloured buildings above the harbour wall. At low tide the many boats sit elegantly on the golden sand, a joy for any painter. There are numerous elevated views of the beach and harbour from the town.

The West Coast of Scotland

Arisaig and Morar

The small village of Arisaig has a collection of largely white-painted buildings scattered around the harbour. Boat trips to the islands of Eigg, Muck and Rum can be taken from the pier. A visit to any of these islands is recommended to the painter looking for quiet, secluded painting locations such as deserted beaches, rocky foreshores and wonderful light. The sunsets from Arisaig are spectacular, with the distant isles combining to make a wonderful composition. The watercolour *Evening Light/ Arisaig* was painted from a bedroom of the Arisaig Hotel on a beautiful June evening.

Several miles north of Arisaig are the famous white sands of Morar, which in the right light are found in conjunction with a turquoise sea.

Skye

Skye is the most northerly island in the Inner Hebrides. Its peninsulas radiate out from its mountainous interior, dominated by the Cuillin Hills. Its main industries are tourism and fishing, and its largest settlement is the beautiful village of Portree, fringed by cliffs and known for its picturesque harbour and pier

designed by Thomas Telford. The whole coastline is interesting from a painting point of view, and a visit to Waternish Point and the lighthouse in its magnificent setting can be recommended, as can Kilt Rock and its falls on the north-east coast. The sunsets, as anywhere along the west coast of Scotland, must be seen to be believed.

Plockton

The picturesque village of Plockton lies at the seaward end of Loch Carron. This haven for artists, with its neatly painted cottages hugging the shoreline, also has a tiny harbour. Palm trees line the main street, and the village is surrounded by heather-clad crags.

On Home Ground

The East Coast from Hull to Staithes

Robin Hood's Bay

The watercolour *Towards Ravenscar from Robin Hood's Bay* shows the much painted view of Robin Hood's Bay that greets most visitors as they approach the village. The time of day for this painting was late afternoon, and the low sun was lighting up the orange roof and side wall of the tall house towards the centre. This group of houses offers a pleasing variety of shape and form, with their chimney stacks and roofs breaking across the distant cliffs towards Ravenscar. In this instance the subject was painted in an extended landscape format, thereby departing from more conventional proportions. Whenever you come across a very popular view such as this, ask youself whether its possible to do something slightly different with composition,

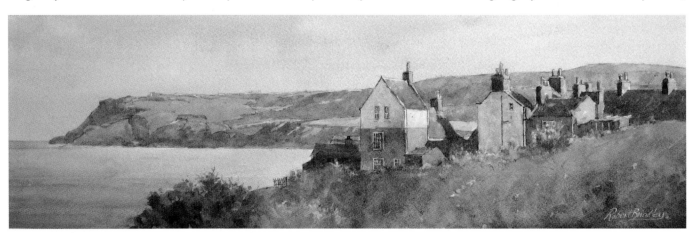

Towards Ravenscar from Robin Hood's Bay *Watercolour, 45 × 15cm (18 × 6in).*

Towards Whitby/
January Snow *Oil*,
40 × 50cm
(16 × 20in).

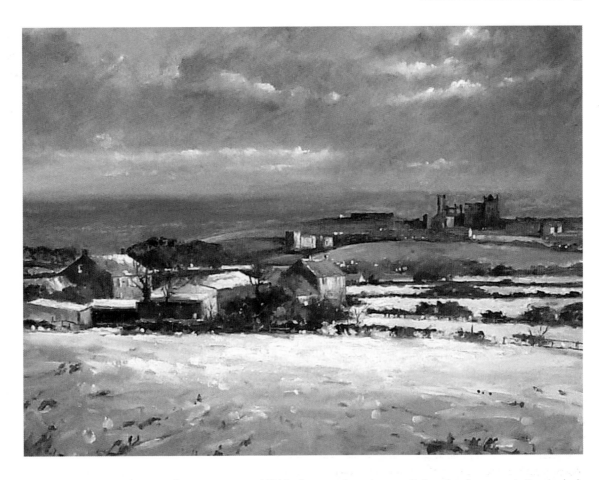

colour, or tone, so that your painting stands apart from many of the others painted from the same location.

Robin Hood's Bay, with its labyrinth of streets and cottages almost piled on top of one another, offers a diverse range of subject matter. A walk down the steep, twisting, cobbled street to the sea reveals much of what this village has to offer. Red pantiles decorate the roofs of stone cottages. A stream runs through a ravine in the middle of the village to the sea below. Different views of the sea and beach can be seen from numerous vantage points, so it will be worth your while to explore.

At low tide, 1,800ft (550m) of exposed sea bed make for great fossil hunting, rock pool investigation and exploring. You can walk to nearby Ravenscar at low tide, when three miles (5km) of beach are exposed – though beware, as the swift turn of the tide can cut off beachcombers and walkers in an instant. The beach is accessed at the foot of the village via a narrow slipway. On rare occasions, with a particularly high tide and the wind in the right direction, the sea has been known to force its way up the main village street.

Whitby

There are many fine views to be painted of Whitby from the higher ground surrounding the town. The oil painting *Towards*

Whitby/January Snow is essentially a landscape painting including a glimpse of the sea in the distance.

The historic town of Whitby is a fishing port and popular tourist destination with a unique 'old world' charm. It is situated on the north-east coast of England. Whitby was once the main whaling port for the North of England, and provides a safe haven for fishing boats and pleasure craft of all kind. It is located at the mouth of the River Esk, and spreads along the steep sides of the narrow valley carved out by the river's course.

The skyline is dominated by the ruins of St Hilda's Abbey, high on the East Cliff. Spreading below Whitby, a maze of alleyways and narrow streets run down to the busy quayside. From the old town, 199 steps lead up to the parish church of St Mary, whose churchyard on the east cliff gave Bram Stoker the inspiration to write his world-famous book, *Dracula*. The town was awarded 'Best Seaside Resort 2006' by *Which* magazine.

The watercolour painting *Cobles/Whitby Harbour* shows an elevated view of two Whitby cobles (fishing boats) moored in the inner harbour.

Runswick Bay

The beautiful village of Runswick Bay is sheltered from the north winds by Lingrow Knowle. Its white-painted cottages and neat

161

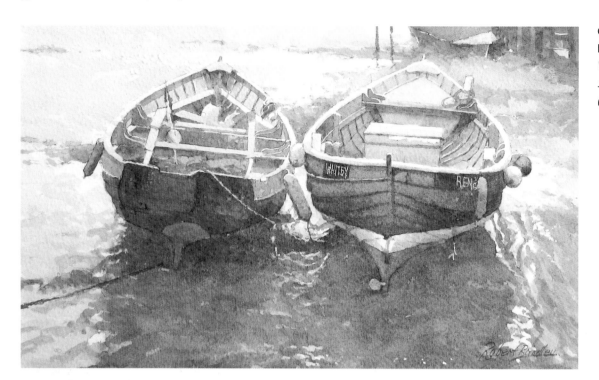

Cobles/Whitby
Harbour
Watercolour,
50 × 40cm
(20 × 16in).

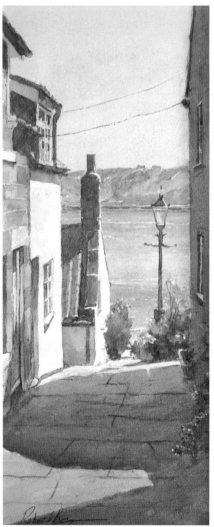

LEFT: Towards the
Beach/Runswick
Bay *Watercolour,*
15 × 33cm
(6 × 13in).

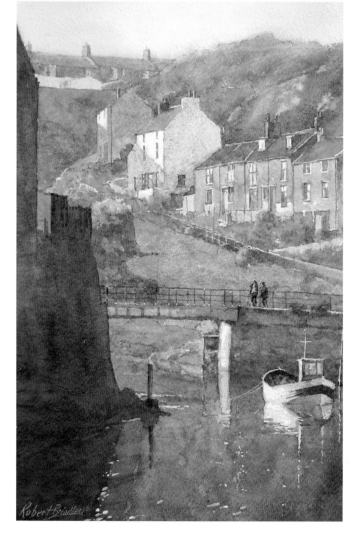

RIGHT: Calm
Moorings/Staithes
Watercolour,
23 × 33cm
(9 × 13in).

Bridge over the Beck/Staithes
Watercolour, 20 × 25cm (8 × 10in).

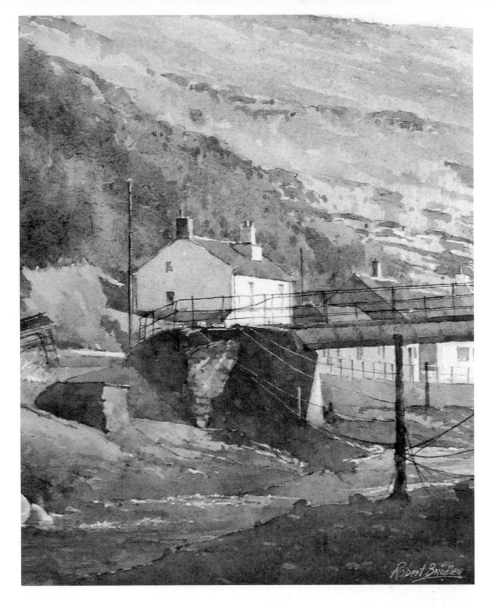

gardens look out on to one of the loveliest bays in the North of England. A view from one of the narrow passages is shown in the painting *Towards the Beach/Runswick Bay*. This subject, and particularly the tall, narrow format, reflects the character of the village.

This picturesque bay, fringed with golden sand, provided safe anchorage for fishing boats for more than 600 years, and when the industry began to decline, its unique setting attracted first artists and then holidaymakers. On a clear, hot summer's day when the sands are almost white and the water a deep blue, you could almost be in the south of France or on a Greek island. This is a painter's paradise.

Staithes

Since the late nineteenth century Staithes, a thriving fishing community with eighty full-time fishing boats, has attracted painters. Young British Impressionists, many of them fresh from Paris academies and eager to put their new ideas and techniques into practice, came to the village and lived and worked alongside the villagers. Sheltered by high, rugged cliffs and surrounded by moorland, the red-roofed cottages of Staithes huddled around the beck provided the subject matter and inspiration they sought.

The watercolour paintings *Calm Moorings/Staithes* and *Bridge over the Beck/Staithes* both capture the flavour of the village in low winter light.

The artistic colony known as the Staithes Group came and went, many of them disturbed by the hardship and loss of life inflicted on the villagers earning their living from the sea. They left a permanent legacy of wonderful artworks as a testament to the years they spent here. Staithes still attracts artists from far and wide who come to paint in the footsteps of many illustrious names from the past, such as Dame Laura Knight.

In today's modern world, this remarkable village still retains the qualities that attracted artists over a century ago.

Conclusion

To conclude this chapter, the importance of travel for most artists must be stressed. We all tend to work in our own local area, maybe extremely satisfied with the paintings we are producing. However, it is not until we travel further afield, especially in other countries where the light may be drastically different, that we realize how 'safe' our work may have become painting in familiar surroundings. Painting light, colour and atmosphere in different environments provides a new stimulus and excitement for those artists wanting to develop their skills.

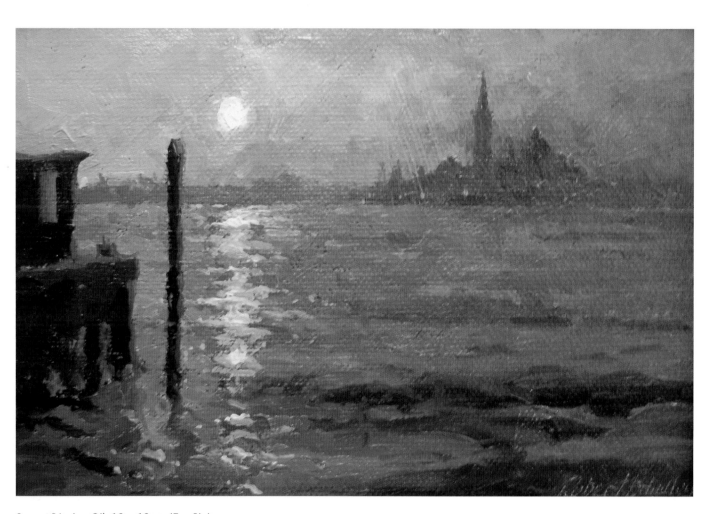

Sunset/Venice *Oil, 18 × 13cm (7 × 5in).*

PROBLEMS AND SOLUTIONS

All artists, no matter how experienced they are, encounter problems with their paintings. The sooner you learn to accept this fact, the more chance you have of dealing with the consequences, such as loss of confidence and self-esteem.

What is before me and what is inside of me governs all.
Henry Casselli

There are many options available to you, some negative, but more importantly there are many positive steps that can be taken.

The negative steps are:

• Discard the painting.
• Avoid the facts and put the painting away with the intention to return to it at a later date. Maybe when you look at it again in a few months time it won't seem so bad? This approach sometimes works and you may be able to salvage something from what seemed to be a failure. However, a painting never improves on its own, and more often than not you will never return to it.
• Attempt to cover over weak passages in a panic without due consideration. This method never succeeds and will never disguise failure.

Dispel these negative options right now; they are of no use to the painter. The only positive solution is to face the facts honestly and objectively. Even though you may have to work hard to improve the painting, by careful consideration and evaluation, more often than not, a failed painting can be rescued. Ask yourself the following questions:

• Are you happy with the composition and the execution of the drawing?
• Has your interpretation deviated substantially from your original concept or objectives, and have you therefore produced something completely different from what you originally intended?

• Have you excluded any vital elements?
• Does the painting work tonally? Try to assess it as a whole in terms of shades of grey: a tonal rhythm and pattern should be apparent throughout the painting. If it lacks tonal variety and design, then adjustments need to be made. Should you have access to a computer, the tonal relationships in your work can be assessed by converting a digital photograph of your painting to 'greyscale' or sepia by using the appropriate software. This will immediately highlight any discrepancies.
• Does the colour harmony work as a whole? Should any colour note appear to take on too much importance, or if the use of colour in any passage is not in keeping with the general colour balance of the painting, then once again changes need to be made.

Always adopt a positive, objective and honest approach to all your work, and you will reap the benefits, and after completing your analysis, you should be in a position to make the necessary changes.

In some cases (especially with watercolour paintings) the extent and complexity of the changes required will make it impossible to rescue the painting. However disappointed you may be by this conclusion, you can take some consolation from the knowledge that by analysing the failed piece of work, and not taking the easy way out by destroying the painting immediately, you have learnt something from the process. Remember, you will always learn more from failed works than from your instant successes. Analyse the elements that you struggled with, and try to resolve how things went wrong. Come up with a few positive solutions, which will be invaluable when similar situations arise on future occasions.

TIP

Nothing is ever learnt from a successful painting that almost painted itself. Always be positive, as far more can be learnt from your failures and mistakes.

Painting is not only about enjoying the successful works, but occasionally – and often more importantly – learning from your failures. On most occasions, however, you will be able to rework certain elements of your painting, and hopefully end up with a success.

The following are some other common problems and considerations encountered when analysing failed paintings:

- Incorrect drawing.
- Too many hard edges; combinations of hard and soft edges are needed in any successful painting.
- Incorrect use of colour.
- Incorrect use of colour temperature, and in some cases too many dramatic changes in colour temperature.
- Painting too loosely, resulting in certain important features and passages not reading correctly. Always be aware that loose painting is not sloppy painting: loose painting requires great skill and observation.
- Overworking: 'Less is always more'.
- Too many distracting highlights or punctuations.
- Muddy colours. Always work from as few colours as possible when mixing, and make sure that every mix, even grey, has a colour bias linking it unmistakably to a primary or secondary colour. Lifeless, synthetic greys and mud colours have no place in your paintings.

All paintings go through many different stages in their development, as can be seen by studying the demonstrations in this book. A few of these demonstrations encountered some of the problems outlined above, which were resolved at the time, or within a few days of the painting being completed. For example, the oil painting *High Aspect/Paleokastritsa*, demonstrated in Chapter 8 (*see* page 142) was changed quite drastically, several weeks after it was hung on the studio wall and 'lived' with.

Never shy away from taking important decisions; if some of the elements in your painting aren't working, change them. Never say 'It will do', because it won't. You must always face up to the facts and be honest with yourself.

The following paintings proved unsatisfactory for one reason or another. The solutions reached may give you some ideas on how you could resurrect or improve some of your own work.

Dealing with Unsatisfactory Paintings

Cropping

The watercolour painting *Sunrise/Venice* initially appeared to work quite well; however, after living with the painting for some time it became obvious that there were two subjects in the one piece of work, and this prevented the viewer from settling on one focal point.

Whilst considering exactly where to crop the painting, it became apparent that two paintings could be salvaged by careful cropping and a little repainting. The first cropped painting *Sunrise/Venice* required no further input other than reframing.

Sunrise/Venice *Watercolour, 53 × 23cm (21 × 9in).*

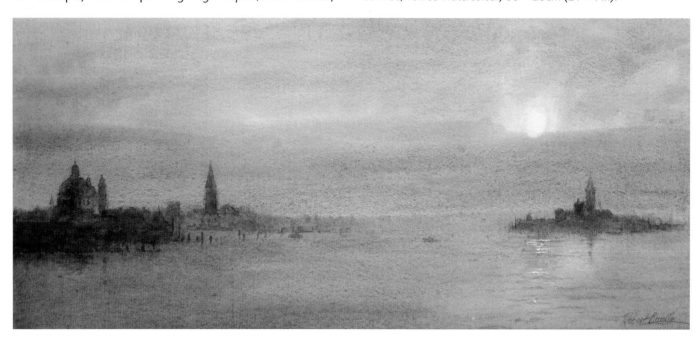

The second cropped painting, *Sunrise towards the Salute,* required a certain amount of careful lifting out of pigment, and repainting to create more impact around what would become the focal point.

Lifting the paint is the best way to overcome water-colour errors. Some colours will lift out without a trace. These are your friends.

Bill Kerr

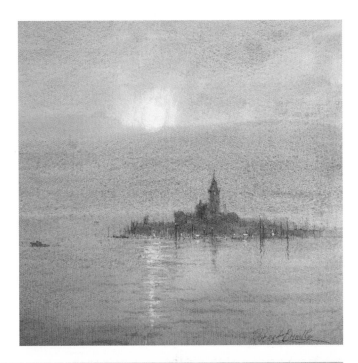

RIGHT: Cropped version of Sunrise/Venice *Watercolour,* 25 × 23cm (10 × 9in).

BELOW: Cropped painting Sunrise towards the Salute *Watercolour, 28 × 23cm (11 × 9in).*

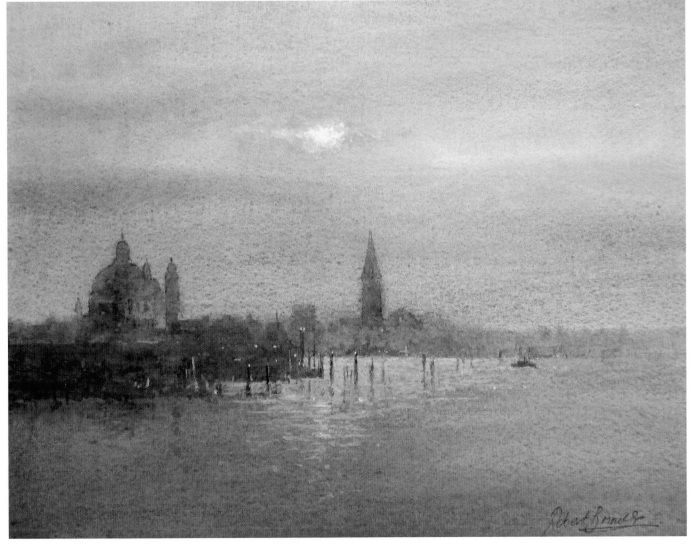

Using stronger mixes of Ultramarine Blue and Light Red, the mooring posts were given more emphasis. White Gouache, Raw Sienna and Burnt Sienna were used to paint the rising sun and create more light on the water, particularly around the enhanced mooring posts.

The watercolour sketch *Towards Whitby* was painted on site on a fine bright September morning. Sometimes sketches are worthy of a frame, however this painting fell short by not having any real focus, so it was decided to add windbreaks and figures. These details were painted back in the studio using White Gouache mixed with watercolour.

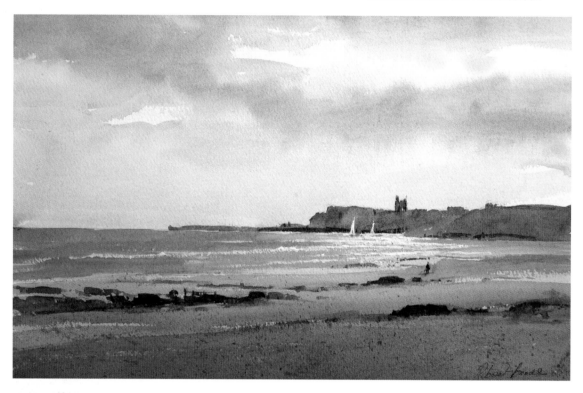

Towards Whitby
Watercolour sketch
30 × 20cm
(12 × 8in).

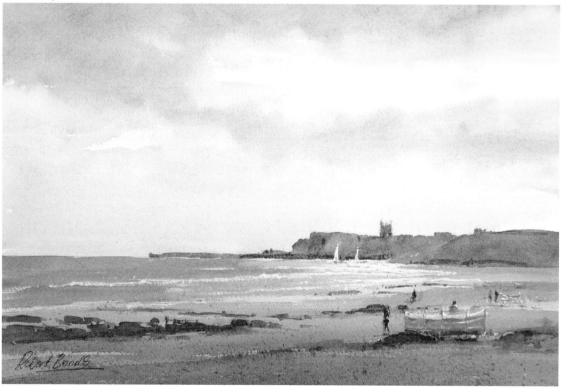

Repainted version of
Towards Whitby
Watercolour
30 × 20cm
(12 × 8in).

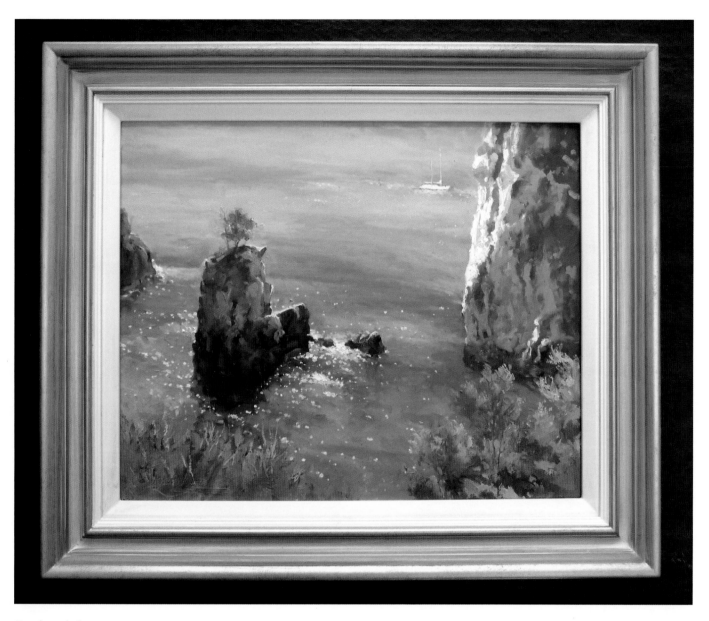

Hand-made frame.

Completing a Painting

When is a painting completed? This question is asked regularly, and there are no set answers to it. In general terms the painting is complete when it satisfies the essential criteria with respect to drawing, composition, tone and colour. However, when the above criteria have been met, you should ask yourself 'Does the painting meet my original expectations?' If the answer is yes, then the painting is probably complete.

In reality, you will occasionally find that you cannot answer some of the above questions. When creating a painting you often become too familiar with the work, which makes any assessment difficult; in these situations, put the work aside for a few days and live with it. You will find that coming across the painting unexpectedly usually reveals any weak areas that require further attention.

It is also advisable to seek honest advice from a partner or close friend. In some instances you may not agree with any comments made, but the important thing is that it has focused your attention and made you look again. Try not to be too 'precious' or over-sensitive to any adverse comments: they are meant well, and are there for you to consider carefully. And having done so, you may completely disagree with any comments made and decide to take no action. However, the process of re-evaluating your work in response to any such comments is extremely important. It will ensure that you keep an open mind in all your work, and could give you a valuable insight regarding the thoughts and reactions of other people when looking at a piece of artwork.

One very useful piece of advice is this: if at any time during the painting process you feel unsure about the area of the painting that you are working on, stop working on it immediately. Take time out for assessment, or continue on another area. Many paintings are ruined during these periods of indecision. You may be able to rectify passages on an oil painting or pastel at a later date, but more often than not, any such errors on a watercolour painting prove to be fatal.

This advice becomes more pertinent as you approach completion, so be careful not to overwork the painting at this critical stage.

Presentation and Framing

The importance of framing is often overlooked by many artists, and many successful paintings are ruined by poor or unsympathetic presentation. A well executed painting, one that you are particularly pleased with, deserves to be shown to its best advantage; however, spending a lot of money on a good frame will not necessarily guarantee that your work is presented sympathetically and will look at its best. Sometimes a simple, less expensive frame can be more complementary to the work.

The illustration on page 169 shows a beautiful hand-finished frame, colour coordinated to complement the painting. Frames such as these look wonderful on the right painting, but can be quite expensive.

There are many ways to frame and present your paintings on a limited budget. This may mean that you only frame your best work, and mount the rest. Consider the following options:

- Although painting in standard sizes may restrict the creativity and variety in your work, it will, however, allow you to rotate your work for different exhibitions by being able to use the same frames over and over again.
- When selecting your frames, be aware of the fact that some of your works would actually look better in simple, and in some cases, cheaper frames. Expensive frames will not necessarily flatter your work. If you have a good framer he will be able to assist in choosing an economical frame that suits your work. Ask him to supply ready-made frames that you can rotate and use on any of your paintings.
- When framing a watercolour, use a single unlined mount for lesser works and a generous wider, lined mount only on your best work.
- Should you have reasonable DIY skills, consider buying yourself some basic framing equipment. There has never been a greater choice of equipment available for the amateur framer.

- Mount all of your work that you consider of merit, and protect it with a rigid card backing and a transparent film covering. This is suitable for oils and watercolours; however, any unframed pastels will need to be stored away safely between sheets of tracing paper for protection.
- A frame should never overpower the painting, so avoid over-wide or strongly colourful mouldings, especially on delicate watercolours.

Simple watercolour frames.

- The two watercolours shown here illustrate how simple, relatively cheap presentation can enhance your work.
- Watercolours generally look at their best in a simple frame with a generous, wide mount. Never mount your watercolours in narrow or uneven mounts. The corner close-up shows a generous, wide double mount.

Even though glass reflects quite badly in certain light conditions, non-reflective glass is a poor substitute, diffusing the image slightly and reducing impact. Non-reflective glass should not be used for exhibition works, and anyway in most cases is not permitted.

Corner close-up.

Summary

This is an occupation known as painting, which calls for imagination, and skill of hand, in order to discover things not seen, hiding themselves under the shadow of natural objects, and to fix them with the hand, presenting to plain sight, what does not actually exist.

Cennino Cennini

First and foremost must be your desire to capture the splendour of nature in all its forms. Without this desire the end product will often be a lifeless rendering of the scene, without heart or soul.

Motivation should come from this desire only. Any subsequent achievements that come along the way should be enjoyed and should reinforce this basic motivation, and not erode its importance for your continued development as a painter. It would be all too easy to be carried away by any success, thereby losing sight of reality by chasing fame and fortune. There is nothing wrong with due progression through the ranks; in fact, any success that comes your way will be a reward for hard work and dedication. Let these successes act as a catalyst to renewed efforts and optimism.

Remember some of the positive points discussed in this book with regard to your growth as a painter; the more you paint, the better you will get. Don't be too impatient regarding your progress; you will find that progress comes in small increments, and often in fits and starts.

Paint for yourself only, and paint only what you love. Try to create a working environment that reflects confidence and a positive attitude towards your work. Have the courage of your own convictions – and above all, enjoy all that you do.

FURTHER INFORMATION

Further Reading

Watercolour

Curtis, David *The Landscape In Watercolour – a personal view*, David and Charles

Curtis, David, *Light And Mood In Watercolour*, Batsford

Zbukvic, Joseph *Mastering Atmosphere and Mood in Watercolour*, International Artist

Oil

Christensen, Scott L. *The Nature of Light*

Curtis, David *A Light Touch, Painting Landscapes in Oils*, David and Charles

Curtis, David *Capturing the Moment in Oils*, Batsford

Macpherson, Kevin *Fill Your Oil Paintings with Light and Colour*, North Light Books

Pastel

Aggett, Lionel *Capturing the Light in Pastel*, David and Charles

Martin, Judy *Pastels Masterclass*, Harper Collins

Savage, Ernest *Painting Landscapes in Pastel*, Pitman

Acrylic

Hammond, John *Free Expression in Acrylics*, Batsford

General

Howard, Ken *Inspired by Light – a personal view*, David and Charles

Ranson, Ron *The Art of Edward Wesson*, David and Charles

Reid, James W. *Edward Seago, The Landscape Art*, Sothebys

Hurst, Alex A. *Arthur Briscoe, Marine Artist*, Teredo Books Ltd

DVDs

APV Films (www.apvfilms.com) are recommended for the intermediate advanced painter. The DVDs by David Curtis, Joseph Zbukvic, Ken Howard, Tom Coates, John Hammond and Ray Balkwill are especially recommended.

Town House Films (www.townhousefilms.com) also make good quality DVDs, generally more suited to the beginner or intermediate painter. The DVDs by Bryan Ryder, John Tookey and Mike Chaplin are especially recommended.

Recommended Materials and Suppliers

Watercolour

Paint

Winsor and Newton artists tube colour (14ml tubes)

Paper

Arches watercolour blocks, Not or Rough
Whatman, Not, 200lb

Brushes

Pro Arte, series 202 Acrylix
Pro Arte, Connoisseur, sables
Winsor and Newton masking fluid

Oil

Paint

Winsor and Newton artists oils, 37ml tubes
Vasari Classic Oil Colours, 40ml tubes
Winsor and Newton Griffin Alkyd, Titanium White, 120ml tubes

Brushes

Pro Arte Sterling Oil/Acrylic brushes
Pro Arte series 202 Acrylix
Escoda 4050 brushes

Boards

Winsor and Newton or Rowney canvas-covered boards in assorted sizes
Canvasses: Winsor and Newton, Daler Rowney or 'Jackson's stretched cotton in various sizes

Pastels

Unison, Rembrandt or Art Spectrum soft pastels

Supports/Boards and Papers

Hermes fine, grey or black glass paper. In a roll or board-mounted*
Fisher 400 art paper
Colourfix Papers mounted on a board
Colourfix Primers, available in several colours for you to make your own boards

Acrylic

Paint

Liquitex in 59mm tubes or Golden acrylics in 30ml bottles

Supports/Boards

As for Oils.

Miscellaneous

Texture paste, fixative, easels and other sundry items.

All the above materials can be sourced from most good art shops or the following on-line suppliers.
Jacksons Art Supplies – www.jacksonart.co.uk
Ken Bromley Art Supplies – www.artsupplies.co.uk
SAA (Society for All Artists) – www.saa.co.uk
Hermes glass paper can be purchased from Youdells Art Shop in Kendall, Cumbria – www.youdells.co.uk

Framing

High quality, hand made frames for oil, watercolour and pastels (*see* page 169) can be purchased from Frinton Frames (www.frintonframes.co.uk) tel: 01255 673707

INDEX